Sense

Lippincott Mercer

GLOUCESTER MASSACHUSETTS

ROCKPORT
PUBLISHERS

Sense

The Art and Science of Creating Lasting Brands

© 2004 Lippincott Mercer, a division of Mercer Management Consulting Inc.

First published in the United States of America by
Rockport Publishers, Inc.
33 Commercial Street
Gloucester, Massachusetts 01930-5089
Telephone: (978) 282-9590
Fax: (978) 283-2742
www.rockpub.com

Library of Congress Cataloging-in-Publication data available.

ISBN: 1-59253-014-1

10 9 8 7 6 5 4 3 2 1

Printed in China

LIPPINCOTT MERCER

Table of Contents

Volume 1

9 **Introduction**

10 **The Birth of Corporate Identity**

26 **Brand and Communications Strategy**

72 **Design and Business**

92 **The Marriage of Science and Design**

122 **Marketing Strategy**

146 **The Role of Naming**

158 **Corporate Brand and Wall Street**

198 **Customer Experience and Design**

217 **Index**

221 **Acknowledgements**

Volume 2

Directory of Articles

Introduction

1-278 **Articles**

281-287 **Index**

Introduction

"What you do speaks so loud I can't hear what you say."—Ralph Waldo Emerson

It's no accident that Gordon Lippincott and Walter Margulies dropped Emerson's enormous concept into an early issue of *Sense*. Right from the beginning, Lippincott Mercer has been devoted to the many crosscurrents of corporate identity, understanding how what a company does combines with what it says to create an image in the minds of its audience.

Sense was created to more fully—and often more critically—explore these threads, examining the newly-emerging disciplines of naming, research, design, and brand strategy.

But as anyone who reads even a handful of these articles will see, as much as we've learned in our first 60 years, our field is still in its relative infancy. We hope you'll find, as we have, plenty of inspiration for solving your current problems in these pages. And we fully expect that the marketplace—and the design and branding solutions that will become possible—will amaze and surprise us for the next six decades.

Enjoy.

The Birth of Corporate Identity

Using a visual symbol to provide identity is hardly a new idea: Egyptians branded their cattle, knights bore their personal crest on their shields. But for a long time—even after mass marketing had dramatically increased the value of a trademark—what a company stood for and how it communicated that identity wasn't given much thought. Making sure that all the appliances left the factory with the "Westinghouse" nameplate, for instance, was about as complicated as it got.

In fact, it wasn't really until the 1940s—with globalization and the remarkable new reach and speed of communications—that businesses began to recognize the urgent need to control their image. The questions of corporate identity became far more complex than stamping a nameplate on a product: What was the best way to introduce new uses to an appliance? What did Brazilians look for in a refrigerator, and the Swiss crave in a washing machine? What did the name "Westinghouse" mean, anyway, to an American suburbanite, an Asian housewife, a Wall Street investor?

CEOs—culled almost entirely from the ranks of manufacturing and finance—didn't have the answers. With the fate of their corporate image (and sometimes by extension their corporate fate) in the balance, they turned to a new category of design professionals, visionaries who were convinced that corporate image design would increasingly be key in maintaining corporate esprit and redefining corporate strategy. These designers were zealots, inspired by the ground-breaking products, architecture, and graphic design of companies such as Olivetti in Milan and AEG in Berlin. About that time, J. Gordon Lippincott and Walter P. Margulies opened Lippincott & Margulies. Integrating brand strategy and design, the two laid out a daunting challenge for themselves. Of course, they would provide the basic elements of corporate identity: package design, new product development, naming, graphic design, and research. But they would never forget their ultimate goal was to make sure that the customer's experience of the brand matched the intention of the marketer.

Lippincott Mercer's early design efforts, such as the Tucker automobile, Royal typewriter, and even the U.S.S. Nautilus submarine, had already won them industry attention. But what American business was missing, they felt, was a deeper understanding of the complexities of managing a company's image. And so they created *Sense,* a publication they hoped would give executives valuable insights into the many facets of branding and corporate identity. Today, we are still trying to provide a closer look at the challenges of successfully managing—and communicating—a company's image.

Nameplates mean more than you think in today's marketing

THE PORCELAIN JUNGLE

DEEPER...

DEEPER...

DEEPER...

HOW MUCH OF YOUR SALE RIDES ON YOUR NAME?

This shield on washer, complete with elaborate crest, is a phenomenon in itself -- appears on no other Crosley products we could find.

Expressed in script, the name here is sandwiched in between various functional parts of the refrigerator.

Here's another Crosley with the name in a busy surround too, and all but disappearing, as it is engraved in onyx-like plastic.

The Identifying Device

Although change is the burden of our civilization, industry has to some extent learned that continuity within change is important for products. Somehow, though, the idea of a symbol -- a nameplate, perhaps -- used continuously, has only reached part of the way through the marketing hierarchy. The result is often mass consumer confusion.

For example, we have collected here a group of nameplates from a number of well-known appliances. We matched them with advertisements from the same appliance manufacturers. Now, although the plates themselves are often distinctive and capable of being easily identified, only one of these advertisements uses the nameplate symbol or shape even in a minor fashion, and only a few use even the same logotype -- or product signature.

Thus, the major means of creating continual identification and familiarity is not employed in the most important of media. Even where it is employed, as for example in the Maytag washing machine, the name, while consistent, is scarcely an important part of the design. Many a product carrying a well-known name - Kelvinator, Thor, Frigidaire, to name a few we've noted -- does so in such a way that the shopper misses it completely. It is either buried too deeply in the other design elements, or is incised into a metal plate with no color differentiation. On those rare occasions when a nameplate has been thoughtfully designed, it is not given a real opportunity to make an impact because the customer's first acquaintance with it occurs in the buying arena. He has no memorable device impressed upon him before he comes to buy which can start the train of association that ends up with "I'll take that one."

Penny Wise and Sales Foolish

It's easy to throw together a few unrelated typefaces, colors and shapes, and then have it fabricated by the most inexpensive method and slapping it on the product, call it a nameplate. Such an uninspired activity is naturally enough, relegated to a member of the firm whose time is not particularly valuable. We have seen some examples of this on products which are among smaller appliances.

Yet the lack of attention to this important marketing device is often obvious to the consumer and can easily vitiate the effects of expensive production and promotion. For aside from the quite striking facts that we've already noted, promoting your nameplate can serve an additional function.

The consumer wants more than just an appliance when she purchases; It is almost a cliche to state that she seeks social status, individuality and many other gratifications. But the nameplate can help provide these. When she is familiar with your reputation for quality, the nameplate tells her that you are proud to have your mark on this product.

More, when you expend obvious effort to make the nameplate smart, attractive, easily readable and recognizable by her, you are giving the appliance dealer an additional post with which to build his corral for your product, particularly if you have used it consistently as a brand mark in all your sales efforts. He may lose your point-of-purchase materials, misplace your booklets, display your posters on your competitor's product. But on the selling floor your nameplate, standing out in the crowd, provides an immediate and permanent ad for your product, in the very situation where the product must sell itself most effectively.

Unmistakably by G.E., name on this washer is clear.

Familiar G.E. brand mark is incorporated in fan design without being lost.

Small appliance carries nameplate identical to larger units.

CROSLEY

Progress Is Our Most Important Product
GENERAL ⊕ ELECTRIC

Familiar Names, New Products—It's a Dilemma

Customers respond well to the familiar, and recognition is important.
But they also expect products to change, and at fairly frequent
intervals. For cars, appliances, and even packaged goods, the consistent
use of a brandmark is a key element driving a purchase decision,
especially when the public has to deal with radical design change.

(See Book 2, V.1, No. 4, "Nameplates Mean More Than You Think in Today's
Marketing," 1956)

13

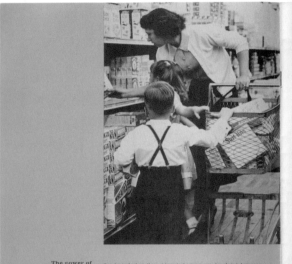

14

The Real Value of a Brand Name

Even as early as 1958, the private-label industry was squeezing national advertisers. *Sense* urged marketers to excel in the one area their private-label competitors couldn't—product innovation. Whether we use a new example like the Palm Pilot, or this 1950s look at the launch of Pledge dusting spray, the key is finding unserved needs.

(See Book 2, No. 10, "Uni-Marketing," 1958)

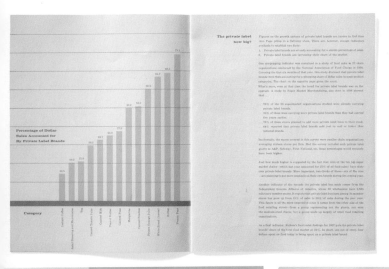

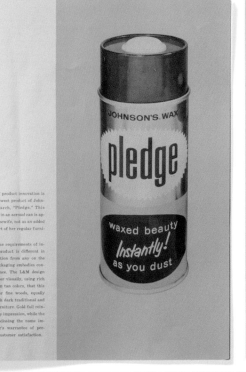

DESIGN AS A MESSAGE CARRIER

How can design create a meaningful and appropriate Corporate Look when the ideas that design must transmit are almost always abstract and frequently very complex?

Understandably, some ideas can be expressed more effectively through design than others. The word "fish", for instance, clearly transmits an image of a "fish." So does a drawing of a fish — only the drawing does the job faster, transcends the barriers of language and literacy and can instantly differentiate between, say, a shark and a flounder.

The idea "warm", on the other hand, is harder to express by design. Graphics here need the help of color to express this higher level of abstraction. Since the color red is universally interpreted as an aspect of heat, it is natural that red be used when conveying the ideas-message, "warm", by means of design.

It is when we try to use design to express the highest levels of abstraction — ideas like dignity, progressiveness, service, quality — that the designer meets his greatest challenge. And it is clear, too, that for many abstract ideas design will need the support of words. In some cases, years of common usage take the place of words. Thus a man with horns, forked tail and pitchfork equals "evil", and a woman with a long white robe holding a pair of scales equals "justice". But, generally speaking, the more abstract the idea, the greater will be the need for some verbal explanation.

Frequently, it is possible to find a symbol that not only identifies but has appropriate mental associations. The Greyhound Bus Lines trademark is one such symbol — a literal expression of the company name and the symbolic expression of swift movement. But as good as the sleek, leaping greyhound is, it still fails to express other qualities which the company would surely like to get across to its customers — qualities like service, comfort, safety. In fact, for some people the greyhound mark may even convey negative connotations of gambling or racing.

This example points up the major design consideration when it comes to developing the symbolism to accompany a Corporate Look. The search has always been — and, we are afraid, will always be — for a symbol (1) that will express just one (or, at most, two) appropriate messages; (2) that is versatile enough to be used in many ways; and (3) that is universally identified with an abstract quality or idea. Given time and enough money to promote it, almost any symbol can be made to work. The goal, however, is symbolism that communicates so effectively that maximum public awareness can be attained with a minimum expenditure of both time and dollars.

In sum, no designer can rightly claim that design alone can do the whole job of creating a Corporate Look. The most that we have ever claimed is that it is ridiculous to depend on public relations, advertising campaigns or even deeds to convey the idea of, say, "a progressive company" if the company's visual communications are transmitting an impression of the brawling, brawny, public-be-damned days that, rightly or wrongly, are usually associated with late 19th Century industry.

CORPORATE NOMENCLATURE: KEY TO IDENTITY

Second element in a Corporate Identity System is composed of the words which

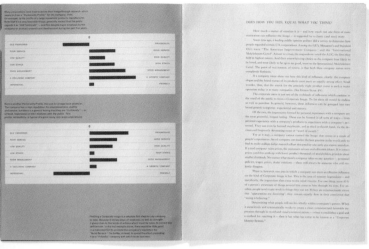

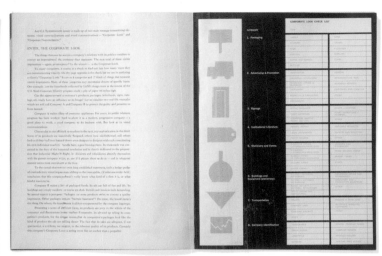

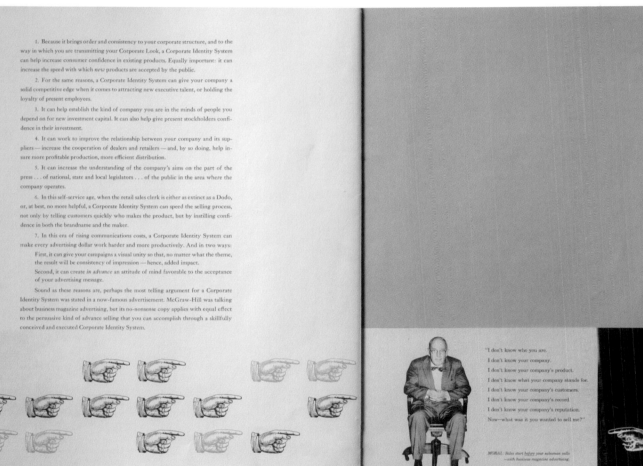

What Your Customer Really Thinks 17

All companies, whether or not they cultivate it, have a corporate image—they get one the minute they open their doors. But understanding how all the bits and pieces of your image—whether hearsay, product experience, or shopping exposure—can amplify or muffle your message is still the first step in any assessment of corporate identity, just as it was in 1958.

(See Book 2, No. 13, "Corporate Identity—Part One," 1958)

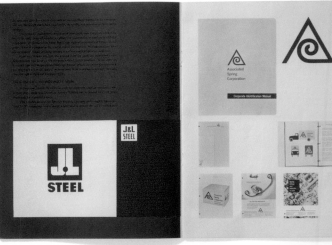

Because they discovered the power of integrated visual and verbal communications — and then did something about it — some companies have already begun to reap the benefits of a carefully planned and implemented Corporate Identity System. One classic example: IBM.

Under the creative direction of Eliot Noyes, and a design triumvirate consisting of Paul Rand, Charles Eames and George Nelson, IBM has managed to project the Look of a company as advanced and efficient as the machines it makes. And at IBM, the program has been a total one.

The company name has been shortened (at least in popular usage) from the somewhat unwieldy "International Business Machines" to the initials "IBM" — which, incidentally, *round* as crisp and business-like when spoken as they appear in the precise letterforms of the re-designed trademark.

The new mark is used everywhere — on nameplates, booklets, matchbooks, ads — even on the carbon paper used by the secretaries who operate IBM's smartly designed electric typewriters.

IBM's computers and other Think-ing machines have the "look" of efficiency. And the look is echoed in the crisp, modern architecture of its factories, the decor of its offices and showrooms.

Consistency of impression over a period of years has given IBM a "Look" that is uniquely its own — a Look, we might add, that is all the more believable because it truly reflects the personality of the corporation.

IBM is an industrial giant. But a Corporate Identity System can work just as effectively for a smaller manufacturer. One example: Associated Spring Company, of Bristol, Connecticut.

C.I. CLARIFIES A COMPANY'S STRUCTURE

Associated Spring makes precision mechanical springs and cold-rolled specialty steels. Formed in 1921 as the result of the merger of three spring manufacturers, the company today has twelve manufacturing divisions in the U.S. and Canada.

Because each division had a high degree of autonomy in its operations, each had, in effect, its own special Image. Some (like the Wallace Barnes Division) were better known than the parent company. Others were plagued with name-similarity problems (i.e., Barnes-Gibson-Raymond Company, Raymond Manufacturing Company, William D. Gibson Company. Pervading the whole structure was an uncalled-for sense of "looseness" which gave the corporation a dual personality in the minds of its customers and suppliers. Many thought of Associated Spring as one entity, and of the Divisions as separate entities. The former was regarded as remote and impersonal; the latter were thought of as close at hand, intimate partners.

The goal of Associated Spring's Corporate Identity program was to clearly establish the relationship between divisions and parent company. First step in L&M's assignment was to develop a uniform system of Nomenclature, and a master plan for implementing it which would provide for a logical progression from the existing diffuse name structure to a simpler, more consistent one.

In the process of revamping the company's Corporate Nomenclature, the need became apparent for a trademark which could serve as the unifying element during

CORPORATE IDENTITY IN ACTION

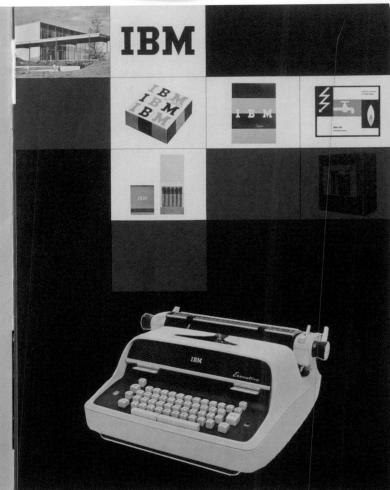

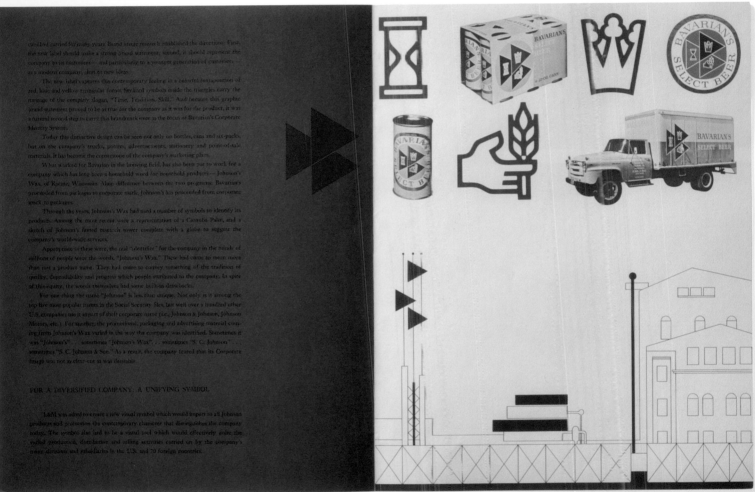

How IBM Got It Right

Starting from its product design (even back when computers were called "thinking machines," the company strove for a sleek, powerful look), every aspect of IBM's culture—its crisp name, its businesslike logo, its uniformly modern office architecture—communicated its image as an efficient, forward-looking business partner.

(See Book 2, No. 14, "Corporate Identity—Part Two: The System at Work," 1958)

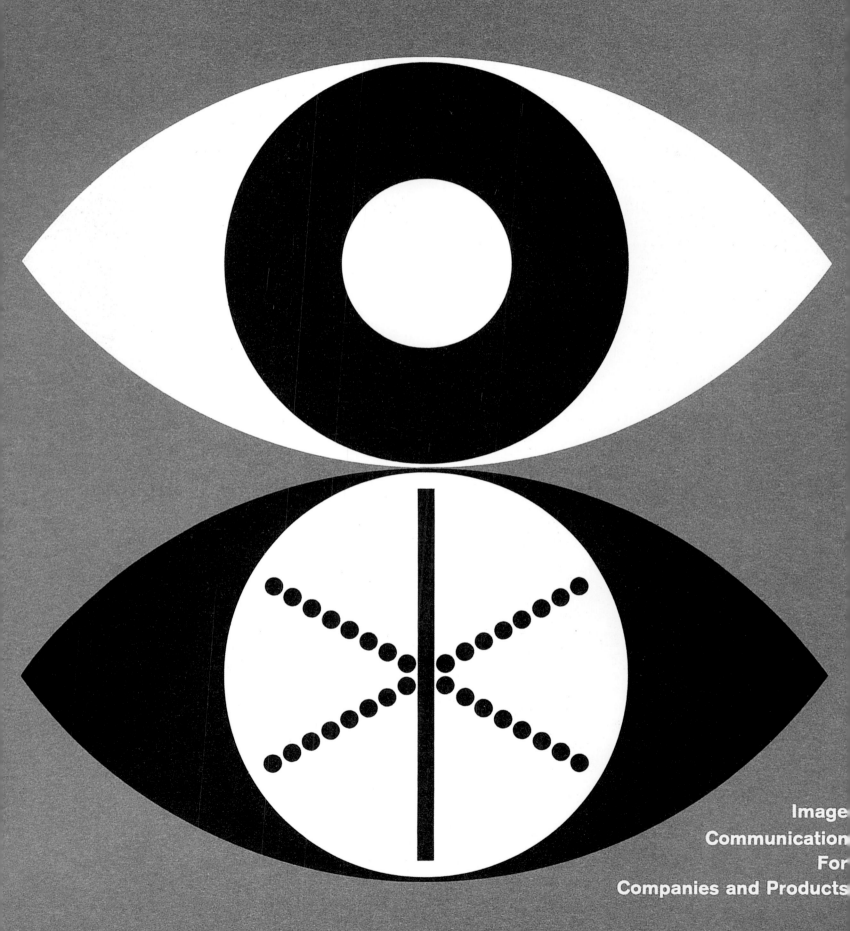

Image
Communication
For
Companies and Products

Lippincott and Margulies, Inc
Industrial Designers
430 Park Avenue, New York 22, New York

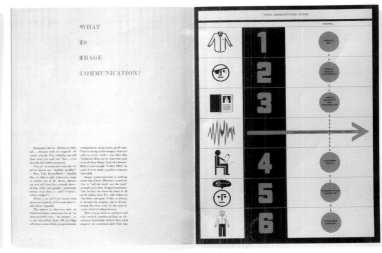

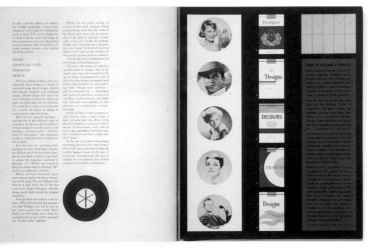

Test Your Design Intuition

Building an image that communicates exactly what you want it to, as complex as that task often seems, is often as simple as using the right design. A fun (once you get past the 1950s celebrities look-alikes) little parlor game tests your ability to mirror a market, and reminds us that, when a design is right, even a ten-year-old can see it.

(See Book 2, Vol. 15, "Image Communication for Companies and Products," 1959)

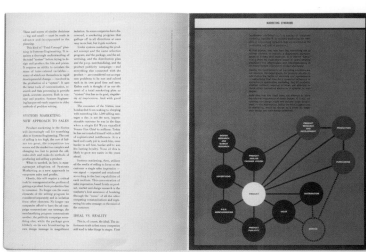

No More Scatter Shots

By 1960, systems engineering was an established business practice,
and *Sense* argued that new products should be launched the same way.
With systems marketing—product concept, name selection, packaging,
advertising, merchandising, and publicity—all interconnected, new
products had a better chance of survival.

(See Book 2, No. 19, "Design for Systems Marketing," 1960)

the product. Then the package (or the product) design. Then the ad campaign. Then the p.o.p. materials. And so on.

The result of such "bits and pieces" marketing can range from the comical to the disastrous. All too often, we have sweated with clients through all the scores of decisions that must be made as a package or a product moves from concept to final design — only to find that the marketing goals at the end of the program are not quite the same ones we started with. Sometimes, this goal-shifting-in-mid-design does not hurt; the design is broad enough to stand on its own, and to work effectively with any of several marketing themes. Other times, when the direction change has been in the neighborhood of 180°, the design solution turns out to be entirely wrong for the product marketing program, and everybody goes back to the drawing boards to start over.

This, is, to understate the case, about as efficient as trying to carry smoke in your hands. And yet it happens. One nationally distributed food product has just gone through its *third* package re-design in fifteen months — a waste of time and money that could have been avoided with just a minimum of pre-planning.

Clearly however, no one group can be blamed for the continued existence of scattershot marketing. At times, we have been guilty as designers, of failing to understand the client's goals and failing to communicate to him our design thinking. (In fact, it was precisely to reduce such communications breakdowns to a minimum that we instituted the Account Manager System nearly four years ago and put design program liaison in the hands of marketing men instead of design personnel.) At times it has been the client who has failed to pre-determine his own product's marketing direction. Occasionally, the advertising agency

has ignored the role of the package in overall marketing strategy. To this day, one of the biggest New York agencies refuses, point blank, to "waste" any advertising space promoting a package change, or to make any use whatsoever of creative selling themes developed during the course of the package design program.

To flip the coin, here is what can happen when client, agency and designer work together as a marketing team:

Soon to be launched nationally is an ad campaign for one of our clients for whom we recently completed a package re-design program. The package design aims at a new and youthful segment of the market — yet purposely retains enough of its original design "feeling" to keep the loyalty of older, established customers. The ad campaign supports the package theme and the new package to the hilt. In short, both ad and package work together to hold the share of the market so painstakingly secured over so many years — yet both reach out simultaneously to encompass a new and broader segment of the market represented by the "young-adult" customer group. Result, in terms of test market sales have been (in the client's words); "Terrific."

We are happy to report that this is not an isolated case. Nor does it represent *just* an example of teamwork among marketing professionals. It is also an excellent example of Systems Marketing at work planning then coordinating all the varied components of the marketing "mix" to create a memorable product image.

PACKAGE DESIGN'S "TREMENDOUS TRIFLES"

One way to suggest the complexity of Systems Marketing is to take a brief look at the complexity of just one element of most marketing systems: the package.

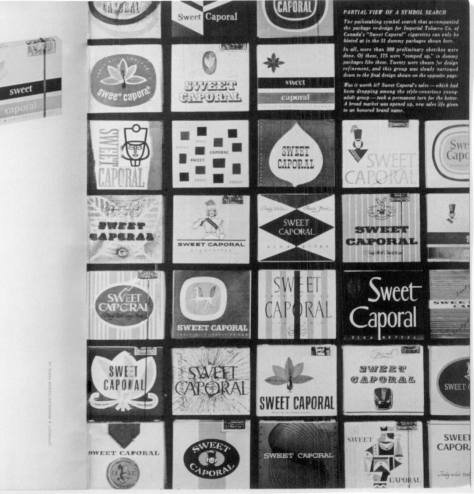

Special Issue on
Advertising
and Total Marketing

THE COMMUNICATIONS EXPLOSION

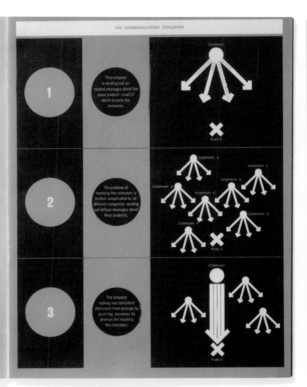

TOTAL MARKETING: A NEW DEFINITION

It is mainly through new products, and new additions to established products, that companies grow. Many companies draw most of their income today from products that did not even exist until recently, and for some executives, the search for new product opportunities has become a full-time job.

Considering the high casualty rate of new products, it is not surprising that many executives are looking for a safe way of diversification through merger (thus acquiring already successful products), rather than developing entirely new products from within the company. Corporate mergers are taking place at the startling rate of three a day.

WHY NEW PRODUCTS FAIL

There is no denying that the introduction of new products is a tricky business. But statistics about the rate of new product failure, like so many statistics, conceal more truth than they reveal. They conceal the fact that some companies almost never have a new product failure, while others seem pathologically prone to fail.

It would seem, considering the general competence of American technology, that what many companies lack is not the ability to make good products, but the ability to decide what products should be made in the first place, and the ability to market them.

TOTAL MARKETING DEFINED

Total marketing is not a particularly complicated idea. It is a two-word concept, and its requirements can be summarized in two sentences.

One, it requires the creation of a product or service idea — a distinctive idea that satisfies a public need.

Two, it requires a careful policing of all the departments within a company and its outside service agencies, to ensure that all of the hundreds of people who promote a product or a service communicate that agreed-upon idea consistently. (Of course a communications program, no matter how consistent, is of no use if the idea communicated is not saleable.)

The people who communicate a reputation or a sales idea are those who work in the corporate identity effort and in the product identity effort — who work on the product's design, its name, its package, its price, its distribution, its advertising, its point-of-sale display, its publicity, all of its verbal and visual communications.

To communicate the same idea in all of these different areas of operation requires discipline from a high source — discipline that prevents anyone from tampering with the central idea. And there are many people in the corporate hierarchy, such as designers and writers, who do have the power and the inclination to tamper with the dominant theme and to substitute one that is more to their own liking. Someone has to direct their skills to the building up of a single strong impression, rather than the random manufacture of several contradictory impressions.

A company succeeds in total marketing when all of the messages it sends to the public add up to one overwhelming and predetermined message. A company fails when it gives conflicting messages — when it tries, for example, to seem friendly in its TV commercials, and at the same time gives a feeling of chill aloofness through its architecture and its receptionists. A company should seem friendly, or aloof, or whatever it is best to seem, all the way. Only those companies with product or service claims that are worth remembering can hope to reach the public today, and they can reach the public only if those claims are communicated in every way a company has at its disposal — from the design of a product or the conception of a service right on through to their advertising.

THE THEORY IN PRACTICE

Total marketing may sound dogmatic as an idea, but in operation its great beauty is its adaptability. In practice what it means is using the maximum number of marketing tools which apply to a company's own goals.

There are really only three marketing goals: projection of a brand name and identity, projection of a corporate name and identity, and a combination of the two. In each, total marketing can be effectively applied.

For an example, we will have to look at an exceptional company. ICM is a very exceptional company, indeed. It may not be listed on The New York Stock Exchange, but it has a special place in our hearts. For it is a company that projects a combined corporate and brand identity, hence one that offers a classic example of many steps in total marketing.

SCIENTIFIC AND PERSONAL PURITY

Years ago, ICM embarked upon what is probably the first and most successful corporate identity program in the history of capitalism. The identity that ICM decided would be most helpful in selling its line of computers was one that blended scientific with personal purity, profits with patriotism.

The company began its new identity program by changing its unwieldy original name to one that more accurately described its business: International Computing Machines. This, in time, became ICM.

Next, ICM took an overall look at its corporate communications program by gathering together in one room, on a large bulletin board, a sample or a photo of every piece of corporate promotion and property the public ever saw. The array included everything from matchbooks to factories. There were hundreds of items, hundreds of opportunities to communicate with the public. But it could be seen at a glance that ICM communicated a confusing variety of messages. They failed to add up to any single impression at all, let alone the impression ICM wanted to give. Many items were not even labelled "ICM;" those that were had different type faces. And the company's trademark had a fussy 19th century flavor.

WHITE SHIRTS AND TOTAL ABSTINENCE

ICM discarded its old mark and had a new one designed — a precise, clean-cut mark containing the company initials embedded in a setting of science symbolism. Gradually, the company stamped its new mark on every conceivable piece of corporate property, including the headquarters skyscraper, branch offices, factories, annual reports, press releases, sales manuals, trade show exhibits, all corporate paper (from calling cards to common stock), signs, trucks, company aircraft, and over every employee's left breast pocket.

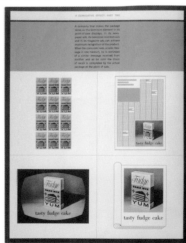

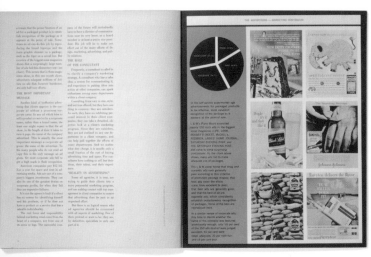

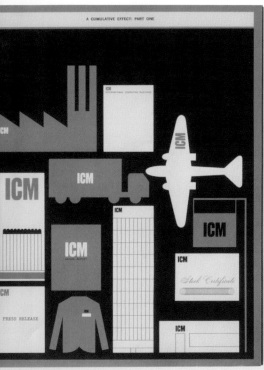

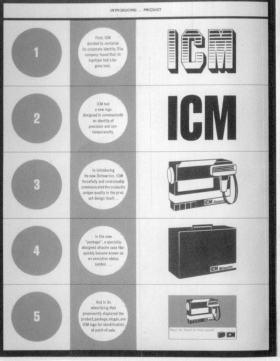

Why New Products Fail

Without total marketing—a careful policing of all departments within a company and its outside service agencies—no company can be sure its image is being communicated consistently. A company can only succeed when all of the messages it sends add up to one overwhelming signal.

(See Book 2, No. 22, "Special Issue on Advertising and Total Marketing," 1961)

25

Few facts are as obvious to us today as this: As marketers, our role is always to think first about our audience. Who should we be trying to reach? What do they need? What do they want? Think? Feel? Believe?

Yet as recently as the 1950s, that statement wasn't obvious at all. The role of any enterprise was to make a product and sell it at a profit. To be successful, we were told a company simply had to make money.

But by 1960—the year Harvard Business School firebrand Ted Levitt published "Marketing Myopia"—a revolution had begun, and L&M embraced it completely. Companies existed primarily to satisfy a consumer need and not merely to earn profits. And only when companies succeeded in meeting those needs did profits follow. Railroads, in his example, struggled to survive because shortsighted executives insisted that filling their railroad cars was what really mattered, all the while losing customers to airplanes, cars, trucks, and even telephones. Railroads failed, Levitt said, because they could not see that they "were railroad-oriented instead of transportation-oriented; they were product-oriented instead of customer-oriented."

That new idea changed L&M forever. Company founders Walter Margulies and Gordon Lippincott added Levitt to the board of directors. Every project was turned on its head. No longer did we allow clients to reflect inwardly on what they wanted their corporations and products to be—that was a vanity none could afford. The key to success, we came to understand, was customer knowledge.

We started from the outside in, beginning with the customer. First, using careful analysis of research, we satisfied ourselves that we were reaching the people who could most use a product or service. Then, we made sure we understood their very heartbeat. We learned about why they bought products, and why they didn't. We asked what they thought of the products we were selling. Based on that knowledge—and the perception gaps that often existed between a company and its audience—we could focus on creating the optimal brand strategy, the critical underpinning for all our work. Brand strategy, for us, always answered three basic questions: Who is our target? What do we want them to know and believe? And how do we create that knowledge and belief?

As our experience grew, we began to understand how critical it was that this strategy be communicated consistently, at every level. Expanding world markets taught us the importance of building strategies that would work in many cultures. Of course—with so many more opportunities to touch our audience, from account statements to web sites to online shopping— we're still learning, striving to achieve strategic consistency in a changing world.

DESIGN SENSE

A MARKETING PUBLICATION OF LIPPINCOTT & MARGULIES INC.　　　NUMBER **28**

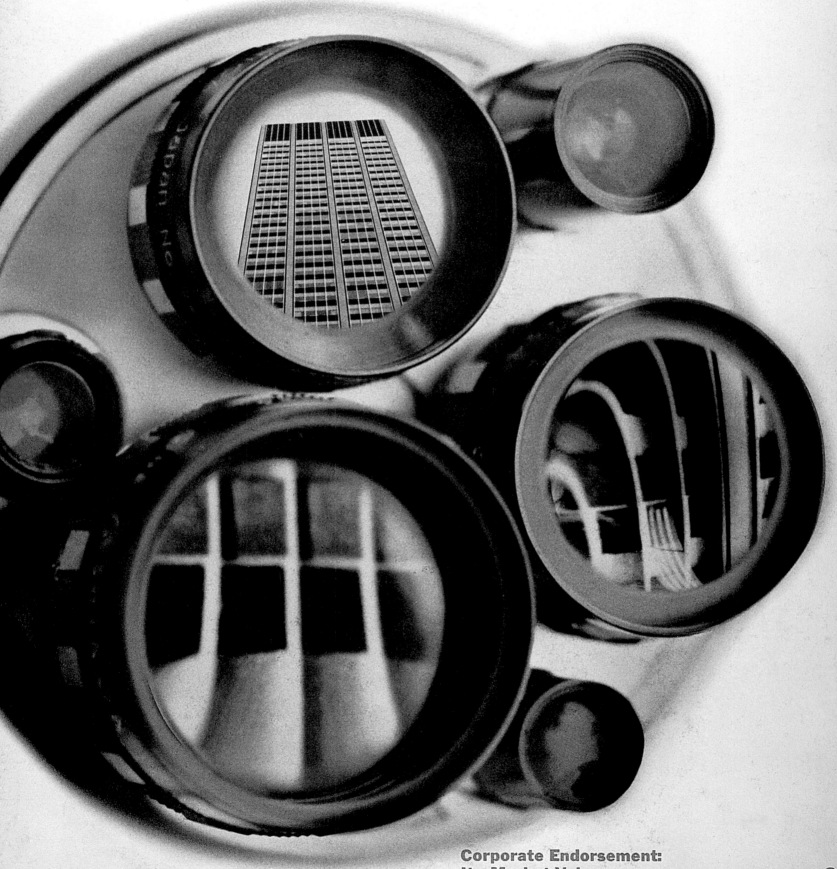

Corporate Endorsement:
Its Market Value page 3

Is the Corporate Image Obsolete? . . . page 7

The Johnson's Wax Story page 11

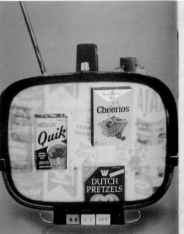

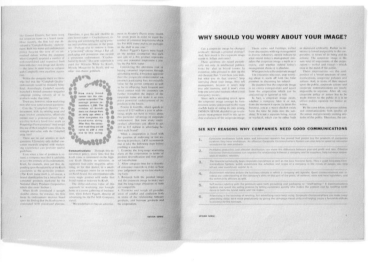
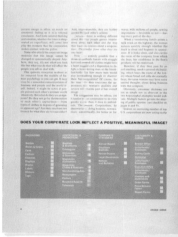
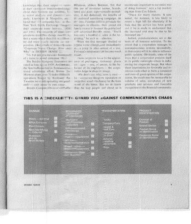

The Rewards—and Risks—of Branding

29

Why will some cheeses succeed under the Kraft label, yet fail when called Crackerbarrel? Timeless lessons from Procter & Gamble and the Campbell Soup Company reveal the subtle shadings of corporate image.

(See Book 2, No. 28, "Design Sense," 1962)

Tailor Services to Potential Markets

When companies try to become more consumer oriented, they first
have to assess the needs of these potential consumers. Are you
still trying to sell them on your stability and integrity, when what they
really crave is innovation or convenience?

(See Book 2, No. 30, "Design Sense," 1962)

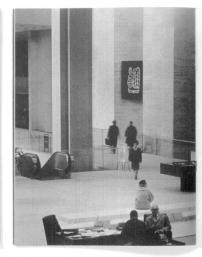

CAN MARKETING HELP THE FINANCIAL WORLD?

HOW ROYAL BANK GOT A NEW LOOK AND IMAGE

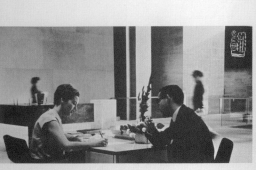

ROYAL BANK

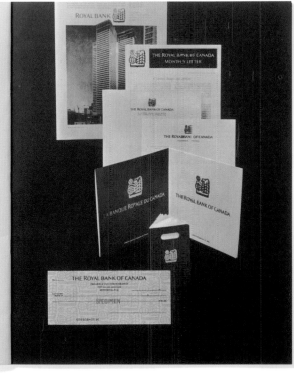

A GROWING BANK CONSUMER-TESTS ITS IMAGE

NATIONAL NEWARK & ESSEX BANK

WHY BANKERS LIFE NEBRASKA WILL REAP FUTURE PROFITS

Design Sense 37
A MARKETING PUBLICATION OF LIPPINCOTT & MARGULIES

CORPORATE IDENTITY New or nothing complexities demand

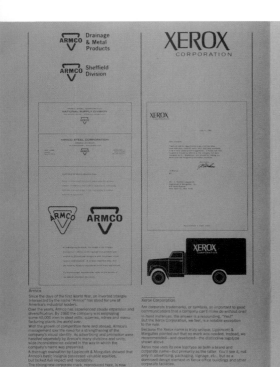

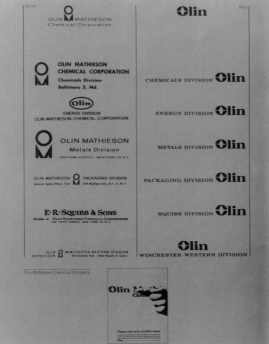

Corporate identity must be more felt than seen. The trouble with so many programs implemented in the 1950's, when the subject was first gaining wide-spread attention, is that they were more seen than felt. That is, they were superficial and ineffective.

There was a marked tendency to apply new corporate graphics and nomenclature in an indiscriminate, wholesale way—a mere rubber-stamping of a new "front" on all those communicative elements, from architecture to letterheads, that make up a corporation's visual and verbal presentation of itself to the world.

It must be different today, if only because today's reality demands more. The key to true corporate identity is the intensification of corporate self-knowledge, acquired through study, research and analysis. Then follows the devising of a meaningful system to communicate that self-knowledge. But these expressions, because they are founded on intense self-knowledge, transcend their physical impress. They are more than merely seen, observed. They are truly felt, in the deep, psychological sense, because they express validity. The pages that follow deal with what we believe is the key to corporate identity—the intensification of corporate self-knowledge, and the implementation of corporate identity systems to express this self-knowledge.

Lippincott & Margulies

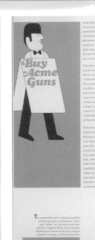

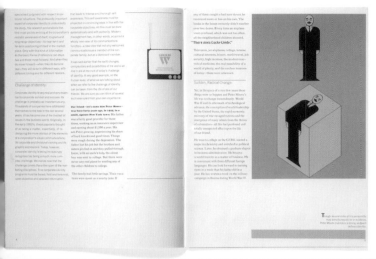

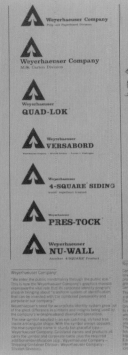
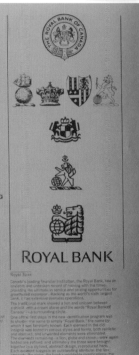

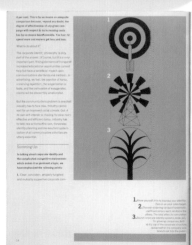

Self-Knowledge Is Key

33

By 1964, corporate identity was a familiar phrase, but too often it meant only a rubber-stamp approach: it was seen more than it was felt. Only those companies who embraced all the subtle challenges—and acknowledged the many ways inconsistencies could arise—could break through the profusion of new products.

(See Book 2, No. 37, "Corporate Identity Revisited: New On-Rushing Complexities Demand a More Subtle, Sensitive Response," 1964

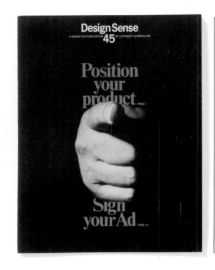

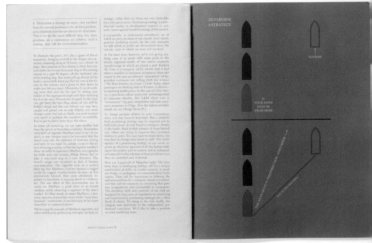

Start with the Audience

An optimal positioning strategy is crucial to defining the goals of product development, name selection, packaging, and advertising. But the first step must always be assessing the market. Your product already occupies a position—are you sure you know exactly where it stands? And what else does your audience want? Do they really crave something new, like a liquid toothpaste, or something better, like the Volkswagen?

(See Book 2, No. 45, "Position Your Product and Sign Your Ad," 1965)

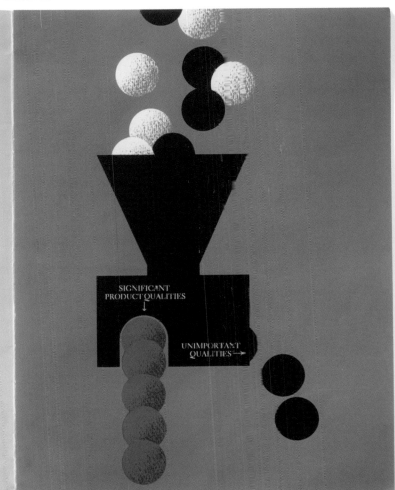

1. *Determine the relevant continua.* Take a hard look at your market, and find the *significant* product qualities that influence *significant* consumers. Weed out the unimportant.

Admittedly, this is so fundamental it also sounds easy. Fundamental, yes; easy, no. Often, indeed, the man closest to the product and its market can get so caught up in things that he loses perspective and is unable to make objective judgments. Long-accepted rules-of-thumb no longer may apply to a new product or to shifting consumer preferences.

Even sophisticated companies can err in determining relevant product characteristics. Take the story of Teel, introduced after World War II by Procter & Gamble. The product, you'll recall, was a liquid dentifrice. But, as P&G discovered millions of dollars later, consumers were perfectly satisfied with toothpaste in tubes, and Teel's only claim to fame was its liquid form. It was certainly different, but not in a significant characteristic.

The point was more subtly illustrated in a recent L&M market study for a manufacturer of portable typewriters. We knew that most typewriter companies had been concentrating on making their "portable" products smaller and lighter-weight. But we discovered that the popular image of a portable-typewriter user—the reporter banging out his story aboard an airliner, the famous writer pecking away with the machine on his knees—does not represent a significant portion of the market. Most portables, it turned out, are used by high school and college students, either at home or at their dormitory desks, and actually are carried back and forth just once or twice a year. Far more important to the market than reducing the typewriter's size or weight by the last possible inch or ounce—at tremendous engineering cost—is the machine's intrinsic value (in terms of appearance and performance) as a typewriter. Communicating such value to the consumer is what counts in making sales. Some of the industry's development money had been misdirected in pursuit of an unimportant and unrealistic product improvement, serving only to make many portable typewriters less salable.

SIGNIFICANT
PRODUCT QUALITIES

UNIMPORTANT
QUALITIES →

It's Later Than You Think

Successful global marketing requires patience, and the recognition that companies must get in on the ground floor of growing markets to establish a strong presence five years later. A well-defined global communications plan is your best hope.

(See Book 2, No. 30, "Global Communications: It's Later Than You Think," 1966)

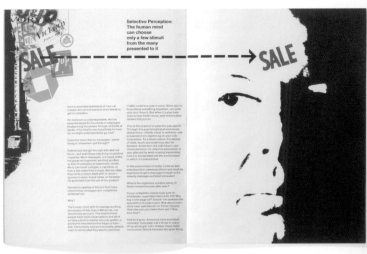

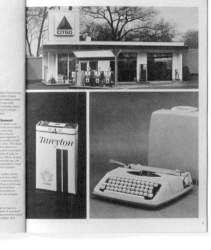

Communications used to be
relatively simple;
today, thousands of messages
compete for the
consumer's attention

Down Memory Lane

You doubtless remember when communi-
cation techniques were very simple and
conducted like a gentleman's game among
U.S. businessmen. Thirty years ago, adver-
tising, by comparison with today's pres-
sures, must have seemed like child's play.
No six-color presses extruded paper faster
than a man could run. No computers bab-
bled a megamessage output. Television
was a crude scanning disc in a laboratory.
Some people still fiddled with cat's whiskers
on their crystal sets in order to tune in Jack
Benny or the Fibber McGee & Molly Show.

If you can remember these programs then
you may even remember their sponsors.
Most people over forty can still dimly hear
Jack Benny selling Jell-O and Fibber
McGee praising Johnson's Wax. After thirty
years, the sponsors have still not faded from
memory. These two shows dominated the
single most important advertising medium
of that time—radio.

Moreover, beyond knowing they would
make an impression, the sponsors could
roughly predict the gains from their radio
advertising expenditures. But that one-time
paradise of predictability has become a
wilderness in which an insistent cacophony
is relieved only by claims and counter-
claims, boasts and rebuttals, weeping,
wailing and gnashing of sponsor's teeth.

Some advertising experts will state with
assurance that inability to associate a
sponsor or product with a TV program is no
measure of the program's effectiveness.
Such results do not spell failure of the pro-
gram, they say. They mumble a new and
mystical jargon about the public's "sub-
liminal perception of the sponsor and his
product," the mental phenomena of "sub-
conscious gratitude and appreciation," the
elusive boon of "a latent induction of buying
motivation." Marketing men, not surpris-
ingly, show some skepticism about whether
their large advertising outlays have bought
anything of real value. How, they wonder,
can they measure such intangibles as
these? The public's "subliminal, subcon-
scious, latent" mental processes are surely,
for psychometric purposes, a mystery
wrapped in a riddle within an enigma.

Product Proliferation

Think of the radical changes we've seen in
the marketing landscape in only three dec-
ades. A quarter century ago there were far
fewer companies and products, even
though recent years have brought more
mergers and acquisitions. The birth rate
of new companies has not slackened; it
more than compensates for the disappear-
ance rate of old companies through ab-
sorption or bankruptcy.

The important factor is not so much the
growing corporate population as the pro-
liferation of what they produce. Improve-
ments in technology have spawned a stag-
gering expansion of lines, marked by an
array of new products, old products, re-
gional products, new and old brand names,
mountains of private labels. All participate

in a massive promotional assault on the
poor consumer.

The plight of the consumer who wants to
investigate the entire new car market before
buying typifies marketing's new look. Chrys
ler, Ford and General Motors once made
only a few models of each brand; the prob-
lem of choice was minimal. Today, the
car makers of England, France, Germany,
Sweden, Italy, Japan and others clamor
for the U.S. buyer's attention. And today,
the buyer, after long analysis, may narrow
the field down to Chevrolet but he's still a
long, agonized way from his final selection.
He must still weigh the virtues of the Ca-
price, the Impala Super Sport, the regular
Impala, the Bel Air, the Biscayne, the Super
Sport 396, the Malibu, the 300 Deluxe, the
300 Regular, the Chevy 2 Super Sport, the
Nova, the Chevy 2 One Hundred, the Corvair
Monza, the Corvair 500, the Camaro, and
the Corvette. Then he must compare two
door models against four door, 8 cylinders
against 6, 118-inch wheelbase against 108-
inch ... colors ... extras ... and optional
equipment.

A computer is needed to sort out the thou-
sands of significant new car factors. But
our buyer is not a computer—nor is he likely
to use a computer in making his decision.

In actual practice, he might abandon his
investigation almost at the outset. He'll
buy a car—but he may choose it on whim,
uncritical preference, or perfunctory evalu-
ation, shutting his eyes and plugging his

2

New! New! New!

By the late 1960s, a proliferation of both new products and me-too ads
in the media meant consumers were skilled at tuning out advertising.
As an antidote to the environment of advertising overkill, *Sense*
outlined the concept of "total communications planning" as a saner
solution, managing communications in everything from packaging
and advertising, to architecture and speeches.

(See Book 2, No. 51, "Overkill," 1967)

39

Design Sense 56

A Marketing Publication of Lippincott & Margulies

Uncommon
Rewards
for the
Uncommon
Marketer

Interviews with/ WILFRID BAUMGARTNER/President, Rhône-Poulenc R.A. MEYJES/Marketing Coordinator, Royal Dutch / Shell

JOCELYN HAMBRO/Chairman, Hambros Bank LORD COLE/Chairman, Unilever HERMANN ABS/Chief Exec., Deutsche Bank

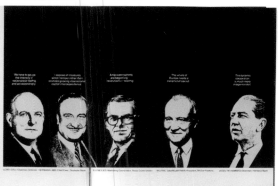

The Uncommon Marketer

How do you communicate fluently when you're a foreigner almost everywhere you go? As the world came to terms with the new power of the Common Market, *Sense* urged readers to think about the role of corporate communications in the increasingly shrinking global market.

(See Book 2, No. 56, "Uncommon Rewards for the Uncommon Marketer," 1968)

Fessing Up: Repair a Tattered Image

Fortune magazine called Con Edison "the company we love to hate," and with good reason: the company was best known for widespread power failures, a poor environmental record, and shabby returns for investors. But selling consumers the new identity—accenting the positive role of energy in daily living—required an honest recognition of past problems.

(See Book 2, No. 57, "Con Edison: A Troubled Giant and Its Dramatic Turnaround," 1968)

Image and reality

Charles F. Luce (left), new Chairman and Chief Executive Officer, together with President J. V. Cleary, announce Con Edison's new communications program, developed by L&M, in a report to the people. Luce acted on early recommendations even before the full program was launched.

Communications Shortcircuit

FORTUNE magazine: March 1966—Con Edison: The Company You Love to Hate

Mapping the strategy

Accenting the positive role of energy in daily living

The modern world runs on energy

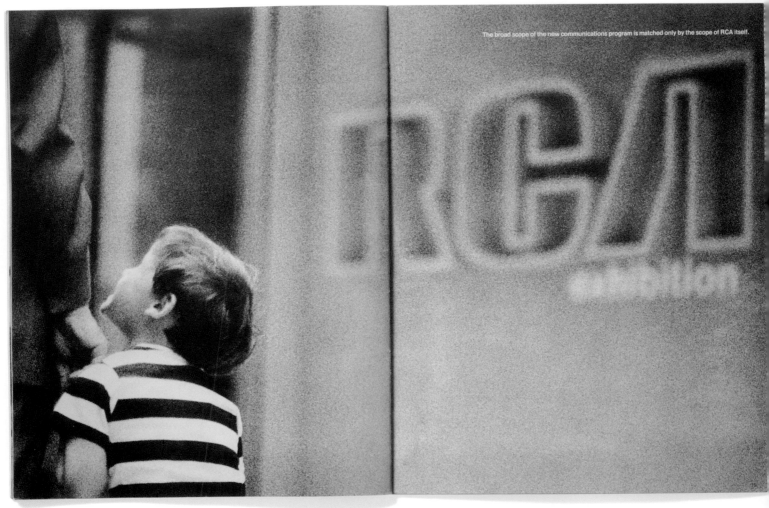

The broad scope of the new communications program is matched only by the scope of RCA itself.

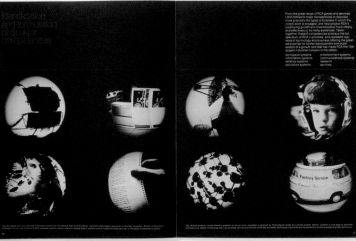

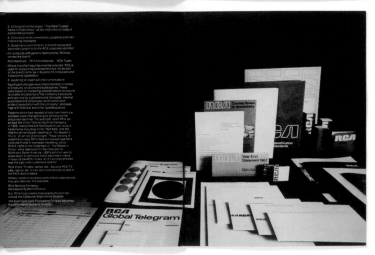

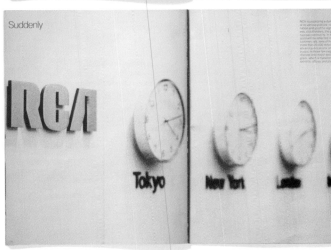

Big and Hungry

For young companies in hot industries, building a reputation for being lean and aggressive is relatively easy. But even a corporate giant—with careful attention to the many signals it sends out through business communication—can encourage the innovative aggressiveness needed for growth. How RCA got its groove back.

(See Book 2, No. 58, "Renewed Vitality for Very Large Corporations," 1968)

Sense 62

Enter Superbrand:

A Unique
Marketing Concept
That Builds For
The Future

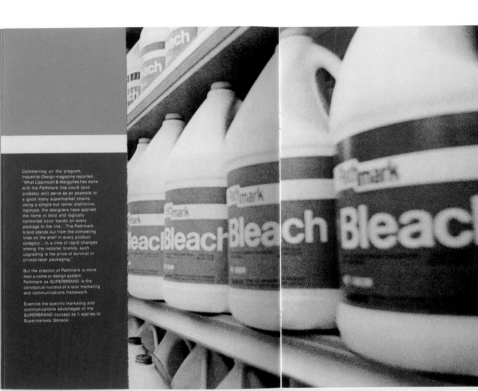

Commenting on the program, Industrial Design magazine reported, "What Lippincott & Margulies has done with the Pathmark line could (and probably will) serve as an example to a good many supermarket chains. Using a simple but rather distinctive logotype, the designers have applied the name in bold and logically controlled color bands on every package in the line... The Pathmark brand stands out from the competing lines on the shelf in every product category... In a time of rapid changes among the national brands, such upgrading is the price of survival in private-label packaging."

But the creation of Pathmark is more than a name or design system. Pathmark as SUPERBRAND is the conceptual nucleus of a total marketing and communications framework.

Examine the specific marketing and communications advantages of the SUPERBRAND concept as it applies to Supermarkets General.

Superbrand:

Private
Labeling

Private labeling is not new. For years many retailers have taken this route to promote lower costs to the consumer and higher profits to the store.

The approach of most food chains to private labeling identification is the multiple communication system: a variety of names are used to identify various lines of products. A&P, for example, in to private line currently, communicates with: Ann Page, Jane Parker, A&P, Sultur, Iona, Sunnybrook, Daily, Sail, Bright Sail, Our Own, Dexola, Super Right, to mention only a few. This is a standard practice among major chains, although the number of identifiers will vary from company to company.

One obvious drawback to this multiple system is that continuity of impression or labeling, both in nomenclature and design.

The reverse is true of SUPERBRAND, or more accurately, unified branding. The unity in Pathmark labeling (coupled a visual and verbal line through all products and lines in both food and non-food categories, identifies both nomenclature and line of design, there is a continual exchange of equity, both in-store and out. Shopper recognition is immediate, an important plus on the highly charged selling floor where private labels must compete with national brands.

The program has is fragmented by an abundance of identifiers tends to confuse the shopper. It is often difficult for an involved merchant to realize that his familiarity with names and design in his own private label program is not necessarily shared by the uninvolved consumer.

Lippincott & Margulies study of the effects of private branding only recognizes positive drawbacks to this system. For instance, one of the strengths of the program lies in the exchange of equities among products. When that exchange is, say, between a cake mix and a biscuit, some areas of opinion between three may be resulting connotations that are undesirable. But this philosophy empanded that food manufacturers share a brand which characterizes a product and its attributes sometimes has problems spanning disparate, generic areas. In the case of private labeling, however, it is not the maker of the product

offering the guarantee, but the retailer itself. We consumer does not have to be convinced of the month's case in legitimacy but must be convinced of the retailer's reputation. It must be pointed out, however, that a poor reputation can adversely affect the entire line of private label products. Thus, right-quality control is essential to unified branding.

But even beyond that, the merits of unified branding, both in terms of a line identity system and in-store brand sales, more than outweigh any possible drawbacks. Supermarkets General's private label program now encompasses more than 1,500 separate items and is still growing.

Forbes magazine in an article on SSC reported, "Due to like Great Atlantic & Pacific trim over their inventories from 12 to 14 times a year, thereby generating sales of over $1 million per store and return 10% to 27% on their stockholders' equities... Particular (Pres.sent of SGC) last year managed to turn over his inventories almost 20 times. This pushed the average sales to an amazing 3.8 million each and SGC's return on equity to 20%, one of the highest in the business."

Superbrand:

In-Store
Diversification

Many national chains are attacking their profit problems by moving into non-food areas. Non-food items now account for approximately 9% of supermarket volume. Our some chains as much as 20%, and a substantially greater share of the profits. Health & Beauty Aids represent by far the largest area of in-store diversification, with sales now more than $8.5 billion. But other categories such as housewares, soft goods, magazines and books, toys, phonograph records, stationery are also featuring often low profit margins.

Nevertheless, there are vast problems that arise in the way of the grocery retailer—most significantly, perceived areas of competence. The shopper in the supermarket must first solve the mental hurdle that a food chain is capable of selling certain non-food items. National brand names present less of a problem, out in the area of private label merchandising at chain store matters, many questions arise that can affect the buying decisions. Who is represented by this name? What does it stand for that makes it unique? What authority or expertise is behind this particular product?

To unfold that, the retailer must broaden his areas of competence in the minds of consumers. It is no longer enough to demonstrate talent as a merchandiser of food, but also talent as a

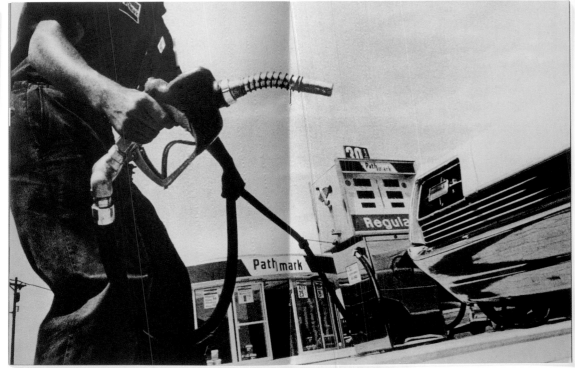

What Makes a Superbrand?

For one supermarket chain, the challenge was to heighten corporate flexibility and communications efficiency. Enter the Pathmark super-brand, a retailing and branding concept that encompassed everything from toothpaste to gasoline stations.

(See Book 2, No. 62, "Enter Superbrand: A Unique Marketing Concept That Builds for the Future," 1969)

Communicating During a Free-For-All

The specifics of the marketplace—the financial services field in the early 1970s—are beside the point. But how companies communicated their image through the chaos, while still remaining flexible enough to explore new markets, applies to many fields today.

(See Book 2, No. 70, "The New Shape of Financial Services," 1973)

The New Shape of Financial Services

Sense72
A quarterly communications journal of... Communication of Lippincott & Margulies, Inc.

American Express,
United Technologies,
Canada Dry,
Pizza Hut, Rainier Bank,
NBC Bicentennial

revitalize their
communicative postures.
A new, aggressive
corporate stance for FMC.

Closing
the
Image

G ap

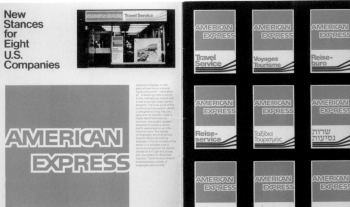

New Stances for Eight U.S. Companies

AMERICAN EXPRESS

American Express, a company whose name is almost synonymous with "international," is keeping in the forefront of the international market with a new corporate-wide identity program. The focal point of the communications system, which is designed to bring the company and its services under a highly identifiable banner, is a bold new graphic system designed to create a strong point, expressed on an international basis. The variety of languages which American Express employs describe a strong business in the far corners of the world, is no problem now in terms of recognition. As shown at the right are but a few of the new system for American Express' Travel Service division encompassing a variety of languages and cultures.

AMERICAN EXPRESS Travel Service	AMERICAN EXPRESS Voyages Tourisme	AMERICAN EXPRESS Reise-büro
AMERICAN EXPRESS Reise-service	AMERICAN EXPRESS Ταξίδια Τουρισμός	AMERICAN EXPRESS שרות נסיעות
AMERICAN EXPRESS Обслуживание Путешествий	AMERICAN EXPRESS خدمات السفر	AMERICAN EXPRESS 旅行サービス

The Story Behind a Major Communications Change

FMC Chairman and President Robert H. Malott

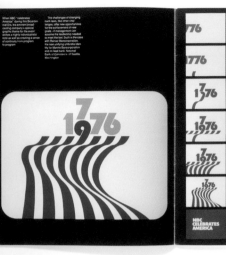

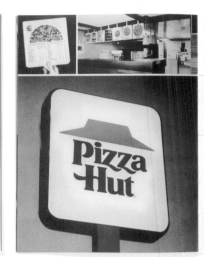

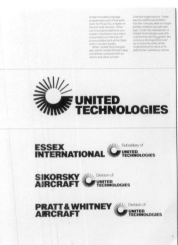

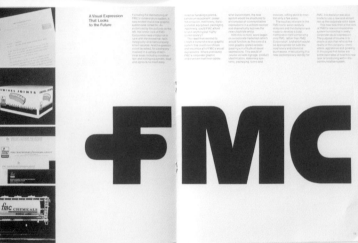

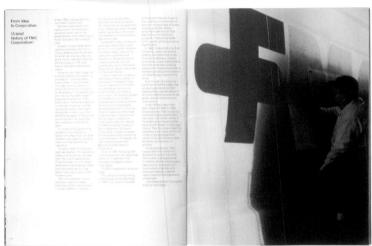

Bridging the Image Gap

Before you try to change the public's perception of your product, you have to measure what that perception really is. For companies like American Express, NBC, and Pizza Hut, perception research paid off not only by revealing a distinctive competitive edge, but with enormous savings in communication dollars.

(See Book 2, No. 72, "Closing the Image Gap," 1975)

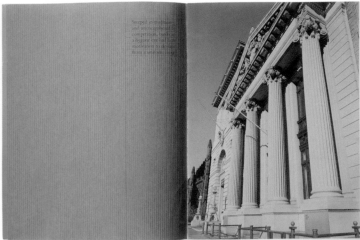

First Union

The British poet W. H. Auden once recommended to his readers "new styles of architecture, a change of heart."

As one surveys the broad spectrum of responses that commercial banks have made to establish a new and positive identity for themselves, an identity at once distinctive and capable of functioning dynamically in retail banking's new competitive environment, it is evident that while, figuratively speaking, "new styles of architecture" are emerging, far too few are imbued by any significant "change of heart."

Had the banking world continued on its uneventful course, First Union National Bank, headquartered in Charlotte, North Carolina, would have had little motivation for a change of heart. Intensified competition and diminished individual visibility, however, were the major factors that impelled First Union, one of the state's top three banks, to come to Lippincott & Margulies for guidance.

First Union enjoyed a reputation as a steady and reliable bank, befitting an institution that had been around for quite some time. A new wide-open marketplace and the response of customers to a new spectrum of stimuli, nonetheless, made the bank recognize that its traditional directives had not positioned it to take advantage of the potential growth of the state's retail business. Competitors, Wachovia and North Carolina National Bank, had moved dramatically to the forefront with intensive, long-range communications programs. To North Carolinians, Wachovia was the bank catering to the carriage trade; North Carolina National (NCNB) became the innovative, responsive, modern and aggressive "mass retailer." First Union remained as it was, quietly in the background. The investment community shared these perceptions.

To compete for retail business in this active marketplace, First Union decided it would have to position itself quite differently than it had in the past. It would re-introduce itself to North Carolinians. The objective would be to achieve public awareness of the bank, not only as a financial institution responsive to commercial needs, but also as a contemporary retail bank with broad expertise and a strong consumer orientation.

A marketing evaluation was the first step in the program Lippincott & Margulies developed for First Union. Research verified the apprehension that the bank's public image was indeed that of the good institution—gray and solid—but out of step with the tempo of the consumer. Signage, architecture, interiors, lack of advertising, all confirmed and reinforced this perception.

The branch design was purposely planned to blend with different community environments by permitting the use of alternative materials in the construction or renovation of facilities.

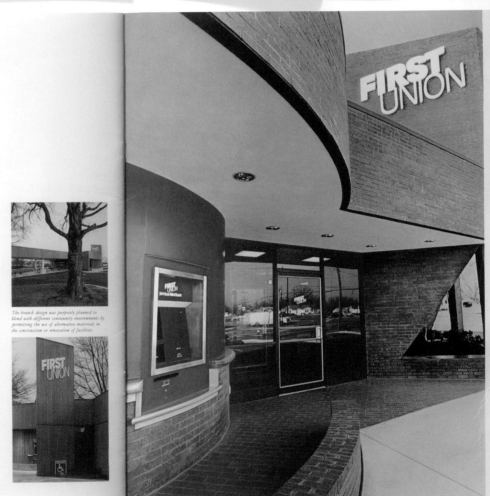

52

Cookie-Cutter Products

Occasionally, an industry lurches into almost complete parity, and only the canniest can find the competitive edge its audience craves. Such was the case with retail banking in the late 1970s, as local banks merged, crossed state lines, and adopted unfamiliar names, signage, and values. Struggling for individuality—with effective and well-aligned communications—some banks stayed ahead of the curve in that environment.

(See Book 2, No. 80, "Banking's Other Asset," 1980)

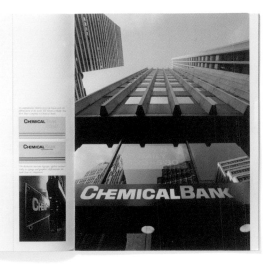

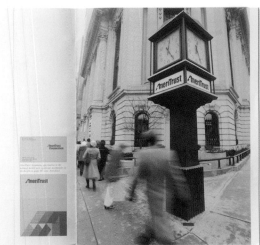

The program's second step was the development of an Environmental Marketing Design strategy, planned to reposition the bank for achieving its overall marketing objectives. This entailed identifying specific image criteria. All elements of the program, from the design of remote automated tellers to the design of a full-service branch, would henceforth be evaluated against these criteria. The image criteria included First Union as a bank of major stature, offering a full range of financial services, retail expertise, personal and friendly service, convenience of facilities, responsiveness to customer needs—and an identity at once constructively aggressive and distinctive.

As in all Environmental Marketing Design programs, these image criteria were recommended only after looking inward at the bank's strengths and outward at the publics for the bank's services. Careful consideration was given to maintaining the stature and dignity important to the corporate customers and simultaneously to enhancing the retail posture—a critical balance for a financial institution. The retail expertise and friendly service had existed all along. Overshadowed by the bank's reputation for corporate expertise, however, it had gone unperceived by the wider audience.

A function of the program was to project forcefully in a contemporary mode the abiding values of First Union. From exterior landscaping to the design of a new logotype, all components of the Environmental Marketing Design program were directed toward molding a unified impression of retail awareness. The interior floor plan was devised for the comfort and convenience of the customers. On one side, teller counters of wood were laid out in staggered fashion, eliminating the monotonous and impersonal effect of a long, even-front counter. On the other side, sales areas were individualized, giving the appearance of privacy and informality by the arrangement of small conference tables and chairs. An illuminated ceiling and skylight reinforced the distinctions between the two areas of the bank, while clusters of hanging plants enhanced the atmosphere of individualized service.

Exterior design characteristics grew out of the interior floor plan. Form followed function. Unique architectural features were developed, enabling the combination of facade, entrance, parking area to identify First Union unmistakably and in a positive manner—even without signage. Consistent with the comprehensive approach of Environmental Marketing Design, landscape was integrated with the facility.

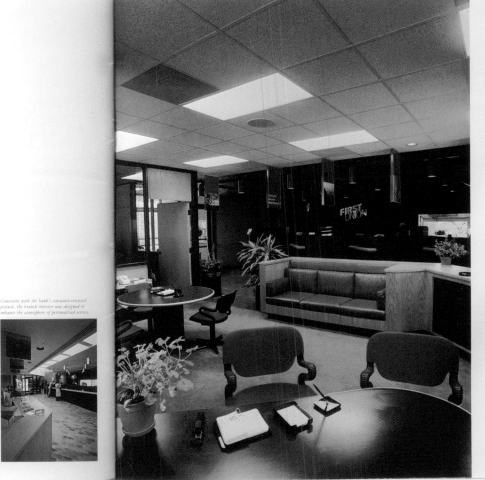

Consistent with the bank's consumer-oriented posture, the branch interior was designed to enhance the atmosphere of personalized service.

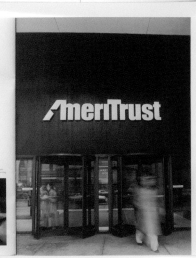

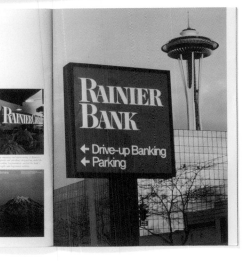

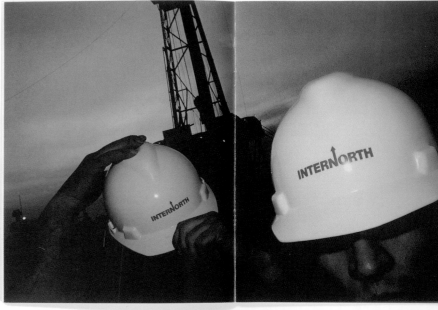

The Pursuit of Excellence in the Emerging Marketplace

SENSE 81 · A Communications, Marketing and Design Publication of Lippincott & Margulies

Building Brands Amid Chaos

Creating a communications strategy for a predictable domestic market is one thing, but building an identity that will withstand the infinite variables of the evolving global marketplace is another. Energy, inflation, government regulation, and intensifying competition are all factors of a rapidly changing world.

(See Book 2, No. 81, "The Pursuit of Excellence in the Emerging Marketplace," 1981)

"Why don't people see your company the way it really is?"

Perception Versus Reality
Sense 82
A Communications,
Marketing and Design
Publication of
Lippincott & Margulies, Inc.

Perhaps because
as it has been, and fai
potential in all you ha
long-term growth ob

Perhaps they mis
Or place you in the w
Even confuse you wit

Public Perception vs. Corporate Reality

Often, we counsel executives of good companies, with impressive earnings and fine products. They scratch their head at what the public thinks; they mistake a small part of the company for its whole, they confuse a company with its competitors. First ascertaining, and then bridging this gap is critical to preserving financial and corporate assets. Even more important, it's vital to what you want your company to become.

(See Book 2, No. 82, "Why Don't People See Your Company the Way It Really Is?" 1981)

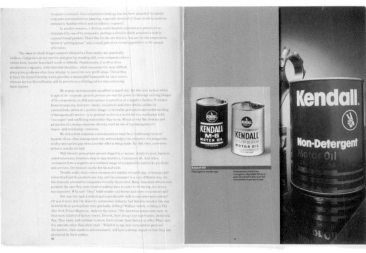
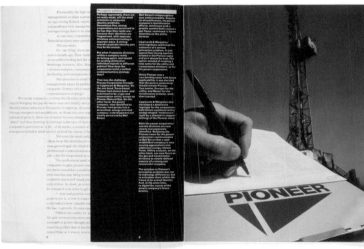

Sense 83

Communications Productivity

A Communications, Marketing and Design Publication of Lippincott & Margulies, Inc.

Understanding Your Company's Touch Points

A communications plan can only work productively when all divisions work together. Any contradictory message at any point in the chain of customer contact undermines your image. Are you sending the same message at all your "touch points" (Lippincott Mercer's phrase for each time your potential audience interacts with your brand)?

(See Book 2, No. 83, "Communications Productivity," 1981)

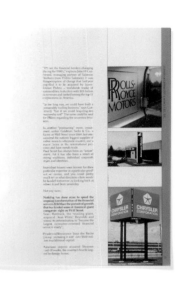

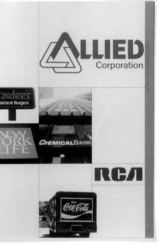

An Identity beyond the "Pure Play"

Diversification meant that, increasingly, a CEO functioned almost as a portfolio manager. The decline of the "pure play" corporate model made finding—and keeping—an identity more difficult than ever. But communicating that enduring corporate position to analysts, investors, and consumers is still just as vital.

(See Book 2, No. 84, "Being One of One: Standing Out from the Crowd," 1983)

61

Corporate Identity and Global Competition

Why should American corporations develop their corporate identities
to accommodate the realities of globalization? Because if they
don't, their competitors will do it for them. A look at what Americans
are really risking.

(See Book 2, No. 89, "The Globalization of American Industry," 1987)

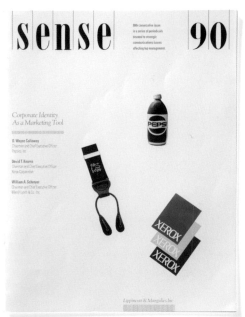

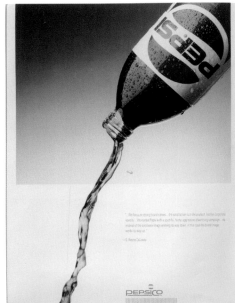

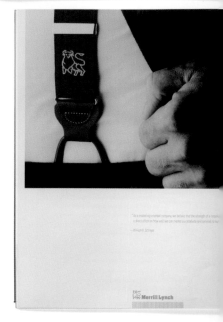

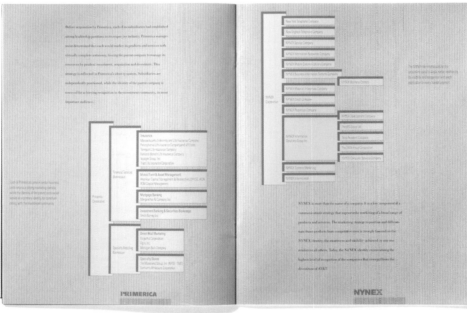

Image As a Marketing Tool

While corporate identity is the sum total of all of a business' communications, different companies use various components of image in different ways. The CEOs of PepsiCo, Xerox, and Merrill Lynch weigh in on image building vs. brand identity.

(See Book 2, No. 90, "Corporate Identity As a Marketing Tool," 1988)

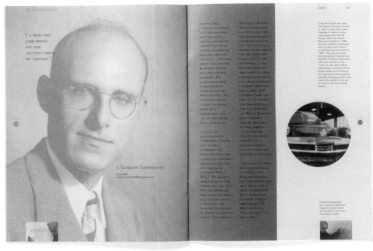

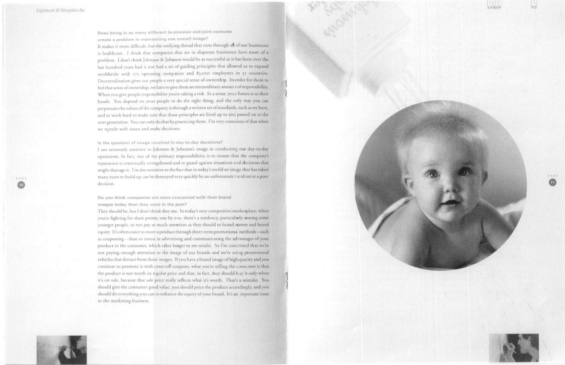

Nurturers of the Corporate Soul

For the CEO of Johnson & Johnson, protecting and strengthening the
company's image as a caring company is not just a big part of his
job, but a daily passion. "An image that has taken many years to build
up can be destroyed very quickly by a poor decision," he says.

(See Book 2, No. 92, "Today's Decisions, Tomorrow's Image," 1990)

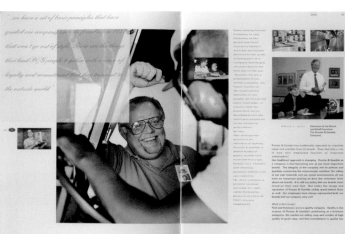

Do you have any specific programs to implement the employee-ownership process?
The key to employee ownership is open dialogue. We have initiated a regular structure of Employee Participation Groups (EPG) that meet regularly to discuss every aspect of the business, how to improve it and how to serve our customers better. Employee representatives are elected by their co-workers to attend monthly district meetings, quarterly zone meetings, semi-annual regional meetings and, finally, a national meeting that takes place every July. This process has been outstandingly successful in obtaining employee input on all aspects of our operations and giving management the opportunity to pass on the objectives we want to meet. One of those key objectives is to improve the quality of service; and it's amazing how our people have achieved new standards of quality since they became employee-owners through the ESOP. They were good to begin with, but now they're even better.

Are they aware they play roles as Avis ambassadors to the outside world?
They sure are. One of the things we're trying to do to make our quality program even more effective is to empower our people to make the decisions needed to solve a customer's problem on the spot without having to go to a supervisor.

Now there are some problems a local employee can't deal with. But there are many they can. Our goal is to provide customer satisfaction and frequently that can be accomplished by employees taking some action on their own. One of our slogans is "Owners try harder," and we try to encourage that by giving our people down the line the ability to make decisions. And if they make a mistake, we'll put our arms around their shoulders later on and explain how it could be done better the next time. Part of our management training program is to get managers in line with this new concept of having their people taking some actions on their own.

Has this empowerment program created any problems?
At the start it did. We had some problems early on when we began the EPG process and employees started coming up with wonderful solutions to certain problems. Sometimes their managers would get nervous that their superiors might wonder why they hadn't thought of those solutions. So we had to get into that and point out that we did that job years ago and we didn't think of it either. And we'd explain that there's nothing wrong with a man or woman who's doing a job eight hours a day seeing things that a manager doesn't. So just welcome the suggestion and make sure the person who made it is recognized for it.

What kind of image do you want your employees to project?
I want them to convey the image that we're a warm and friendly company that's also very efficient. I want our customers to feel that our people care about them as individuals and not just credit-card numbers. I think we're far ahead of anyone else in doing that. My whole philosophy about business is that if you make employees feel appreciated, if you treat them properly and correctly, they'll give you a good day's work, and more. But you have to keep emphasizing the importance of their roles, and you have to keep in touch with them.

How do you do that?
We meet with our people regularly at all levels. There are, of course, the EPG meetings. And I devote at least one week every two months to going around the country to meet with them — flying to two cities a day — to fill them in on how we're doing, to listen to their views on how to make things better. Keeping communication lines direct and uncomplicated has been a goal of senior management at Avis for many years and the advent of the ESOP has given new importance to this management style.

In recent years, many companies have experienced a loss of corporate loyalty on the part of their employees, a lack of pride in their work. What's been your experience?
One way to restore it is to give them a piece of the action. Our people are motivated. They feel they're participants, that they can make the company better and therefore their own positions better. They're now players, and they know that to be an effective player, they have to provide added value. And we know that rubs off in their role as ambassadors of the corporate image. We had some outside researchers come in not long ago and they were overwhelmed by the activities of some of our people. There's a significant group of employees who are just supercharged. What we want to do now is take some of those supercharged people and see how we can use them to charge others.

You emphasize that Avis is a people-oriented company, but you're also a leader in developing a global, real-time information system. How does that relate to the service image you want your people to project?
Our Wizard system enables us to process the car-rental operation faster and more efficiently. I'm a firm believer in computerization and it has enhanced the service we can offer our customers. We like to think we can get technology and people to complement each other. Instead of hiring computer experts and teaching them manners, we like to hire friendly people and teach them computers. Our objective is to separate ourselves from the rest of the industry by continuing to improve the quality of our service. We want our customers to recognize that quality is worth something. Then it becomes a value relationship rather than just a price relationship. Look at a busy time at an airport. The car rental counters are all lined up. But very rarely will you see a line at an Avis counter. That's because the technology our employees have helped develop and perfect is so fast it gets our customers right through. But it's also because our people are going like lightning. After all, they're owners as well as workers, and they take pride in their work.

The Employee as Ambassador

Three companies share their experience with turning their employees—
one of the main ways they interact with customers—into corporate
ambassadors, leveraging their culture into a significant asset.

(See Book 2, No. 93, "Employees and Image: The New Corporate Ambassadors
in the Marketplace," 1991)

Sense

The 95th consecutive issue in a series of periodicals devoted to strategic communications issues affecting top management

Dr. Heinrich von Pierer, Siemens AG

M. Douglas Ivester, The Coca-Cola Company

Creating the Preeminent **Global Brand**

How the Leaders Do It

Howard Schultz, Starbucks Coffee Company

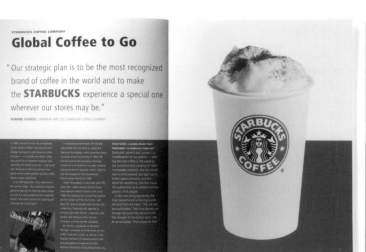

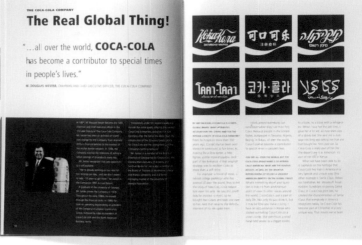

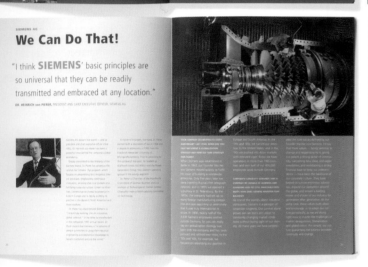

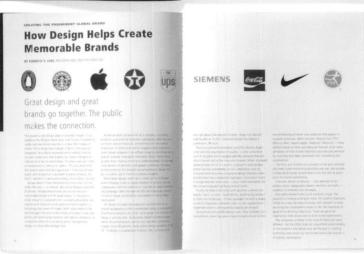

Delivering on Your Promise

Executives from Coca-Cola, Starbucks, and Siemens explain why their brands mean as much to consumers abroad as they do at home: it's a commitment to fundamentals, a clearly defined brand message, and a corporate culture that is both focused and flexible.

(See Book 2, No. 95, "Creating the Preeminent Global Brand," 1998)

Design and Business

One thing that hasn't changed since the first issues of *Sense* is the role of designer as problem-solver. To be sure, design was once the precious domain of the individual—the talented, intuitive, creative type, best given instructions and then left on his or her own. Most executives probably thought of this group—if they thought of designers at all—as those eccentric shaggy types cranking out new-product sketches.

But right from the start, both Lippincott and Margulies had a different idea. Since they each operated best when straddling the worlds of business and design, they looked for those same scientific, analytic skills when hiring young designers. Traditional design projects were approached through the lens of corporate vision. The role of the designer was that of a marketing consultant. First, he or she helped clients understand how people truly saw their product then helped the company articulate how it wanted its products to be seen. Using all elements of design as the solution, they sought to build bridges across those gaps in perception.

For example, when Kroger realized 1950s women shopped at supermarkets, but viewed them as barren barns, designers helped create a series of stores-within-a-store, recreating a feeling of Main Street and a little bit of shopping fun. A lawnmower manufacturer was stumped by its inability to appeal to well-to-do suburbanites; research found these people scorned most lawnmowers as simply being ordinary. So L&M designers set out to create a lawnmower that was distinctive and efficient: Enter the country's first ride-on lawnmower.

Of course, there have been changes. Certainly, the tools and resources designers now have at their disposal are far more complex. Computer design programs, electronic communications, and instantaneous multimedia information delivery have vaulted graphic design from a two-dimensional "stamped logo" to something much greater. Increasingly, designers wrestle with balancing the local needs of a brand with its global vision. What's more, today's consumers are a more sophisticated design audience. They not only accept change, they expect it.

Sometimes, it's easy to feel that in the explosion of graphic awareness, all the best ideas and designs, looks, and visual approaches have already been taken. But we think this line, while it may have appeared in *Sense* in 1956, has never been more true: "Far from being at the point where we are running out of ideas, we may well be at the beginning of one of the most productive periods yet."

Design Sense

A newsletter on Packaging, Product Styling, Store Planning and Merchandising trends
Lippincott & Margulies, Inc., Industrial Designers, 430 Park Avenue, New York
May, 1956, Vol. 1, No. 2

Design Can't Stand Still

If Rip Van Winkle were to take a short nap of about five years between now and 1960, he would probably awake again in a world in which few of the things he knew in 1956 still looked the same. This last decade has seen what is, it seems safe to say, the greatest acceleration in our history, of new design, new approaches, new products and new possibilities. The speed has increased in geometric proportion to the increase in competition. The rate will not lessen during the coming years.

There are two dangers in this trend from the merchandiser's point of view, which relate directly to the problem of design. One of these is the danger that the clamor for "something new" can deteriorate into a spate of unrelated, unneeded and unmarketable newness that has little relation to the real demands of the market. The other extreme, and equally dangerous, is the feeling that there are really no new directions possible -- that there are no new good ideas.

Both of these attitudes are closely related to panic. One is frantic grasping for a solution to a problem which usually cannot be solved by design alone; the other is resignation and surrender.

But both the knowing marketer and the trained industrial designer know that while design cannot stand still, its directions are determined by the clearcut facts of everyday existence. A product with a better design sells better. A product which has a "new" design (new just for the sake of newness) is likely to fall on its face. The design of the Marlboro package is not new -- flip top boxes are no novelty. But it is better, and meets a specific need in the cigarette market, one which has been neglected for years.

There is scarcely a product in today's market place which could not be improved by redesign. Nor is there any lack of new directions in

which design can move for these products. This arises from the fact that in today's market design must express function as well as esthetic fashion. The more we learn about possible functions of a product, the more new functions for products we develop, the more opportunity will we have for a creative design approach.

Far from being at a point where we are running out of ideas, we may well be at the beginning of one of the most productive periods yet. A look at the super market shelves, at the appliance store, at the new materials and new products coming forward is evidence enough.

The real test for all of us will be our ability to comprehend and to anticipate the real needs that will arise, and in the most creative manner.

There is a new key element in creativity today, and that is planning. It takes three years to tool for a new car design, many months to create new packaging machinery. Both the industrial designer and the marketing specialist therefore must be prophets as well as business men. New design must be programmed today in the same way that plant expansion is planned -- years in advance. This type of planning presents great possibilities for a truly organized approach to developing new design. It is also insurance against either of the extremes resulting from panic. By design planning, you are sure that you are getting new approaches, you guarantee an awareness of design trends, and you have the greatest asset of planned creativity, the best source of productive and provocative ideas.

J. Gordon Lippincott and Walter Margulies

Merchandising New Packaging

by HARRY PENHAM, President, Swanee Paper Corporation

No matter how much careful thought, preparation and hard work goes into the production of a new package design for a product, the real payoff -- and the real test -- does not come until that agonizing moment when it is first exposed to the market. For almost seven years, we had been operating with the old design for our Swanee line of paper products. For months we worked with the design team at Lippincott and Margulies to produce the new design which would take its place. Now that we had it, just exactly what were we going to do with it?

Of course, we had not waited until the final design was all the drawing boards and into production to make our decision. We had been involved in a careful reappraisal of the way in which we were to introduce the package during the entire process of design. When the package was ready, so were we.

EVALUATING THE NEW DESIGN

In selling paper goods -- towels, toilet tissues, napkins -- the package is the most direct possible expression of the product itself. Obviously, it's the woman who chooses the paper products for the home. We know that she chooses these paper products for their femininity, their softness, their quality -- and that the package is the key factor in transmitting these impressions. Also, we are most conscious of the new trend to more color in the home.

With Lippincott and Margulies we chose home decorator colors. We felt that L & M had designed a package which would induce the consumer to carry our products home, where they would fit right in with other contemporary home furnishings. All the different products were now family-related by the distinctive Swanee logotype, backed by the alternating striped "S" motif. On all packages the Swanee logo was now a pleasant charcoal gray. We felt too that the new packaging now expressed the quality of the product. For the competitive super market shelf we now had a package that would stand out.

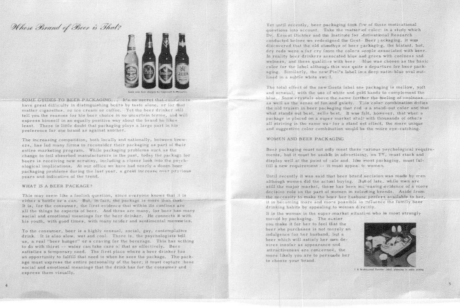

The Perils of Not Changing

A redesign is always frightening. Change for its own sake is pointless, but the risk of not changing—of selling a product that appears dated or less functional than its competitors—is greater. "Industrial designers and the marketing specialists must therefore be prophets as well as businessmen. Better designed products will sell better."

(See Book 2, V.1, No. 2, "Design Can't Stand Still," 1956)

76 **What Makes a Good Trademark?**

A good trademark is a quality statement as well as a memory trigger, and the design core of any distinctive look. Today, consumers have come to expect that these core identity symbols will be updated frequently, but count on them to somehow stay the same. Like Coca-Cola's ever-fluid wave or the shifting shape of Prudential's rock, good trademarks are built to evolve, signifying a company that is constantly improving.

(See Book 2, No. 7, "Trademark Issue," 1958)

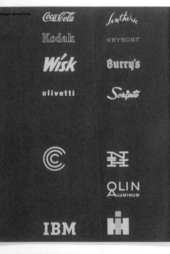
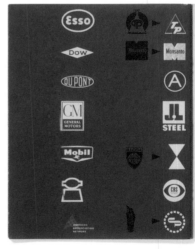
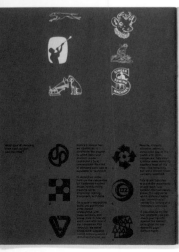

11

DESIGN
FOR
SALES

THE
INDUSTRIAL
DESIGNER
NEW
FACTOR
IN
MODERN
MARKETING

CASE NO. 1
DESIGN
TO OPEN
CLOSED DOORS

CASE NO. 2
NEW IMAGES,
NEW SALES

Research Drives Design

To find the right solution, designers need to fully understand the problem. When American Tobacco relaunched Tareyton, for example, Lippincott Mercer created more than 100 package designs in a ten-month period. Four finalists were tested extensively to make sure the winner successfully conveyed the brand's stately old image, yet announced the modern promise of its new filter.

(See Book 2, No. 11, "Design for Sales," 1958)

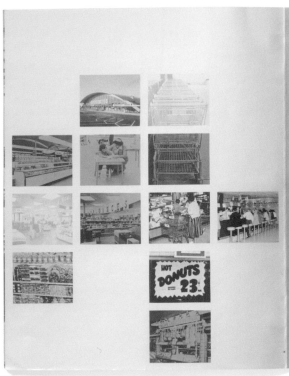

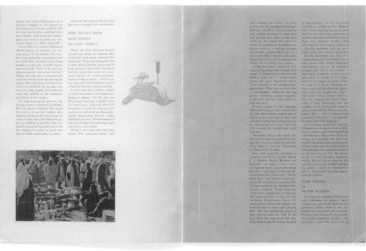

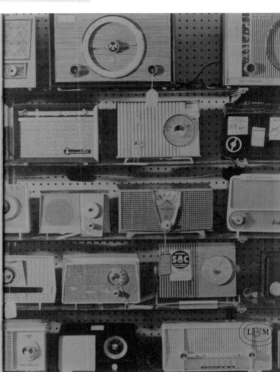

How Design Clinches a Sale

As America discovered discount stores, major brands and retailers struggled to find and communicate points of difference other than price. Lippincott Mercer research uncovered something important about superior design: where price and brand familiarity are about equal, and real product differences are minimal (and this is most of the time), the "look" is the most important factor influencing purchase.

(See Book 2, No. 16, "Revolution in the Marketplace," 1959)

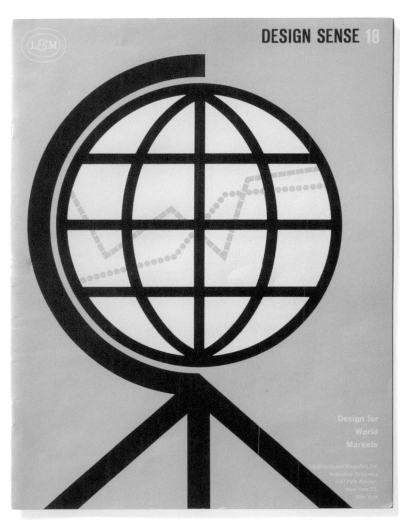

DESIGN SENSE 18

Design for
World
Markets

Lippincott and Margulies, Inc.
Industrial Designers
430 Park Avenue,
New York 22,
New York

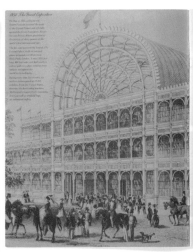

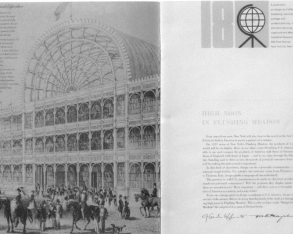

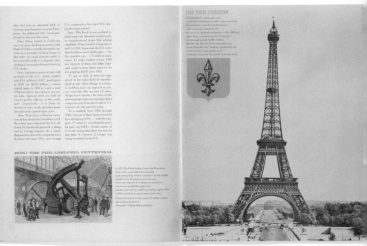

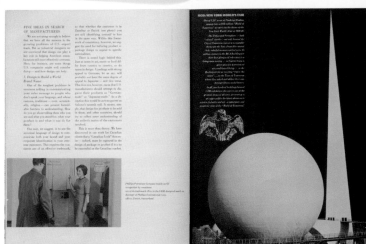

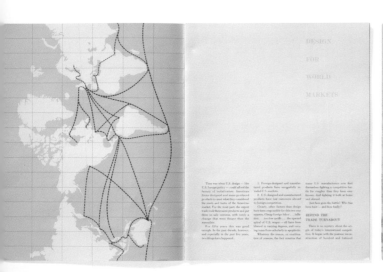
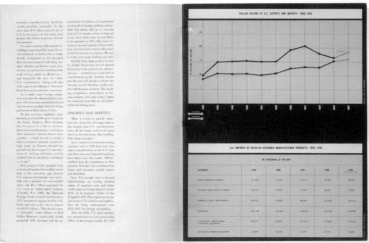

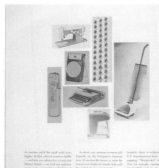

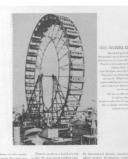

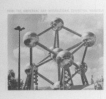

The Designer As Global Citizen 83

With the deadline of the 1964 World's Fair looming, *Sense* urged American businesses—already overwhelmed by foreign competition—to stop bellyaching and start innovating. Americans loved the new imports because they were better; American companies needed to become students of the world market. "We need better products, sold harder."

(See Book 2, No. 18, "Design for World Markets," 1960)

The Designer's Expanded New Role

By the early 1960s, and with the greater acceptance of corporate identity, Lippincott Mercer designers increasingly found themselves pushed beyond their narrow areas of expertise. Whether their background was in architecture, graphic design, or engineering, their broader role was always to improve the communication structure of a company.

(See Book 2, No. 21, "The Design-Marketing Consultant," 1961)

When the choice is hís to make, the Creative Man may follow the same route twice . . . but chances

as it is for him to say, "Hell, no!" at the first sign of monkey-see, monkey-do alterations.

And it's equally characteristic for the same person to spend years in research, a fortune in development and tooling up, and even risk losing all competitive advantage by clinging to test-market schedules, as it is for him to build an over-night hunch into a product line worth millions.

What we're saying, beyond all else,
is that sophisticated and successful marketing practices do need, and must have, a solid platform. This platform, however, can be constructed on one man's vision— don't we all rent cars?— or the collective efforts which have produced so many major marketing triumphs.

On Emerson and Diversification

From time to time, one of our marketing studies prompts a remark like this: "It's good, very good and very complete. I'm certain this is the approach we must take. Now, if we can just get the approval of our Board"

More than any thing else, such situations have caused us to wonder, what kind of man is he—he who can get the approval of the Board?

"He's a burden bearer," we've been told. "Wrestles every problem into the ground, and won't let up until things go his way."

"Greatest spell-binder since William Jennings Bryan," another version goes. "When he raises his voice, the Board members lower their heads and stop bickering."

"There's no trick to it," others will tell you. "If the proposal is sound, you tell them so and why. The Board will have no objection to making a profit."

Our point? Just this: where people are concerned,
there is more than one course open for influencing their actions, or predicting their reactions. Past experience in charting the right course can be invaluable, but it should be remembered that yesterday's route to success can lead to catastrophe tomorrow. And this is as applicable to companies as it is to individuals — even those who can get the approval of the Board.

"Foolish consistency," said Emerson, "is the hobgoblin of little minds." We couldn't agree more, and if Emerson seems a strange source for marketing men to quote, consider the staggering investments in corporate diversification today.

Is it consistent, for example, for Armstrong Cork Company's total product line to consist of less than 1% in cork items? How many of the giant tire and rubber companies are producing only tires and rubber products—and wouldn't a change in their corporate names be extremely wise? Hasn't it been fairly well established that the railway companies would now be much better off if they had looked for new horizons?

To get back to people,
how many college graduates actually are working at the job—or even in the same general area—for which their degrees were taken? We don't know with any certainty, but suspect that a phenomenal number have gone a'wandering.

And why shouldn't this be so? Witness the speech teacher turned inventor: Alexander Graham Bell. The gunpowder merchant turned chemical pioneer: E. I. du Pont de Nemours. The budding lawyer turned Broadway columnist: Leonard Lyons. The engineer turned president: Herbert Hoover. The junkman turned Hollywood Rajah: Louis B. Mayer. The bank clerk turned heavyweight champ: James J. Corbett. The medical student turned novelist: W. Somerset Maugham. The list is endless.

These were not Renaissance men in the grand sense; no da Vincis, no incomparable humanists chanting . . ."Men can do all things if they will." Nor were they, and this is their common greatness, limited by the "foolish consistency" that so often stymies the growth of corporations and executives alike.

No Merlins, No Mittys

Perhaps the greatest danger in sketching our Merlin-of-the-Marketplace is that he brashly comes through larger than life.

Here he is, it may seem we're saying, second-guessing his research department, out-guessing his advertising agency, and making the world over with pinfeathers and pipedreams. Backed to the wall by the Robinson-Patman Act, and stymied overseas by the European Common Market, he can still smile and forecast how the population explosion will solve all corporate ills by 1970. Asked for an an analysis of consumer taste preferences in the 11 Western states, his answer comes back—by morning—as concise and penetrating as a Hearst crime reporter's eye-witness report of how a hand grenade was slipped into the governor's sandwich.

There are such men. Walter Mitty was one. Horatio Alger, Jr., chronicled their lives frequently. And wasn't Babbitt something of a self-made soothsayer, too?

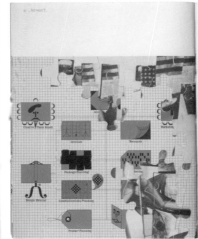

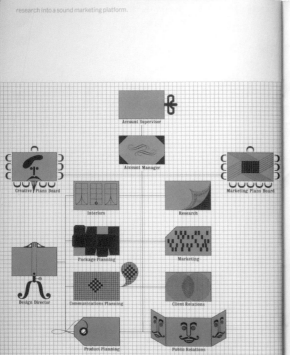

Your Most Innovative Employee

Funny that a *Sense* article with as dated a title as "The Creative Man" could offer one of the most up-to-the-minute lessons in this collection. Can you spot the innovators in your company? Do you know them? Are you giving them what they need to be the daVincis, the Marco Polos, the Amelia Earhardts they have the potential to be?

(See Book 2, No. 38, "The Creative Man," 1964)

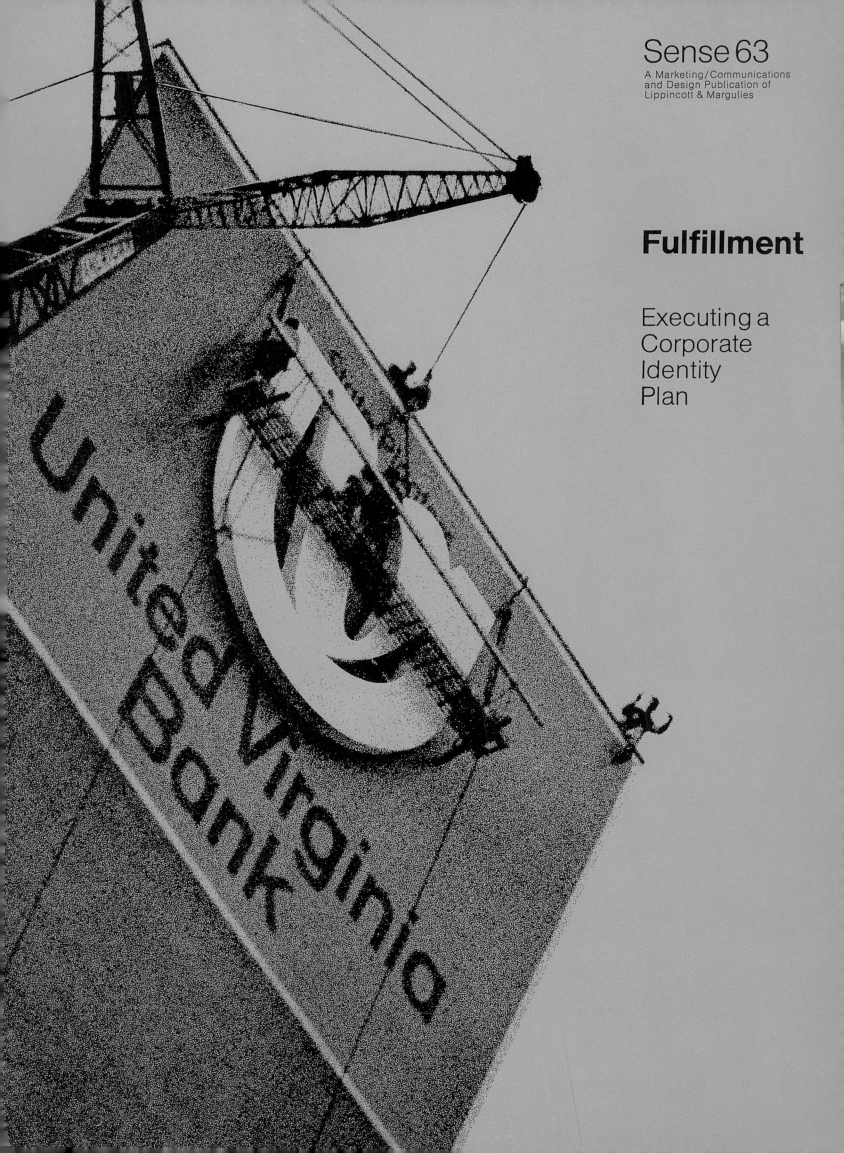

Sense 63
A Marketing/Communications
and Design Publication of
Lippincott & Margulies

Fulfillment

Executing a
Corporate
Identity
Plan

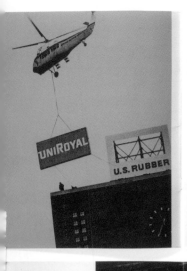

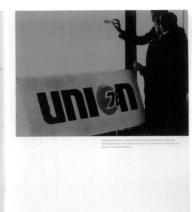

Fulfillment

Executing a Corporate Identity Plan

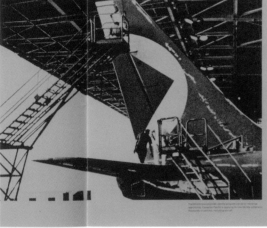

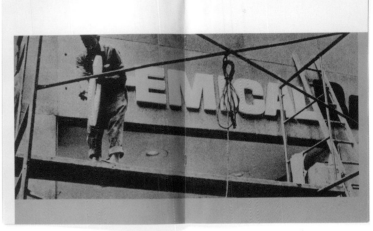

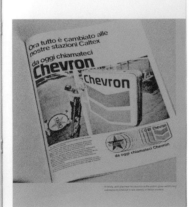

Implementation: The Devil in the Details

89

The best-executed corporate identity program in the world will fail if it's not implemented well. Companies like RCA and Bendix discuss the importance of orchestrating a new identity program.

(See Book 2, No. 63, "Fulfillment: Executing a Corporate Identity Plan," 1969)

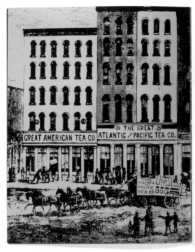

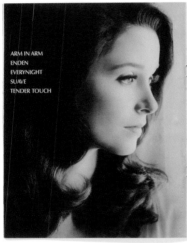

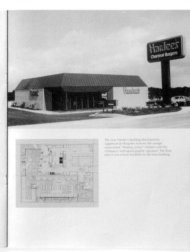

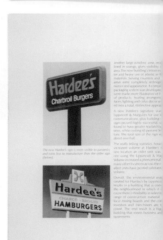

The Designer As Ringmaster

The more sweeping the change in an identity program, the more impor-
tant it is for many professional disciplines to work together to align all
aspects of the brand. Whether it's reinventing the company entirely (trans-
forming a regional nursing-home company into Humana Inc.), or a con-
sumer makeover (like the update of the Hardee's restaurant chain), only
working across all divisions will bring about increased sales.

(See Book 2, No. 76, "Multi-Disciplined Marketing," 1976)

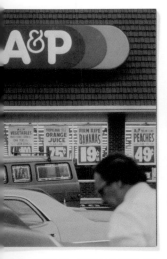

4

A new corporate symbol was required by Equitable Life Insurance Company, a firm selling over $500 million a year in coverage, which was leaving its long-time headquarters location in Washington, D.C. to relocate in Virginia. Lippincott & Margulies developed an Emblem abstract symbol that is used also by the parent corporation, Equitable General, and a subsidiary, First Data Corporation. The symbol effectively serves as a linking element between the three entities. As part of the insurance carrier's new graphic look, Lippincott & Margulies also created a cleaner, more contemporary design to the firm's insurance policies.

Equitable Life

7

Lippincott & Margulies was called on to create the name and the graphic system for a new bank formed by the merger of the Union Trust Company of the District of Columbia and the First National Bank of Washington. Intensive studies resulted in the retention of the most significant identity elements from each bank to form the new name—Union First National Bank of Washington. The graphic system employs Union 1st in all usual communications in the new bank, which operates 20 branch offices in the Washington area and has assets of $475 million.

UNION**1**ST
Union First National Bank of Washington

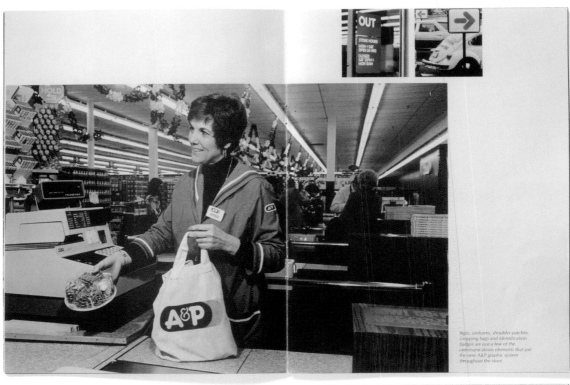

Signs, uniforms, shoulder patches, shopping bags and identification badges are just a few of the communications elements that use the new A&P graphic system throughout the store.

5

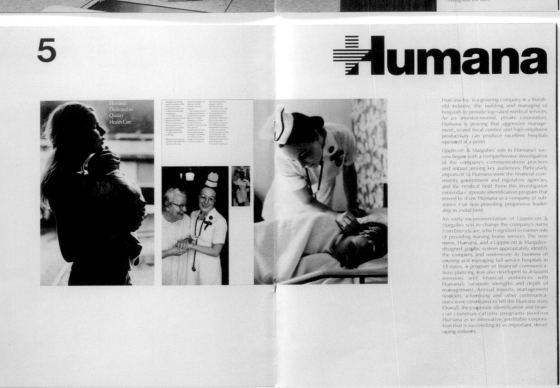

Humana

Humana Inc. is a growing company in a threshold industry: the building and managing of hospitals to provide top-rated medical services. As an investor-owned, private corporation, Humana is proving that aggressive management, sound fiscal control and high employee productivity can produce excellent hospitals operated at a profit.

Lippincott & Margulies' role in Humana's success began with a comprehensive investigation of the company's communications practices and impact among key audiences. Particularly important to Humana were the financial community, government and regulatory agencies, and the medical field. From this investigation evolved a corporate identification program that served to show Humana as a company of substance that was providing progressive leadership in a vital field.

An early recommendation of Lippincott & Margulies was to change the company's name from Extendicare, which signified its former role of providing nursing home services. The new name, Humana, and a Lippincott & Margulies-designed graphic system appropriately identify the company and underscore its business of owning and managing full-service hospitals in 13 states. A program of financial communications planning was also developed to acquaint investors and financial audiences with Humana's corporate strengths and depth of management. Annual reports, management booklets, advertising and other communications were developed to tell the Humana story. Overall, the corporate identification and financial communications programs position Humana as an innovative, profitable corporation that is succeeding in an important, developing industry.

The Marriage of Science and Design

"Doesn't research hamper creativity?" Over the years, it's become one of the most common questions we've heard, and the answer is always "No." In fact, the connection between design, brand strategy, and scientific research goes back to the very heart of the Lippincott Mercer mission: If design is a way to solve a problem, research is the path to making sure the problem is fully and completely understood. Our solutions, we hoped from the beginning, would help companies make decisions that would yield business value.

Of course, the last 60 years have seen enormous changes in the kinds of research available, as well as innovations in the best ways to use it. While consumer research had been around for some time (early psychometric research techniques were established in the 1920s), the late 1940s and 1950s saw an explosion of new methods to support the postwar "Consumer Revolution." And as the packaged-goods world grew so rapidly, Lippincott Mercer's early focus on research in package design scrambled to find new ways to measure people's perceptions of brands, design, and image.

The goal was to produce packages that would cry out for attention in the growing glut of products. Research was used to establish the "design criteria"—what the packaging should communicate to increase consumer attention. Was it fresh looking, light, and readable? Lippincott Mercer's research efforts quickly expanded to include brand loyalty and corporate identity, and today's "brand science" builds upon all these techniques, and more. Scanner data allows us to analyze major trends and minute changes in the sales of packaged goods. We can employ complex experimental designs in our research. And perhaps—in what may be the most exciting breakthrough in the research field of all—we are finally learning exactly how much, in terms of dollars and cents, certain brand perceptions can add to brand value.

While we've always known that brand perception translates into economic behavior, it's gratifying that we're at last able to say by how much. And that, of course, allows our clients to make better decisions.

Design Sense L&M

A newsletter on Packaging, Product Styling, Store Planning and Merchandising trends
Lippincott & Margulies, Inc., Industrial Designers, 430 Park Avenue, New York
June-July, 1956, Vol. 2, No. 3

Is Good Design Practical?

The designer's art involves a very specialized mode of thinking. He is always concerned with things as they are, and, at the same time, must, in a very practical sense, be directing his skills at what they could possibly be. Perhaps the greatest satisfaction in his working life is the achievement of a change which brings the product or package on which he is working, one step closer to an ideal.

This is possibly a highflown position from which to examine the subject of this article, yet it is nevertheless a correct starting point. It is widely assumed that the one function of a design is to make a product "prettier" -- to "dress it up" or "give it class." In fact, the major function of design is to make the product perform its job better, and inherent in this improved performance is the designer's job to help the product better express its own function, by its design.

It is similarly assumed that you must keep your designer in check because he is always up in the wild blue yonder, simply not practical, since he is an artist after all.

The new American Seating Company chair shown here is a case in point. One unit of a redesigned line of school furniture, it follows a trend to deinstitutionalize the classroom. Grimness, say the manufacturers, is being taken out of education. Emerging now are campus type schools with informal interiors where children put pin-ups on a cork bulletin board and bring their pet mice into the classroom. Equipment suppliers have been slow in accepting educational informality, however. As late as 1953, according to one

From rugged clumsiness to rugged grace . . .

educator, no "really comfortable low-cost desk and chair had been produced." The problem was to design a line which would suggest the home living room to the children, but which, while not sacrificing durability to style, could withstand the ravages of the young. The theory was that children are exposed to contemporary styling and design in their homes, new stores and transportation, and are adversely affected by stodgy, heavy looking furniture.

American Seating had been using stamped steel in a sturdy, block-like, rather ugly design, an engineer's concept of how to get the strongest possible chair using the minimum of materials. The new chair is all steel except for a plywood seat and back. Despite its graceful appearance, it is extremely rugged and has come through sandbag destruction tests in the American Seating Company laboratories. The design is a good example of close coordination between creative styling and the product engineering group of the American Seating Company, spearheaded by Bill Hendrickson.

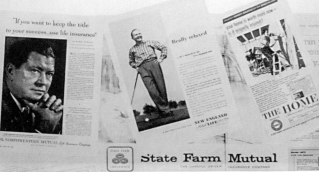

How to Lose Your Identity

Why do people buy insurance? Although the insurance industry has made a number of guesses, and established a number of policies, there is no one who can give an unequivocal answer to this question. Even less answerable, to date, is the question: what makes people buy one company's insurance rather than another's?

The companies, to judge from their advertising, would seem to be certain (a) that advertising pays, but (b) it isn't necessary to establish a real visual identity for a company.

This is paradoxical. Since we don't know why insurance is purchased, it would seem that the alert company would want to give its brand every possible advantage and identity. Yet the brandmarks* on this page are not eyecatching, are generally more alike than different, and reveal little concern with establishing individualized symbols which will make my company stand out in the crowd -- whether on the pages of a magazine, in the midst of a batch of mail, or in the agent's cards.

We suggest that insurance companies can create identifiable distinctive symbols which might add considerably to the feeling of confidence in a company, which would seem to be a key element in insurance purchase.

* A distinctive design symbolizing a product or company; a term coined by L&M.

Research & Package Testing

When it comes to determining the best package for a product, Lippincott Mercer has always firmly believed that research, used properly, can lead to better design. And while the research methods available in the 1950s are certainly primitive by today's standards, the issues remain the same: There's no cookie-cutter research solution to any design project.

(See Book 2, V. 2, No. 3, "Is Good Design Practical?" 1956)

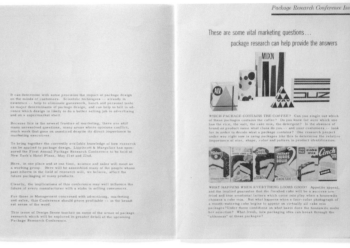

Eliminating the Guesswork

Early on, Lippincott Mercer was committed to taking the guesswork
and hunches out of package design, and even organized the first
Annual Package Research Conference, designed to answer the tough
dollars-and-cents questions that are still worth asking today: How
much should innovation cost? Is it always wise to modernize a pack-
age? How much is your corporate "look" worth?

(See Book 2, V. 2, No. 3, "These Are Your Customers…," 1957)

WHAT IS THE BEST WAY TO DOT AN "I"? At first glance, these two Parliament packages may look the same. But look again. On the package at the top (dummy package) the "i" has been dotted with a dot. Below (actual package) the "i" is dotted with a "V" shape, echoing the emblem or brandmark above it. Coincidentally or not, this repetition conforms to established psychological information about human behavior and to valid theories about human perception. Repetition of the motif helps the consumer identify the brand. In testing designs for the new Parliament package, researcher Louis Cheskin discovered that the package which repeated the "V" motif in the dotted "i", scored considerably higher in recognition.

IS IT ALWAYS WISE TO MODERNIZE YOUR PACKAGE? If yours is one of the older packages -- a package that successfully expressed the personality of your product and your company, or one which is firmly established on the American scene -- change might prove disastrous. After all, why redesign a violin?

This is one of the uncomfortable questions the designer faces frequently. Perhaps the package is "right" the way it is. Package research can give the answer -- can weight package familiarity against the considerations of new design treatment -- and by doing so avoid a mistake that might well prove disastrous.

IS HALF A LOAF SOMETIMES BETTER THAN THE WHOLE? Just as sentences which end by trailing off in a series of dots....... can sometimes be more meaningful than the completed thought, the human mind tends to remember best the visual form which is almost, but not quite, complete. The mind subconsciously goes on to close the gap -- to finish the design -- and this subconscious effort acts to reinforce the memory. On the rice package shown here, the right side of the plate is cut off at the edge of the package. As a result, the package itself is made more memorable. Research applied to this package -- or to yours -- can establish the value of devices like this.

HOW COSTLY IS INNOVATION? New products are the lifeblood of a growing corporation, but each year the cost of promoting a new product is going up and the fatalities can be staggering.

In 1956, Colgate-Palmolive Company's profits were down and, according to Forbes magazine, it was not due to any lack of earnings on Colgate's traditional lines but rather to the extraordinary expenditure of $12,000,000 to promote three new products -- Colgate's Brisk (fluoride toothpaste), Liquid Vel and Ad (short for Advanced Detergent).

Forbes reports Brisk as "an expensive failure." We wonder what percentage of the $12,000,000 was spent on package research, if any.

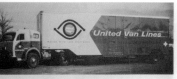

How would you rate this company for service?

Even a moving company can have a corporate look

PACKAGE RESEARCH AND THE "CORPORATE LOOK"

Whether you mine coal, run a railroad, or operate a fleet of moving vans, you have a "packaging problem." The "package" is you. Your company. For as surely as "My Sin" perfume suggests a clandestine affair, the sight of your company name can evoke an image in the mind of the viewer.

The image is the "corporate look" -- the visual manifestation of your corporate personality, based on the totality of the impressions the corporation makes on the viewing public.

The question is -- is the image evoked by your corporate look the right image? If not, what is the right image? In either case, how can we be sure?

Because the corporate look is based largely on visual impressions the answers to these questions lie in the realm of research -- the same kind of research as that applied to packaging. Just as we are now able to determine which box of cake mix is likely to prove a better salesman on the supermarket shelf, so we are able, through visual research, to determine what image is evoked by the sight of your corporate name and the visible manifestations of the corporation's activities.

Achieving a successful corporate look cannot be done overnight. It is no job for amateurs -- nor is it, unfortunately, something that can be accomplished simply by changing the style of type used on a company's executive stationery. It calls for long-range, concerted, top-level management planning. It involves every area of corporate operations. It takes into account not only the visual impressions left

by the sight of the company's logotype or brandmark, but the impression on the viewer of the corporation's packages, advertising and promotion literature, calling cards, exhibits, offices -- even the colors used on the company's equipment.

Although few companies today have achieved a completely successful corporate look, increasing numbers of them are becoming aware of the problem. They know their company's image is one thing to management, something else to employees -- and something completely different to the general public. And they are aware that this is somehow undesirable.

Motivation studies already completed have indicated just how undesirable the lack of a well-defined, favorable image can be. They show that when the image of a company is ambiguous or hazy, the consumer is likely to harbor an innate distrust of the company -- and, by extension, the company's products -- for the simple, human reason that he doesn't know "who they are", or "what kind of people" he is dealing with. This holds true no matter whether the corporation involved is a bank, a railroad or an insurance company. People feel more secure, and are more likely to do business with companies whose "corporate look" is a favorable one.

In sum, when all the impressions of a company have been channeled into a common, favorable, unique visual image, the corporate look is a successful one. When the impressions are weak, diffused and lack cohesiveness, the result is an image that, at best, is not as effective as it might be; at worst, one that evokes a negative, "no-sale" response.

Future issues of Design Sense will discuss in detail the problems involved in achieving a corporate look, and suggest some solutions.

From the Wall Street Journal April 5, 1957

"Today's query for corporation presidents: Does your company have 'visual identity'?

In other words, do your buildings, your letterheads, your office decorations, your reports to stockholders, your trademarks, your ads, and your products themselves picture you and only you in the public eye?

If they don't, you may be at a competitive disadvantage...."

PROGRAM

TUESDAY MORNING May 21

Package Research:
A New Tool for Management
J. Gordon Lippincott

The Conference Work Plan
Dr. Myron J. Helligan

Behavioral Science and Packaging
Dr. James G. Miller
The various faces of knowledge accumulated by social scientists in many fields will be shown in their relationship to package research.

Perception Research and Packaging
Dr. H. A. Witkin
Laboratory research on the relationship between human personality and our way in which people perceive the world provides important new clues to packaging effectiveness.

Panel Discussion: Louis Cheskin, Albert Kner, Sherwood Dodge

TUESDAY LUNCHEON

The Hidden Persuaders
Vance Packard
Vance Packard, whose book "The Hidden Persuaders" will be published this spring by David McKay, will discuss the unseen forces that influence consumer purchase decisions—the motivational forces at work.

TUESDAY AFTERNOON

The Package As A Symbol
Barbara Kaye
The emotional implications of the package BRANDMARK in stimulating consumer response.

Experimental Methods in
Package Research
Dr. Arthur Witkin
The experimental methods available to research and testing and means for their validation.
Panel Discussion: Dr. Kermit Schooler & W. Harding, Dr. Thomas L. Coffin

WEDNESDAY MORNING May 22

Motivation Research in Packaging
Dr. Ernest Dichter
Case histories showing the use of motivation research in package design and advertising.

Predicting Package Success
Robert F. Hiteli
Reconciling consumer response to proposed new package designs. Given a choice of several good design approaches, how do you select the best?

Panel Discussion:
Jennifer Macleod
Dr. Herbert Fisher
Douglas L. Smith

WEDNESDAY LUNCHEON

Packaging For a Changing Market
Anne H. Johnson
The uses we sees will see an unprecedented break between one brands and new products in the enmeshed brands of today. A lament of trends significant to those who market packaged merchandise.

WEDNESDAY AFTERNOON

Panel Discussion:
Women & Marguerites
Presentation of the "Package Research '57 Award"—the first annual presentation for the conference to an individual for outstanding achievement in original research related to packaging.

Award Presentation:
Women & Marguerites

Panel Discussion
Program participants lead in a review of conference findings, with entire conference membership.

Design Sense

8

Planning for new products: Part 1

A publication on Packaging, Product Styling, Store Planning and Merchandising

Lippincott and Margulies, Inc.
Industrial Designers, 430 Park Avenue
New York

"New products today are the key factors, not only in company growth, but often in company survival."

Booz, Allen & Hamilton Management Consultants

"Four out of five new products are market failures."

Dun's Review & Modern Industry

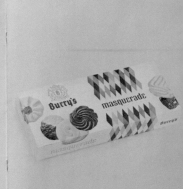

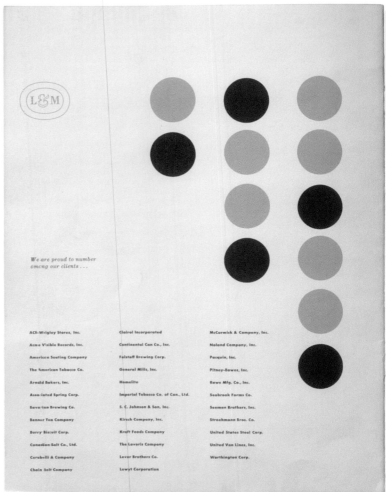

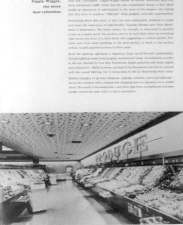

Uncovering Strengths and Weaknesses

One soft drink manufacturer, troubled by poor sales, commissioned a package-effectiveness study. The study showed that the product didn't need a new package—in fact, while its clear glass packaging was appreciated by customers, they only noticed it after they brought the product home, well after the buying decision. Displaying the package differently in stores solved the problem.

(See Book 2, No. 8, "Planning for New Products—Part One," 1958)

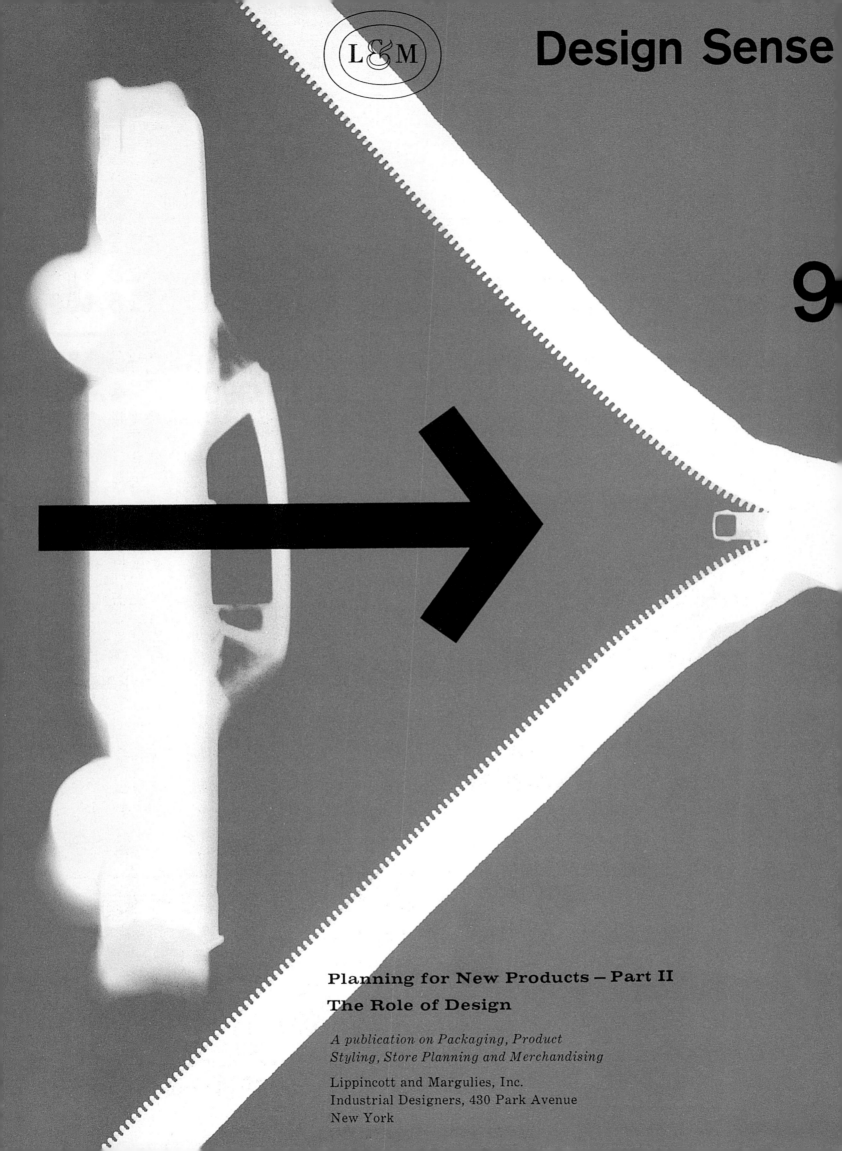

Design Sense

L&M

9

Planning for New Products — Part II
The Role of Design

A publication on Packaging, Product
Styling, Store Planning and Merchandising

Lippincott and Margulies, Inc.
Industrial Designers, 430 Park Avenue
New York

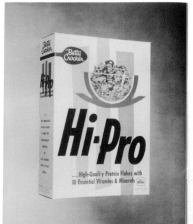

101

Measuring the Degree of Change

When U.S. Steel hired Lippincott Mercer to update its trademark, the
two-year process started with research that revealed its image was
badly blurred. The new mark—which research showed was not even
visible to consumers—enabled the company to achieve its goal: it
gained a strong new corporate look without appearing different.

(See Book 2, No. 9, "Planning for New Products—Part Two," 1958)

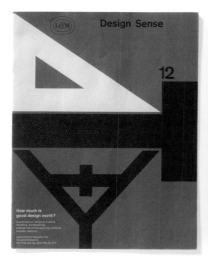

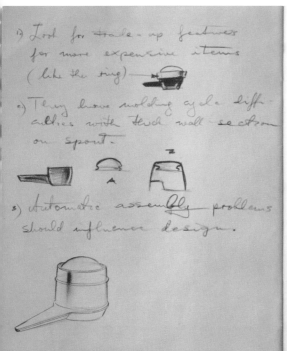
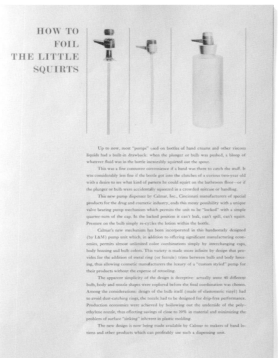

Testing Package Designs through Advertising

For a household cleaner, Lippincott Mercer prepared two nearly
identical ads. One, however, showed the product in its existing
package, the other a proposed new design. Consumers believed the
"easy cleaning" claim of the new design at a rate of four to one.

(See Book 2, No. 12, "How Much Is Good Design Worth?" 1958)

HOW MUCH IS GOOD DESIGN WORTH?

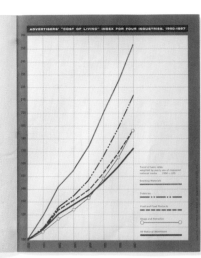

EVOLUTION OF A MARK

One offshoot of L&M's all-encompassing Corporate Identity design program for U.S. Steel Corporation is now appearing in retail outlets across the country. This is the "Steelmark"—an identifying tag (or sticker) which tells consumers that the product so marked is made of the metal that "Lightens your work—Brightens your leisure—Widens your World."

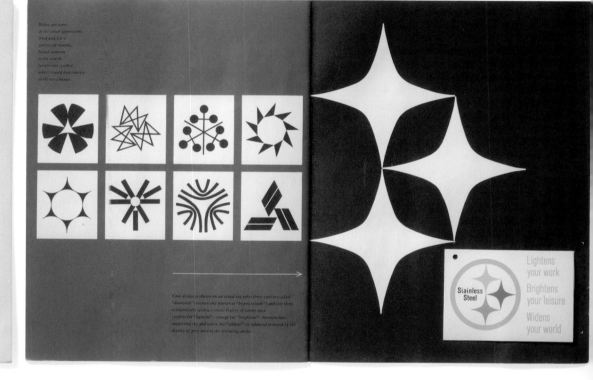

Stainless Steel

Lightens your work
Brightens your leisure
Widens your world

PROGRESS REPORT
ON DESIGN RESEARCH

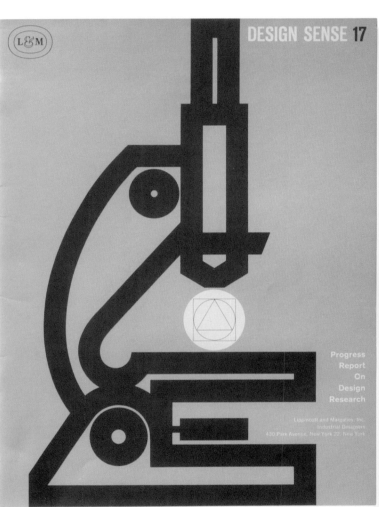

DESIGN SENSE 17

Progress
Report
On
Design
Research

Lippincott and Margulies, Inc.
Industrial Designers
430 Park Avenue, New York 22, New York

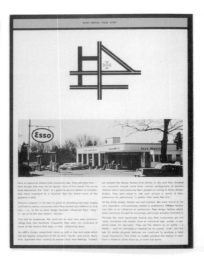

Fact No. 3
The consumer can — and does — react to a given design, but is almost totally inarticulate when it comes to talking about design in the abstract.

The consumer, we have discovered, cannot tell us what kind of design she would like to have. When asked to do so, even the most articulate among them run aground on the rocks of verbal cliches. They want it to be "nice." They think the colors should be "bright." They would prefer a "good looking design." And so on.

These are non-committal — and, clearly, non-helpful — answers. To get meaningful responses, we must present the consumer with a set of design alternatives in the form of mock-ups of products, dummies of packages, etc. Once she has something concrete to sink her mental teeth into, the consumer can then make a valid choice (which she immediately justifies, as noted earlier, with a set of reasons that almost never are the real ones for her preference).

The application of this principle in various studies we have conducted on the design of gasoline service stations disclosed another interesting — even startling — fact: When a consumer does *not* have some design features on which to base, and around which to build her choice, then loyalty to the brand just *does not exist* (at least in the field of gasoline marketing). To put it another way, gasoline brand loyalty is less a loyalty to the brand than to the design appeal of the company's service stations.

Fact No. 4
The reactions of consumers towards design tend to support the existing realities of the marketplace.

Among the most baffling and unhinging experiences of the past three years was the fact that when we gave consumers a choice between a new

package and the *existing* package of the same brand, time and again the vote went to the existing package.

Obviously, something was wrong. Fifteen years of experience in design told us instinctively that the new was visually better than the old. Yet, apparently, consumers didn't think so. And while this defense of the old varied in intensity from product to product, it was persistent enough to present a worrisome problem in terms of the validity and the usefulness of our research. So we probed deeper in a series of special motivational studies.

We discovered that (in design, at least) familiarity often seems to breed, not contempt, but a kind of "old shoe" affection. Probably in line with today's attitudes towards age and oldness generally, consumers apparently find it highly distasteful to *participate* in the killing off of a familiar design.

However — and here is the important thing — hard as it is for consumers to vote against an old design while it is still alive, once it is removed from the market they will react with astonishing speed and vigor to the new design. They won't "make" the change themselves, but when the right change is made by somebody else, they will welcome it avidly, and proclaim renewed loyalty toward the brand. In sum, the old cry of "The King is dead; long live the King!" seems to apply to design as well as monarchs.

Discovery of this inbred bias toward the familiar explained why our proposed designs did far better in the marketplace than we had predicted from laboratory comparison with the existing designs. But in addition to restoring our self-confidence, this series of studies holds lessons of value for anyone who, at one time or another, is faced with the problem of assessing the relative effectiveness of new vs. old in package or product.

In effect, we now know that re-

6

Predictable, Yes; Rational, No 105
Consumer responses to design, though not rational, are nevertheless predictable. Research methods need to take into account this truth: Consumers respond to familiarity, and will never choose an unfamiliar design over a familiar one. But when the right change is made, they will welcome it avidly.

(See Book 2, No. 17, "Progress Report on Design Research," 1960)

So far we have defined the two kinds of obsolescence we are opposed to: "phony" and "built-in." To flip the coin, we are all for two other kinds: "functional" obsolescence and "style" obsolescence.

Functional obsolescence occurs when a real improvement in the way a product performs its job is brought about through the development of new processes, or ways of doing things. One good example this year is Chrysler Corporation's new "Alternator" — a device that will charge your car's battery even while the engine is idling. This significant advance may render the conventional generator obsolete, just as the mechanical refrigerator rendered the ice box obsolete, but surely no one would claim that this is a "bad" thing. Everybody benefits except perhaps the competitive manufacturer who has been caught napping in his research and development department. But that, as they say along Madison Avenue, is the way the marketing meat axe minces.

THE CONSTANCY
OF
CHANGING TASTE

Unlike functional obsolescence, which no one really opposes, style obsolescence is the storm center around which most of the pro-and-controversy about "obsolescence" rages. Our position as designers and marketers is simply that so long as the tastes of people are subject to change, style obsolescence is inevitable.

The fact that tastes do change is no news. Wigs and lace cuffs were once de rigeur for gentlemen. Mid-Victorian gingerbread was once the rage in houses and furniture. The "streamlined" appliances of the 1930's look strangely out of date today. And it is a safe bet that another generation will look back on the "Best Designed Products of 1960" and think them somewhat quaint.

The main difference between taste changes now and a century ago is that the changes today come at a much faster rate. In part, this can be blamed on mass-production and its opposite number, mass consumption. But even more basic than these is the fact that products wear out faster now than they used to.

Unlike a spinning wheel, or a scythe, or a scrubbing board, many of today's products are made up of fast-moving parts — which get faster-moving all the time. Today's cars are expected to *cruise* at speeds which represented maximums only a few years ago. Even with the best engineering and components, the inevitable result of this ever increasing mechanization has been an increase in the "wear-out rate." This, in turn, has meant more frequent replacement, which, to bring the wheel full circle, has increased the tempo with which changes in taste can be reflected in the marketplace.

To put it as a theorem: the rate of style obsolescence is directly proportional to the durability of goods. This is a vital point, and one which the critics of style obsolescence tend to overlook.

Another point consistently ignored by the anti-style-obsolescence group is that, Paris fashions notwithstanding, "style" is not something that manufacturers and designers have forced down the throat of the consumer. Rather it is the outward expression of people's inner needs and desires, and as such it represents a potent "third force" working to influence the destinies of products.

To cite a classic example, the Airflow Chrysler of 1934 represented an undeniable advance in automotive engineering, and its design conveyed this "new" message in styling unlike anything else on the road. In spite of this, the Airflow flopped with a crash that shook Detroit to its assembly lines. Its singular non-success, unquestionably,

TASTE: A CYCLICAL PATTERN?

Is there a cyclical — perhaps predictable — pattern in consumer taste changes? Thanks to mass production and mass consumption which **have** compressed taste changes into a matter of years rather than centuries, what looks like a cyclical pattern now seems to be emerging.

The most rapid fluctuations, of course, occur in women's fashions, and the drawings below cannot begin to show all the ups and downs of hem, neck and waistlines. The toasters and car silhouettes, however, suggest that there has been a return, in the past year or so, to something akin to the "squared-off" look of the late 1920's and early 1930's. It is a

distinctly **different** kind of squared off look, to be sure, but clearly today's cars and toasters have more in common with the designs of thirty years back than with the designs of, say, ten or fifteen years ago.

A prediction for the future about the operation of taste cycles — we are now approaching a period of more ornate, richer, warmer design as the cycle swings back away from the severe, sparse, squarish lines of today.

In any case, the possibility of anticipating the market by reliably predicting the direction, extent and duration of consumer taste changes is an intriguing one for designers, as well as for marketing men generally.

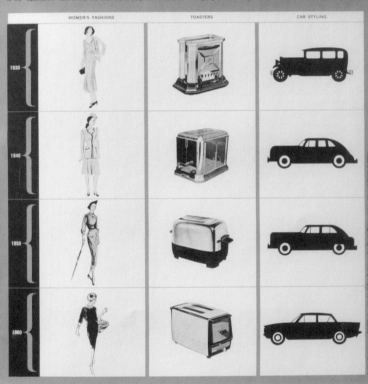

WOMEN'S FASHIONS	TOASTERS	CAR STYLING
1930		
1940		
1950		
1960		

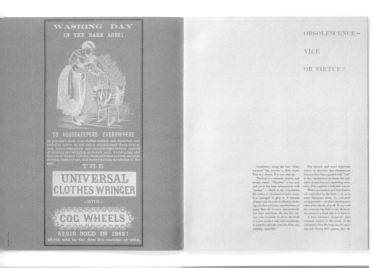

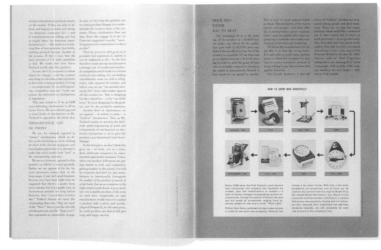

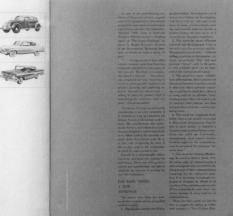

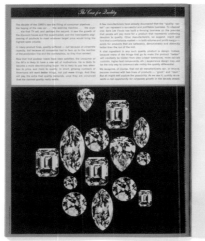

Measuring Changes in Taste

Change in consumer taste is a given, in cars and toasters as well as
in clothes. But for researchers, the questions of how, when—and
even why—tastes change are some of the most important parts of
new-product planning. They can help spot potential R&D successes,
and nip losers in the bud.

(See Book 2, No. 20, "A New Approach to New Product Planning," 1961)

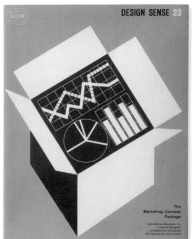

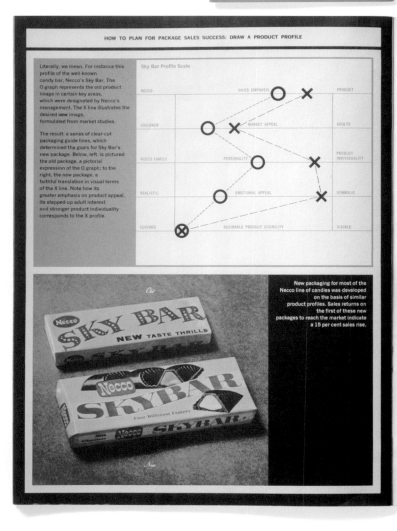

HOW TO PLAN FOR PACKAGE SALES SUCCESS: DRAW A PRODUCT PROFILE

Literally, we mean. For instance this profile of the well-known candy bar, Necco's Sky Bar. The O graph represents the old product image in certain key areas, which were designated by Necco's management. The X line illustrates the desired new image, formulated from market studies.

The result: a series of clear-cut packaging guide lines, which determined the goals for Sky Bar's new package. Below, left, is pictured the old package, a pictorial expression of the O graph; to the right, the new package, a faithful translation in visual terms of the X line. Note how its greater emphasis on product appeal, its stepped-up adult interest and stronger product individuality corresponds to the X profile.

Sky Bar Profile Scale

NECCO	SALES EMPHASIS	PRODUCT
CHILDREN	MARKET APPEAL	ADULTS
NECCO FAMILY	PERSONALITY	PRODUCT INDIVIDUALITY
REALISTIC	EMOTIONAL APPEAL	SYMBOLIC
COVERED	DESIRABLE PRODUCT VISIBILITY	VISIBLE

New packaging for most of the Necco line of candies was developed on the basis of similar product profiles. Sales returns on these new packages to reach the market indicate a 15 per cent sales rise.

The responsible executive studies the various solutions paraded before him with painstaking attention. But how can he decide, unless he knows what it is about the product that he wants to project to the buyer?

AWAY FROM THE PACKAGE

Once again, he has to turn resolutely away from the package and go back to the market, this time to the product itself. Research can be of invaluable aid to him here. Nowhere else can he find the facts he is seeking. But how to select and structure the research? A wealth of unrelated facts about the product is only going to confuse the picture.

A solution that is both a short-cut and an answer in depth is the use of a Product Profile.

The structure of these profiles varies from product to product, of course, but the key to it is the posing of a series of questions — direct, searching, and profound — the answers to which will provide a clear-cut and unmistakably sturdy design platform.

THE NECCO PROFILES: ORDER FROM CHAOS

In the course of an extensive redesign program for the New England Confectionery Company (NECCO), we were asked to create new packaging for their line of candies. The problem was a unique one. The name "Necco" was familiar to a generation of Americans as the name for a colored sugar wafer, so familiar, that to the consumer it represented a product rather than a corporate or even brand name. But the Necco company made many other types of candies, each with a special appeal and a special market. Ideally, each of these candies could profit from association with the Necco name, yet each had to retain and reinforce its own individual personality. At the same time, the Necco Company

could further its competitive position in the industry by upgrading its packaging, applying some of the modern techniques of food packaging to candies.

To solve the problem, our marketing-design team developed five criteria which they felt defined the marketing problems which the packaging had to solve. They included such elements as the problem of corporate versus brand endorsement, market appeal, product personality, emotional appeal, and product visibility. Using market information supplied by Necco's management, they constructed a profile of each candy. The individual profiles could be reproduced in words (short, pithy descriptions of the product) or charted in a curve which depicted the brand's relation to the selected criteria. In this way, almost all elements of doubt were removed and clear guidelines set for the new packaging directions. For an example of one of these profiles and the package it resulted in, see page 8.

The design techniques represented here, candy experts tell us, represent a genuine breakthrough in packaging for this industry. Frankly we feel that it could not have been achieved if we had confined ourselves solely to design experimentation. The marketing approach — in this case, specifically the use of the Product Profile — set the direction.

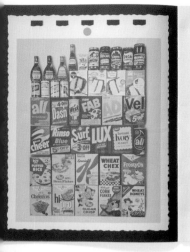

NEW FOCUS

FOR THE SIXTIES:

THE MARKETING-CONCEPT

PACKAGE

MARKETING
SOLUTION #1:
POSITIONING
THE CORPORATION

MARKETING
SOLUTION #2:
A PRODUCT
PROFILE

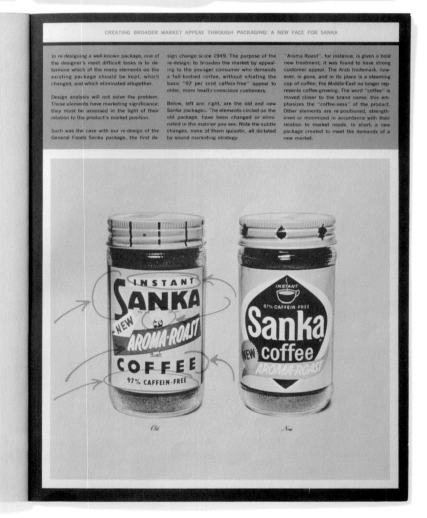

MARKETING
SOLUTION #3:
SURVEYING THE
INDUSTRY

IRRATIONAL INDUSTRIES

MARKETING
SOLUTION #4:
KEYING
THE PACKAGE TO
THE ADVERTISING

The Proof Is in the Package

While the numbers of new products and stores that sell them have changed since this was written, the problem is the same: There are far more products than shelves. When making their decisions, retailers are looking for packaging that will command attention. Consider Sanka's success story.

(See Book 2, No. 23, "Marketing-Concept Package," 1961)

Creativity and Research

"The function of industrial design is not unrestrained creativity in a vacuum," writes Walter Margulies. "There can be no creativity without discipline. We need skillful research to provide guidelines for the creative effort."

(See Book 2, No. 33, "Design Sense," 1963)

CREATIVITY AND RESEARCH

Does research hamper creativity?

Can package design and commercial art measure up to standards of excellence, when they are created according to marketing and research criteria rather than for pure artistic motivations?

Periodically, these questions come up, and periodically varying awards are presented within the design profession for "excellence of design" and "originality and creativity" for products and packages which subsequently flop in the marketplace. Does this mean that art and commercial success are incompatible?

Lippincott & Margulies has found that the answer to the last question is a resounding "no". *Only the successful marriage of marketing planning, creativity and research can produce excellence of design of the caliber that wins top consumer acceptance.*

"The function of industrial design in not unrestrained creativity in a vacuum," emphatically says Walter P. Margulies, president of Lippincott & Margulies. "As a matter of fact, we agree with the great masters of the fine arts who have said throughout history that there can be no creativity without discipline. In commercial art, this discipline — unlike the fine arts — consists of a strong marketing orientation and skillful research to provide guidelines for the creative effort."

The evolution of the design program for Montclair Modern Cigarettes is a perfect illustration of this Lippincott & Margulies concept in action: This already successful consumer product is the offspring of a harmonious marriage between creativity and research. The way in which research and creativity both were brought to bear on the marketing and communications problems of Project Special may provide important guidelines and a fascinating case study for any manufacturer planning to bring out a new consumer product.

It is interesting to begin by taking note of the sequence of events which preceded both final design and final research activities. As it is usual for Lippincott & Margulies design program, Project Special had begun with the development of marketing strategy and criteria. (See "Montclair Modern Cigarette: A Case History in Cigarette Marketing" on page 3 of this issue.)

These marketing criteria were then developed into a design platform to guide the design team in its creation of packaging elements from a symbol to a logotype, package design pattern, colors and copy. Within two weeks of the original October 1961 orientation meeting between The American Tobacco Company and Lippincott & Margulies, design explorations along the guidelines indicated had begun.

At this time, a search for appropriate name candidates for the new mentholized cigarette were also getting under way.

Of course, the design platform which emerges out of a positioning statement, in the case of Montclair as in the case of any product, allows the design group a vast amount of leeway.

For example, the appeal target for the product as "unself-conscious masculine rather than a feminine appeal" does not dictate to the designer what he should be doing. Rather, it points up the pitfalls for him to avoid. For instance, a masculine appeal product is unlikely to call for pink color or romantic drawings, to use an exaggerated example. At the same time, there is little restriction about the kaleidoscope of colors and range of design and graphic elements which could qualify as being "unself-conscious masculine" in appeal.

During the period when design exploration was being carried on, dozens of different name candidates for the product were selected, researched and processed through American Tobacco legal clearance. The group was narrowed to four most promising candidates which were subjected to final evaluation as to availability and legal clearance. Out of this group

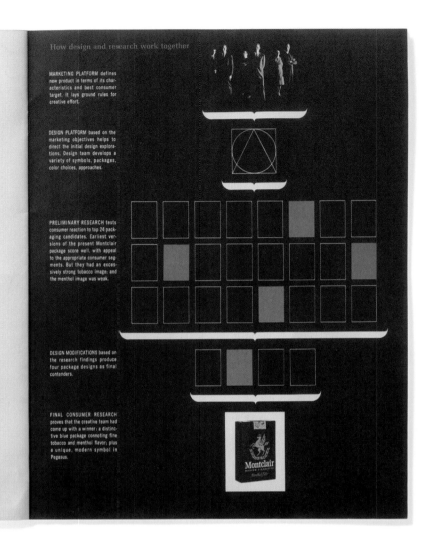

How design and research work together

MARKETING PLATFORM defines new product in terms of its characteristics and best consumer target. It lays ground rules for creative effort.

DESIGN PLATFORM based on the marketing objectives helps to direct the initial design explorations. Design team develops a variety of symbols, packages, color choices, approaches.

PRELIMINARY RESEARCH tests consumer reaction to top 24 packaging candidates. Earliest versions of the present Montclair package score well, with appeal to the appropriate consumer segments. But they had an excessively strong tobacco image; and the menthol image was weak.

DESIGN MODIFICATIONS based on the research findings produce four package designs as final contenders.

FINAL CONSUMER RESEARCH proves that the creative team had come up with a winner; a distinctive blue package connoting fine tobacco and menthol flavor; plus a unique, modern symbol in Pegasus.

A MARKETING PUBLICATION OF LIPPINCOTT & MARGULIES/NUMBER 34

DESIGN SENSE

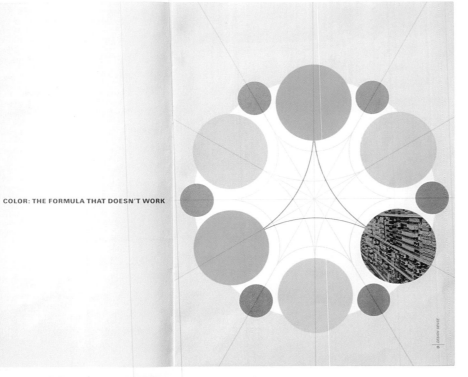

COLOR: THE FORMULA THAT DOESN'T WORK

COLOR AND COMPETITION

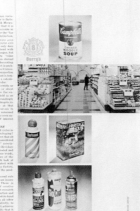

IS THIS
SYMBOL
REALLY
NECESSARY?

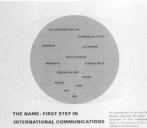

**THE NAME: FIRST STEP IN
INTERNATIONAL COMMUNICATIONS**

But Don't Women Like Blue Best? 113

The range between skill and chance is especially broad when
companies make decisions about the use of color, international
naming, and symbolism. Skilled marketers use careful, well
thought-out research before making decisions.

(See Book 2, No. 34, "Design Sense," 1963)

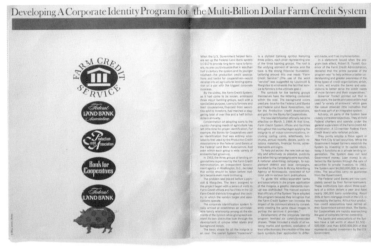

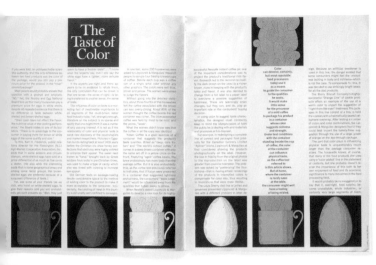

Sheaffer Corporate Identity Program

When a company earns a top place in its field through many years of producing high-quality, dependable products, it would seem to be in a most enviable position in the business world. It is, but there can be one drawback. The public is sometimes inclined to equate long experience and solid dependability with conservatism. This is the position that the W. A. Sheaffer Pen Company of Fort Madison, Iowa, found itself in. Actually, Sheaffer is a company with a long history of solid progress and innovation. Its Skrip writing fluid, Snorkel fountain pen, Safeguard Clip Ballpoint and it's cartridge fountain pens are but a few of many trail-blazing products to come from Sheaffer's product development people. Early in 1963, Sheaffer called on Lippincott & Margulies to investigate the establishment of a new corporate identity system, aimed at making the public aware of its progressive programs. One of the early steps undertaken was a comprehensive study of Sheaffer's corporate and brand "images," which involved 1600 individual interviews with high school and college students and adults in areas throughout the country. This was the base upon which the structure was built.

Gives Pen Company New Public Image

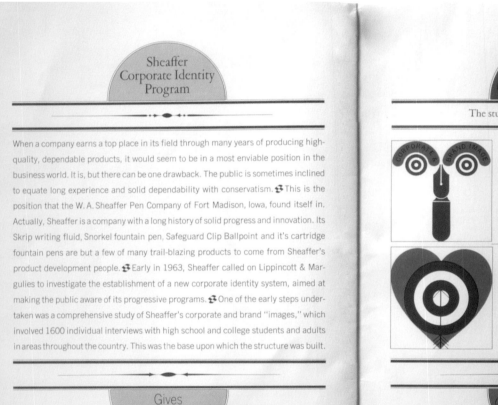

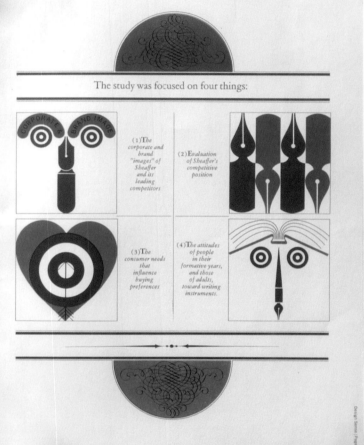

The study was focused on four things:

(1) The corporate and brand "images" of Sheaffer and its leading competitors

(2) Evaluation of Sheaffer's competitive position

(3) The consumer needs that influence buying preferences

(4) The attitudes of people in their formative years, and those of adults, toward writing instruments.

White Eggs Taste Fresher 115

There is no rational basis for spurning brown eggs; or believing coffee from a red can "tastes richer," while coffee from a yellow can is "weak"; or deeming half-red apples are twice as delicious as red ones. However, knowing what to expect via taste research is by far the cheapest way of assuring success.

(See Book 2, No. 39, "The Taste of Color," 1964)

Is U.S. justice Janus-headed?
The Supreme Court, in two recent rulings,
views the relationship of a product
to its advertising in two different ways.
To marketing men, the conflicting rulings
are of utmost significance.

The United States of America

v.

The Borden Company

The United States of America

v.

Ralph Ginzburg and Eros Magazine, Incorporated

Two rulings of the U.S. Supreme Court recently exploded in the business community-at-arge, and the effects are still ricocheting around. The court's decisions touched on the function and value of advertising and laid down certain restrictions. Somebody's bound to get hurt, the restrictions are far-reaching.

On the surface, one case had nothing to do with the other. The litigants, the viewpoints they defended, and the constitutional regions they explored had about as much in common as the economic philosophies of Keith Funston and Mao Tse-tung. One ruling, in an anti-trust action, throws judicatory light into a shadowy corner of the Robinson-Patman Act; the other probes the dismal business of pornographic "literature" and the extent to which a publisher may find protection under the First Amendment. But by their chance conjunction in the news, these disparate cases reveal an apparent inconsistency in the way the law views the relationship of a product to its advertising.

The defendant in the anti-trust action was the Borden Company, whose sales of milk and food and chemical products soar above $1-billion annually. The publisher was Ralph Ginzburg, whose output of erotic—some say "obscene"—publications is, comparatively, a shoe-string operation. Both cases were complex in the extreme and neither elicited a unanimous decision from the high tribunal. While the court considered the relationship of a product to its advertising in both cases, in neither was advertising the point at issue. Despite this and despite the differences between the two defendants and the legal areas in which the contests were fought, one would hope to find consistency in the law. Instead, a comparison of the two cases makes the rulings seem arbitrary.

FREDDA SPERA

..
Daddy,
daddy
look.
New
York
Life.
..

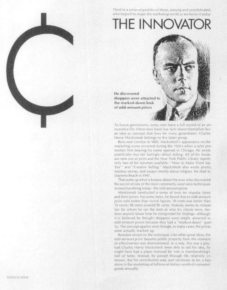

THE INNOVATOR

He discovered
shoppers were attracted to
the marked-down look
of odd-amount prices

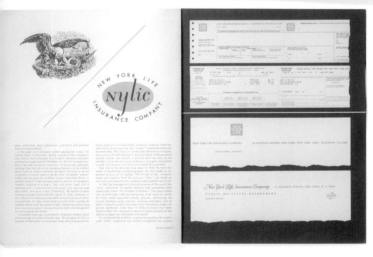

Time to Get Rid of the Eagle

Whether or not to change a corporate symbol is a difficult decision to
make. But after extensive research revealed that NYLIC's eagle meant
little to insurance buyers, and a strong and simple image was called for,
the memorable New York Life logo was born.

(See Book 2, No. 48, "Marketing & the Supreme Court," 1966)

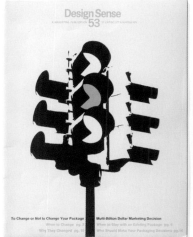

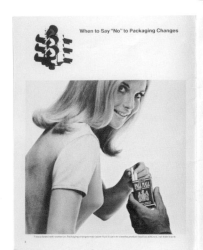
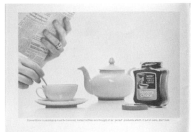

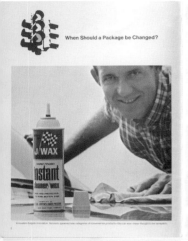

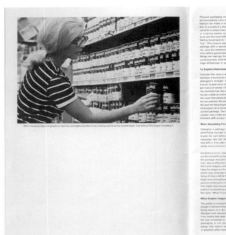

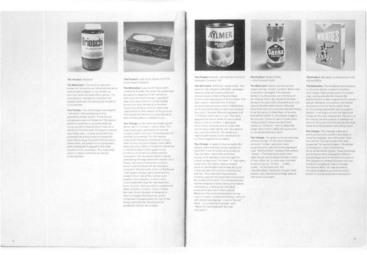

Updating a Package

Deciding whether or not to change a package design can be a multi-billion dollar decision, but done right, it can pay off handsomely. Often, changing consumer attitudes will create an opportunity.

(See Book 2, No. 53, "To Change or Not to Change Your Package: A Multi-Billion Dollar Marketing Decision," 1967)

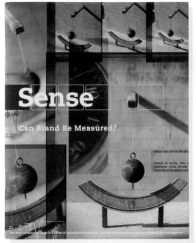

John Zeglis became chairman and chief executive officer of AT&T Wireless in October 1999 and oversaw its separation from its parent, AT&T. He joined AT&T in 1984 as corporate vice president for law, became AT&T general counsel in 1986, retained that title while serving in a number of executive roles including president, and was elected vice chairman in 1997. He is a trustee of the United Negro College Fund and sits on the boards of Helmerich and Payne Corporation, Georgia-Pacific Corporation and Sara Lee Corporation.

AN INTERVIEW WITH JOHN ZEGLIS

By first gaining a deep understanding of its brand, AT&T Wireless was able to begin life as a public company with a rock-solid business strategy.

Foundation for a New Business

www.attwireless.com

Early in 2002 **Sense** interviewed John D. Zeglis, chairman and chief executive officer of AT&T Wireless, America's largest independent wireless company and a client of Lippincott & Margulies. We measured the AT&T Wireless brand, including detailed surveys of three thousand people, to establish a foundation for fundamental business decisions and future brand development. A second and third round of research was completed at time of publication.

Sense 3

120 **Brand Value, in Dollars and Cents**

In the wake of the dot.com crash, "brand value" is under the microscope as never before. But assigning a dollar value to an image— something that resides in the collective imagination of everybody touched by the company as it conducts business—is no small feat. A look at strategic brand assessment.

(See Book 2, No. 96, "Can Brand Be Measured?" 2002)

How big are the risks to a company's brand?
In direct proportion to one's unwillingness to find out.

Managing Brand Risk

Many companies are now comfortable with the idea that a brand has value, however difficult that value may be to measure.

Likewise, executives are familiar with the benefits of a relatively strong brand, including stronger loyalty, a premium price for products and services, the ability to attract and retain good people and a higher stock price relative to rivals.

Yet this knowledge has failed to generate the same interest in guarding the

brand against threat – or even a desire to understand the likely threats and their often swift and certain consequences.

Clearly, if brands have value they can lose value. Strong brands can go off course, suffer a blow or simply fall apart. And, unlike the difficulty of measuring brand value in good times, when a brand weakens, the ramifications for the underlying business will be all too easy to gauge in lost market cap, profits, revenue and future sales. You never know how good you've had it until it's gone.

Moreover, for most managers, the notion of "risk" usually evokes something catastrophic – a natural disaster, an act of sabotage, a technological meltdown – when, in fact, the risks most companies face are from strategic missteps. In a study of Fortune 1000 companies that lost at least 25 percent of their market capitalization in four weeks or less during the mid to late 1990s, 58 percent of those declines were from strategic error and many were brand-related (see chart on page 16).

This brief article discusses ways companies can understand and minimize brand risk. The idea is not just to prepare for the worst but to put in place a process that manages brand risk – including a plan to control any potentially harmful situation to maximum advantage.

Three types of risk

A great brand is inseparable from a company's business. Its strength courses through every decision, outward gesture and personal deliberation the company makes as it moves forward and upward. Such a brand does not live in a vault without time or threat. In fact, among the ways a company can lose value rapidly – management change, departure of a major customer, catastrophe – serious brand damage is high on the list.

Definition: Brand risk is the threatened loss of value due to a change in people's perceptions about the company.

These changes in perceptions can impact the demand for a company's products and services and, in the worst-case scenario, its license to operate.

We believe there are three different types of risk. It is important to distinguish among them because each requires its own approach. This is particularly important when two or three risk types are prevalent at once, with one risk masking another and the risks multiplying the danger.

Brand Equity Risk: The loss of what differentiates a company from its competitors. Without this, the company is selling a commodity.

Reputation Risk: The loss of the quality and trust built over time – what a company must provide to attract customers, employees and partners.

Marketplace Risk: A change in the economy, industry or marketplace – circumstances a company may share with others, but unevenly.

Major risks and some results

The three general types of brand risk can produce a variety of harmful results, some more apparent than others.

Portfolio Weakness: If a portfolio of closely related brands is not strategically sound, brands can overlap, lose distinctiveness in the minds of managers, or otherwise damage each other. The risk of this is greater immediately after a merger, but it can occur whenever a large, healthy company fails to clearly define distinct paths of growth for each of its brands. Recently, the major accounting firms all made brand decisions to distinguish an accounting practice from a consulting business. When and how this separation was managed will have big implications for each company's brand and future. Another example: After much initial struggle under the athletic-shoe companies (Nike and Reebok) that acquired them, two quite different brown-shoe brands, Cole-Haan and Rockport, found their niches – which are wisely worlds apart from their parent brands.

Commoditization: Companies do this to themselves when they decide to compete on price alone. Soon the brand is far less compelling. The counter-strategy is to build strong brand preference through brand positioning, brand differentiation and brand management. Many personal computer makers perished in the price wars of the last decade; that few of their names leap to mind today is precisely the point. Oil companies, by contrast, are confronting the consumer perception that gasoline is a commodity by building brand preference with extra services and on-site convenience stores.

Cultural Shifts: The reality of this risk is a decline in desire for a company's products or services. Some cultural changes are easier to spot and adjust to than others. Oldsmobile, once one of

Marketing Strategy

"Marketing is to managers what democracy is to politicians," *Sense* griped back in 1963, "the most often invoked and frequently abused concept." And while businesses have come light years in their marketing skills, we have to admit there are still days when we agree.

The appreciation for brands—and brand strategy—has become greater than ever. With a glut of new products and services (not to mention new channels of distribution), a brand's image is often what drives sales. And measurement techniques have advanced so far that we are finally able to illustrate how brands can drive shareholder value, even shifting the demand for products and services.

Good news, too, is that after many years of blindly chasing market share—for decades the primary goal of many marketing plans—companies are recognizing that sometimes low share in a high-growth market is a better deal than high share in a low-growth market. And thanks to far more sophisticated methods (many of them Internet-based) of gathering information on customers, companies are finding it easier to gather the intelligence required to segment their audience into smaller, more lucrative slices.

Within the corporation, marketing has also changed dramatically. While corporate marketers were once regarded as keepers of corporate communications, they are increasingly seen as stewards of all the brands within a company. And as brands are increasingly seen as key assets, these marketers are gaining power. In many instances, we've even seen the creation of the Chief Marketing Officer, or CMO.

But even with those advances, marketers are beset with many more challenges, as the marketing mix changes on a daily basis. More channels. More mediums. Shifting consumer priorities. More specialized audiences that want to be spoken to directly, increasing the chances of alienating those in slightly different groups. Can a mass brand that has high mainstream recognition ever cross over to smaller, hotter niches? Can a product seen as relevant and innovative to one generation have the same appeal to the next?

What's more, large companies still struggle—and perhaps always will—with paradoxes that come from selling abroad. On one hand, it is more important than ever to be—as so many past issues of *Sense* urged—globally consistent, giving customers the desired experience in Pakistan, Peru, or Peoria. And yet, as anyone who has watched CNN lately will observe, there has never been greater pressure for brands to find local relevance. For every company that gets it right many still struggle to shed their U.S.-centric market strategies.

Doubtless, few of these worries were on the marketing executive's plate when Lippincott Mercer started 60 years ago. But ultimately, the basic definition hasn't changed: "Marketing is a system or technique for approaching business and business problems…It is how we do, not what we do."

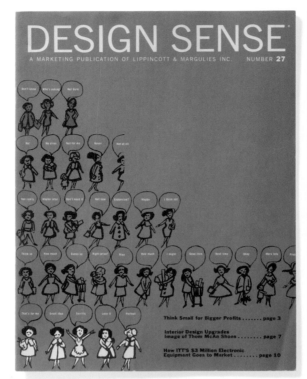

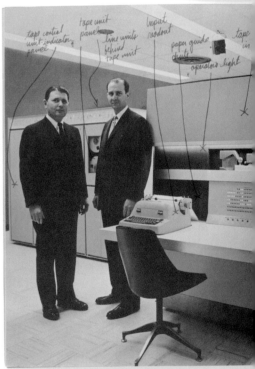

THINK SMALL FOR BIG PROFITS

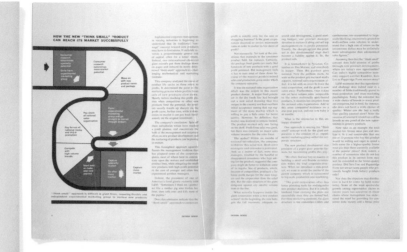

HOW THE NEW "THINK SMALL" PRODUCT CAN REACH ITS MARKET SUCCESSFULLY

HOW A CORPORATION CAN THINK SMALL AND EARN BIGGER PROFITS

CAN STORE DESIGN UPGRADE PRODUCT IMAGE?

HOW ITT'S MULTI-MILLION ADX EQUIPMENT WENT TO MARKET

Targeting the "Influentials"

Does a company need to dominate the entire mass market for a product category? "Thinking small" through catering to a more specialized market can yield bigger profits. This tension continues today. Coca-Cola, for example, the supreme mass marketer, still strives for relevance among smaller audiences.

(See Book 2, No. 27, "Design Sense," 1962)

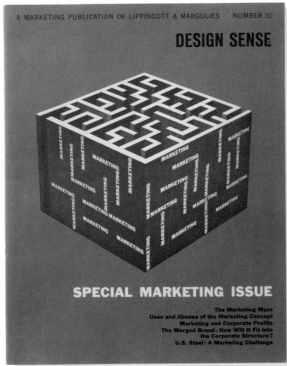

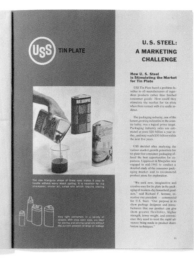

Every Executive Is in Marketing

As many companies embraced the idea that marketing couldn't
be delegated to one executive in one department, divisional marketing
heads became commonplace. Today, companies are taking the
next step, and adding Chief Marketing Officers at a corporate level
to protect the enormous equity of the brand-image portfolios.

(See Book 2, No. 31, "Special Marketing Issue," 1963)

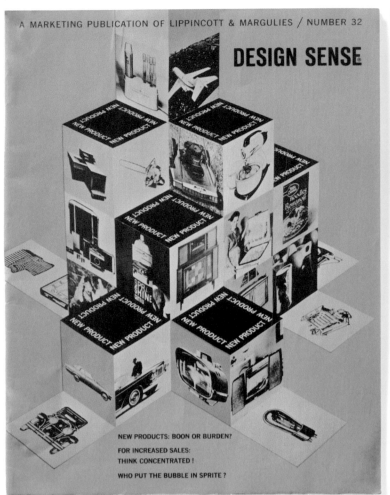

A MARKETING PUBLICATION OF LIPPINCOTT & MARGULIES / NUMBER 32

DESIGN SENSE®

NEW PRODUCTS: BOON OR BURDEN?

FOR INCREASED SALES:
THINK CONCENTRATED!

WHO PUT THE BUBBLE IN SPRITE?

HOW TO SEND NEW PRODUCTS TO MARKET

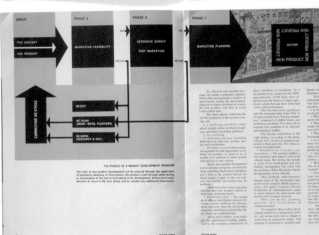

THE PHASES OF A MARKET DEVELOPMENT PROGRAM

Minimizing New-Product Risks

Companies need new product successes to grow. Yet most product launches fail, either due to distribution snarls, design inadequacies, poor presentation, or a simple (in hindsight, anyway) breakdown in consumer communications. Sprite's success is an example of how one company got it right.

(See Book 2, No. 32, "Design Sense," 1963)

130 **A Strategy to Grow Into**

While Westinghouse Broadcasting Company was a household name (it produced such 1960s staples as "The Steve Allen Show" and "America Sings"), the public didn't understand what it did. Neither a TV network nor an independent station, executives wanted an image that would allow for even more diverse broadcasting activities. The creation of Group W answered those growth needs.

(See Book 2, No. 35, "Design Sense," 1963)

GROUP W

A BROADWAY OPENING NIGHT ON TELEVISION

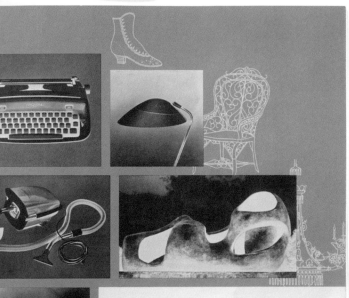

BOUNDARIES OF GOOD TASTE

Doesn't everyone agree that good taste is the hallmark of a civilized society? When an individual possesses it, we know he is a man of education and sensitivity. When a society displays it, we can assume its affairs are well-ordered, and that its people live in a state of grace and harmony.

On the whole we share these views. Who would deny them? At the same time, it is very important to make this point. Namely, that good taste can become something of a fetish, a snobbish, and pretentious one at that, and as such interfere with true creativity—its expression and its appreciation.

HUMOR IN MARKETING

Design Sense

A MARKETING PUBLICATION **42** OF LIPPINCOTT & MARGULIES

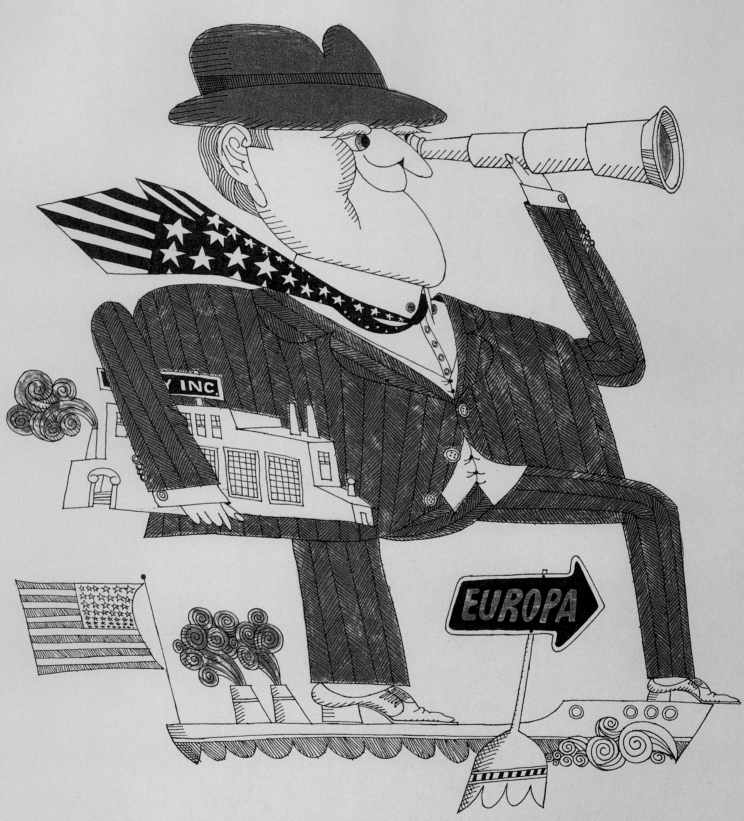

International Markets

Global Product Marketing

133

A global product manager? Ridiculous, say many CEOs. How can one person know what will sell in Kyoto, Bogota, or Stockholm? *Sense* argued that while a global product manager would of course rely on others for local particulars, he would need to think beyond geographic boundaries to succeed in the Common Market—and beyond.

(See Book 2, No. 42, "International Markets," 1965)

Design Sense 46

A MARKETING PUBLICATION OF LIPPINCOTT & MARGULIES

Ici on parle marketing ethnique

Design Sense 46

Ethnic Marketing Spoken Here
A common error, forged from marketing's oldest and most fundamental commandments, often today's marketing was the means of capturing consumer loyalty and other shapes of market groups.

Page Opposite

The Interview
He changed the character of retailing by placing merchandise in open bins, selling at fixed low prices, and testing all sales-cycle transactions. Concerning sales today, his methods were once considered revolutionary.

Page Six

Hormel Outfits Its Product with a Vigorous New Look
Intensive research produced a low surprises for the used packing and food processing firm: suspicion that led to a new logotype, packaging, color classification, gives a stronger communicating love to the public.

Page Eight

Ethnic Marketing Spoken Here

"...the ethnic concept poses, in fact, all sorts of knotty traps for the marketing man who moves too precipitously."

[body text columns partially legible]

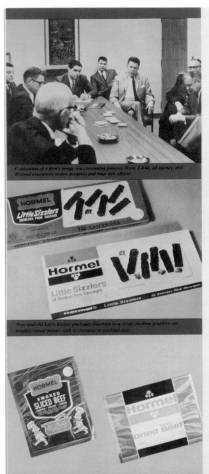

and evaluated. From the exploratory sketches, L&M picked six final contenders as worthy of further consideration. To accurately evaluate the potential and versatility of each logo under various supermarket conditions sample packages were made up and placed side-by-side with competitive brands. A strong leader—used in conjunction with a modular brand-mark—was found to have the most memorable impact and became the recommended design.

The language of the logotype

The new Hormel logotype retains some resemblance to its predecessor in that it's friendly, informal, and believable. Yet it also possesses uniqueness, crispness, and a modern flourish that says "we're the same reliable company but we have progressive ideas." Central to this system is a modular element containing the word "Hormel" in a unique letterform. Above and below the logotype are modules on which stylized parsley sprigs are centered horizontally. The parsley connotes both fine food garnish and freshness.

The basic elements in the new identification system were established on film and set photomechanically to assure accuracy and eliminate human error. This includes a hand lettered alphabet (based on the letterforms in the logotype) which was designed for use on all product names. The photomechanical process also accelerates the production aspects of redesigning Hormel's entire package line.

The more corporate-oriented areas of application, e.g., ad signatures, letterheads, invoices and bill forms, etc., drop the use of the module and the stylized parsley sprigs are repositioned at either end of the logotype. Where appropriate as an endorsing element, the phrase "Fine Food Products" is placed below the logo.

In packaging application, the L&M design staff worked closely with Hormel Executive V.P.—now President M. B. Thompson and Vice President Richard Arnold. Jointly, they created a Color Identification System to maintain a "family" resemblance and simultaneously help the consumer to differentiate between variations in similar type Hormel products.

The product line was broken down into three groupings, each with special color identification: 1) Primary (black/red/green) for use on top quality products; 2) Secondary (red/blue/green) for products less active in sales, and, 3) Tertiary (brown/red/green) for specialized products with unique appeal.

A special "ethnic category" was also established. Many popular Hormel products have definite ethnic overtones—such as Genoa Salami, pepperoni, pizza sausage, hard salami, etc. The individual ethnic products groups were assigned their own color system. The strong Hormel family relationship is maintained with a constant red logotype supported by the modern

Cultivation of a firm's image is a continuing process. Here, L&M, ad agency, and Hormel executives review progress and map new efforts

New and old Little Sizzler packages illustrate how crisp, modern graphics can amplify visual impact with no increase in package size.

The Hormel endorsement and concept of a "family" of products gains full expression through the use of a strong, flexibly logotype.

134

The Hormel alphabet extends recognition and identification from the logotype throughout product names and design panels in all Hormel packaging.

COPYRIGHT 1966 BY GEO. A. HORMEL CO.

Finding the Right Audience

What passed for ethnic marketing in the 1960s was pretty obvious, like Rheingold ditching its Miss Rheingold contests (which once drew more votes than Presidential elections) because African-American and Hispanic beer drinkers couldn't identify with the fair-skinned women. But there's a great deal to learn from America's early efforts at learning about ethnic markets.

(See Book 2, No. 46, "Ethnic Marketing Spoken Here," 1966)

135

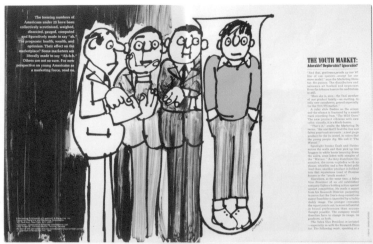

Baby Boomers: Beyond the Watusi

Marketers struggling today with Baby Boomer issues may not care about frugging, but they will be familiar with questions *Sense* initially raised about Boomers. Then, as now: plenty of buying power, but not much brand loyalty.

(See Book 2, No. 47, "The Youth Market: Adorable? Deplorable? Ignorable?" 1966)

NEEDED: RESEARCH BEYOND RAW STATISTICS

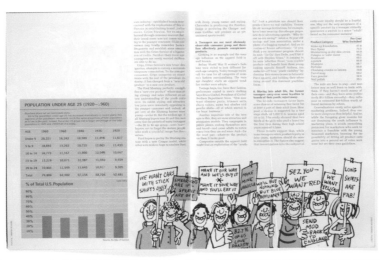

POPULATION UNDER AGE 25 (1920–1960)

AGE	1960	1950	1940	1930	1920
Under 5	20,321	16,242	10,599	11,498	11,617
5 to 9	18,692	13,262	10,720	12,061	11,433
10 to 14	14,773	11,167	11,000	12,049	10,667
15 to 19	13,219	10,871	12,387	11,556	9,659
20 to 24	10,801	11,549	11,645	10,917	9,305
Total	79,806	62,982	57,154	58,704	52,681

% of Total U.S. Population

1040 and all that

U.S. Individual Income Tax Return 1965

U.S. INDIVIDUAL INCOME TAX RETURN—1964

DesignSense 52

Canada's Future: Market or Marketer?

Canadian Business in a Changing World

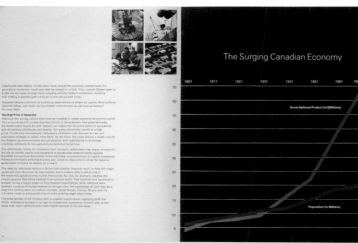

The Surging Canadian Economy

The Problems of Canadian Communications in a Shrinking World

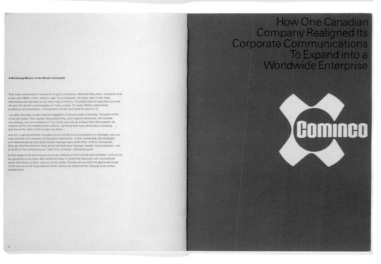

How One Canadian Company Realigned Its Corporate Communications To Expand into a Worldwide Enterprise

Cominco

Facts and Fables: Toward and Away from Canadian-U.S. Understanding

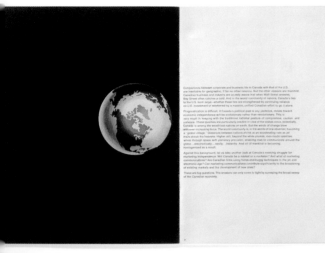

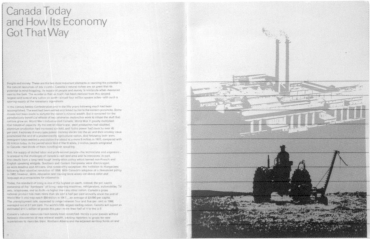

Canada Today
and How Its Economy
Got That Way

Mines and metals...ores and concentrates...hydro-power plants...chemicals and
fertilizers...electronic products...docks and warehouses...manufacturing plants...a
sales volume approaching $230,000,000. This is Cominco Ltd., major world producer of
lead, zinc and chemical fertilizers.

The fact that it is 95 per cent Canadian-owned suggests a kind of North American
parochialism—a suggestion that is only partly true. Less than ten years ago, Cominco's
operations were indeed confined to Canada. Today, its far-flung affiliates include
Cominco Binani in Calcutta, Mitsubishi-Cominco in Tokyo, Cominco-Gardner in
Dusseldorf, and Cominco American in the U.S. And tomorrow where? In Cominco's words,
"Anywhere in the world."

Where is Cominco headed financially? Up; decidedly so. Among the fiscal highlights of
Cominco's recent past, several factors clamour for one's attention. In 1961, after 55 years
of steady growth, Cominco's sales totaled $124,403,000 and its net earnings reached
$21,435,000. By 1966, sales had almost doubled ($228,752,000) and net earnings had consid-
erably more than doubled ($49,183,000). In the same five year period, Cominco shows an
almost six-fold increase in capital expenditures—from $10,877,000 in 1961 to $66,006,000
in 1966. While Cominco indicates this rapid rate of growth to be an uncommon one,
obviously, Cominco is on the move.

Significantly, the five year period 1961-1965 saw the firm establish its manufacturing
affiliates around the world. The following year it shed its portmanteau corporate name—
The Consolidated Mining and Smelting Company of Canada, Limited—for the shorter,
easy-to-use, more memorable Cominco, Ltd. The change was not happenstance. As it
prepared to branch out internationally, the firm realized the importance of communicating
with the nationals of other countries. However explicit, the name "Consolidated Mining
and Smelting Company" is a good-sized mouthful in English. Would it come trippingly
off the tongue in Japanese? In German? In Hindustani? What about the more than 2,000
other languages around the globe? More to the point, would the long name communicate
the less explicit qualities of a modern management, confident of its global destiny?
The firm decided that it did not.

The company had been using the name Cominco communicatively for some years.
It now called upon Lippincott & Margulies to evaluate its new name in terms of effectiveness
as a legal name as well. An L&M study confirmed the validity of its suitability as a
corporate title. But while a shorter name was important to Cominco's goal, it was only
a first step. L&M advised the firm to restructure nothing less than its entire
communications system—and for good reasons.

The firm's activities had grown to include much more than mining and smelting. The
different divisions of the company needed to be bound together for their common good.
Cominco had to decide, first of all, what its corporate personality was, whether it had to be

18

Curing Canada's Image Problem 139

Turning a glaring light on Canada's lack of marketing and
communications prowess—"horse-and-buggy techniques in a
jet-age world"—*Sense* considers how a country's confused
image can hamper its economic health.

(See Book 2, No. 52, "Canada's Future: Market or Marketer?" 1967)

DesignSense 54
A MARKETING PUBLICATION OF LIPPINCOTT & MARGULIES

The New Adults—
Marketing's Bewildering Bonanza pg.

Bendix Communicated:
From Conglomerate To Entity pg.11

An enigma comes of age

Remember the post-war baby boom you've heard so much about? Well, in case you haven't looked lately they're all grown up and ready to rock the marketplace with all the new values and ideas that have accumulated in the yeasty years that led from Glenn Miller to the Beatles and the Rolling Stones.

Even if you've heard of the Rolling Stones and the Animals and the Living Dead you've got some marketing homework to do to get ready for these New Adults. Thirty-one million of them, who will be forming households, making product decisions and spending more money than any other New Adult group in history.

The facts are at hand, buried in sober gray statistics from the Census Bureau and other record keepers. They tell you lots of things about people but they add up to one important alert. The New Adults have happened, and they'll be around for a long time to play havoc with market strategies born at the country store and graduated from Kay Kyser's Kollege of Musical Knowledge. If you're old enough to remember Kay Kyser, you may be part of the problem.

Unhappily for earnings statements, those same columns of dull figures pin-point another significant development that will change corporate thinking for years. *The birth rate in the United States dropped 23 per cent between 1960 and 1966.*

A Battle of the Bulge in the Years Ahead

Thus, if you accept the pre-war rate as some kind of workable norm, the big post-war surge followed by the sharp drop beginning in 1960 has created a population "bulge." On the high side of that bulge are the perplexing New Adults, who will wield increasing influence in the marketplace. *And on the low side the alarm signals are sounding for everybody who sells something to babies or growing children.* Ultimately, of course, the next crop of youngsters will take their place in the adult ranks with spending power shriven by "The Pill," or new mores, or sociology, or any other combination of causes you want to credit.

Let's put aside the statistics for a moment and look at these New Adults to find out what we know and what we think we know about them.

This is the generation born under a mushroom cloud. They're waiting to buy tickets to the moon, so why get excited about micro-circuits and eye transplants and masers and lasers? They were raised in the age of the technological blitz and the farthest-out research is only a day or two away from reality to them. They're the most sophisticated Americans ever born.

They've had more education, more medical care, more travel experience, better housing, more conveniences and theoretically, more thoughtful rearing than any in the world ever. They've had more money and will earn more than anybody. That "good life" you used to talk about is taken for granted now.

Personal Involvement and the Megaton

But these New Adults are something more. They are the repository of the tedium and shattered hopes of a generation of Cold War, and some of it not so cold. They know what megaton means. They've heard it used to measure nuclear killing power. They're closer to and more concerned with the grave problems of their time than any other generation. It may come as a bit of a jolt to realize that the teenage rock-and-roll addict across the street who was too lazy to earn money mowing your lawn is ready to begin helping shape the future of the world.

What does all this mean to marketers? The statistics are again quite meaningful. For statistical purposes this New Adult group in 1965 fell into the 15 to 24 age group. They accounted for 16 per cent of the total population.

By 1970 they will range in age from 20 to 29, a prime time for household formation and all the purchases that go with it.

Already, they have become a market factor. In 1965, a time when many of the boys were still too young for marriage, they formed nearly 3.5 million households, about six per cent of the national total. They bought 911,000 automobiles, 9.8 per cent of that year's output.

By 1970 when they can really qualify for the New Adult label, they will form 10.3 million households and buy 2.4 million automobiles, 23 per cent of estimated production.

Look five more years ahead to 1975. They're 25 to 34 years old now and they will run 14 million households and buy an estimated 25 per cent of the nation's automotive production.

More Income, Borrowing and Buying

And that's only the beginning. These are New Wave New Adults. Their better educations will bring them more income. And 55 per cent of new households include a working wife these days, compared to less than 40 per cent in the general population. That adds to the purchasing power.

Grandpa thought the installment plan was sinful. To these New Adults it's a way of life. A consumer study reveals that eight of ten households under 35 owed personal debt and for seven of ten some of it was installment financing.

Here then is the basic structure of the

4

5

The Mustang: Satisfying a Swinger 141

Meet the car that made the new VW Beetle, the PT Cruiser, and the Hummer possible. As the pockets of the Baby Boomers deepened, marketers realized that the 1950s "New and Improved" pitches failed to resonate. More and more, this group demanded marketing that addressed their aspirations, emotions, dreams, and desires. Ford's Mustang struck that chord.

(See Book 2, No. 54, "The New Adults—Marketing's Bewildering Bonanza," 1967)

Sense 68

A Marketing/Communications
and Design Publication of
Lippincott & Margulies

Advertising: in the eye
of a hurricane

"The need exists for companies today to structure a *communicative overview.*"

Strengthening other communicative channels

The communicative channels available to the average marketer are many, but unfortunately most have been allowed to atrophy. With the decreasing effectiveness of advertising, however, those that allow this trend to continue may in time find themselves behind the marketing eight ball.

In our work for American Motors several years back when the company was attempting a turnaround, advertising was an important part of the total communications program but it was not allowed to dominate the marketing stance. Following the development of a marketing strategy which carefully "positioned" American Motors in its challenge to the Big 3, substantial time and monies were invested in special sales and dealer promotions plus a new company-sponsored racing program to generate added interest among younger auto enthusiasts.

Special attention was also focused on the vital selling environment and Lippincott & Margulies was given the assignment to create a look for dealer showrooms that would make a strong statement about the company's new character and the products it sells. The end result has been highly successful—a clean, functional environmental system, economical to implement and maintain, and flexible enough to be adapted to a variety of architectural styles.

As 1972 comes to a close, American Motors with its balanced communicative approach is registering one of its most successful years in its history.

Certainly no stranger to advertising, The Coca-Cola Company approached Lippincott & Margulies to structure a brand communications strategy for its major product, Coke. The solution involved unifying all the individual communicative elements of Coca-Cola into one powerful system of brand identification. This program is still being implemented in all promotion materials and point-of-purchase displays. The P-O-P implementation worldwide—including all signage, displays, dispensers, rolling stock and the like—is probably the most massive program of its kind ever undertaken.

Why Customers Ignore Your Ads

Writing in 1972, Walter Margulies examined how an explosion of advertising messages had resulted in a steady slide of advertising effectiveness. More ads aren't the answer, unless we want the communicative tail to wag the corporate dog. The solution: strengthening other communication channels and touch points. Coca-Cola's decision to shift TV spending into event marketing is just one example of how marketers still struggle with these issues today.

(See Book 2, No. 68, "Advertising: In the Eye of a Hurricane," 1972)

Sense 69 A Marketing|Communications and Design Publication of Lippincott & Margulies Inc

Lifting the Fog from Multinational Marketing

One World, Many Names? Or One Name, Many Worlds?

Chrysler—while using its highly recognizable Pentastar logo—relied on many different brand names in different markets, yet Uniroyal is the same in every country. Today, these issues are still on the minds of all marketers. While recently the trend—to rationalize costs—has been to move to one name, there is a growing recognition that, internationally, a brand can only stretch so far.

(See Book 2, No. 69, "Lifting the Fog from Multinational Marketing," 1973)

The Role of Naming

"How do you go about getting a good name—particularly when so many (sometimes nearly all) the best ones are already taken?" While that question was written in *Sense* in 1961, we continue to hear it every day. Oh, to have been a naming consultant back when only 22,000 applications for trademarks had been filed for, when there was no URL, or little linguistic clearance to worry about! In those days, naming consultants needed little more than a thesaurus and a mythology textbook.

Name development continues to be a unique balance of art and science, dumb luck and painstakingly detailed procedure. And at the risk of sounding self-aggrandizing, it's a far more complex and difficult undertaking today than it was in 1961. And no doubt it will be exponentially so in the future. Clients today still demand easy-to-understand dictionary words that communicate what the company is or what its product does. But rarely are such names legally available. In 2002 over 200,000 trademark requests were filed in the U.S. alone. And of the precious few words that can be claimed and registered in the U.S., most are unavailable in at least one of the umpteen international markets where the company does business. A web address? Forget it. Over 97 percent of the English dictionary is currently registered as a "dot com." Another thing: names need to make sense in Italian and Dutch, Tagalog and Mandarin as well, both linguistically and in terms of cultural appropriateness. While most of the world probably doesn't know that Nike was the Greek Goddess of Victory, great care was taken to make sure the word still works all over the world.

As a result of these complexities, the boundaries of "acceptable naming" have grown enormously. The public accepts arbitrary and invented names. Pairing unexpected words— fruit (Apple) with a computer; or a country yokel with a high technology (Yahoo!); or even the creation of wholly new and meaningless words (Haagen-Dazs)—has been more prevalent. We can thank the Internet boom with all its wacky and mostly deceased names for pushing the limits. Imagine how radical Kodak must have sounded when it was introduced in 1900, a time when every other name was either descriptive (American Telephone & Telegraph) or a founder's name (Ford Motor Company)?

The quest for "good names" will continue to be paramount. Companies that can break through the media cacophony in a unique way, while still presenting a clear and compelling product proposition, will be the winners. While much has changed—global competitiveness, technology, and audience sophistication to name a few—a lot remains the same. The questions and challenges raised in these *Sense* articles are as relevant today as they were forty years ago.

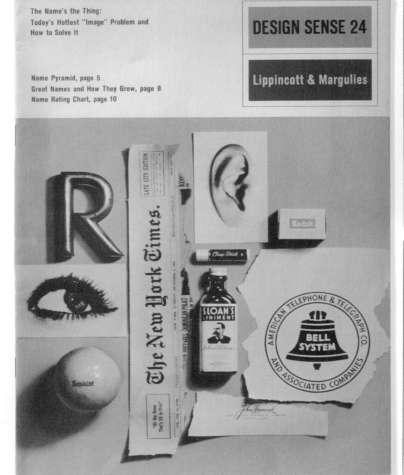

The Name's the Thing:
Today's Hottest "Image" Problem and
How to Solve It

DESIGN SENSE 24

Lippincott & Margulies

Name Pyramid, page 5
Great Names and How They Grew, page 8
Name Rating Chart, page 10

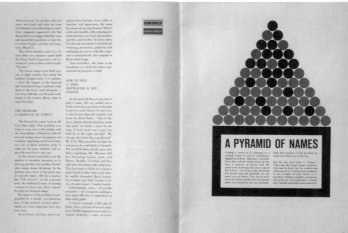

148

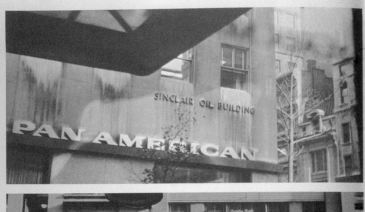

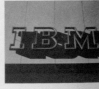

THE NAME'S THE THING

Last year, 22,800 applications for new trademarks were registered with the U.S. Patent Office. Over the last five years, the number of companies on the New York Stock Exchange, announcing a change in their corporate names, represented nearly 10 per cent of all the corporate stocks listed.

One firm announced that it had spent $300,000 in communicating and promoting its name switch. Another estimated that the direct costs of merely finding a name for a new product added up to $50,000 plus an uncounted number of frustrated man hours.

In one case, the stockholders' battle over a new name waxed so hot it reached the front pages of the *Wall*

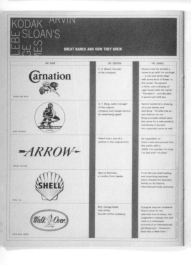

Naming Brands, Umbrellas, and Companies 149

From the hokey (Uneeda Cracker) to the meaningless (George Eastman's strong feelings for the letter K were what led to the invention of Kodak), inspiration for a strong name can come from many places. But names only stick if they are developed through a rigorous and comprehensive approach.

(See Book 2, No. 24, "The Name's the Thing: Today's Hottest 'Image' Problem and How to Solve It," 1961)

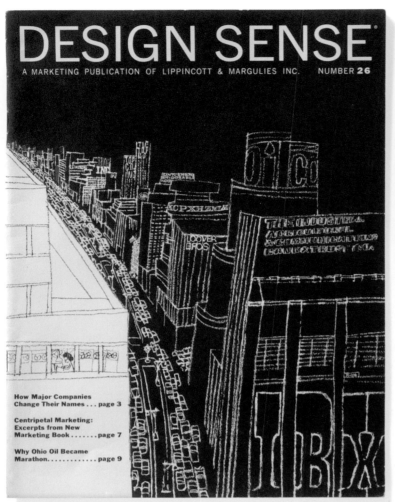

DESIGN SENSE®

A MARKETING PUBLICATION OF LIPPINCOTT & MARGULIES INC. NUMBER 26

How Major Companies
Change Their Names . . . page 3

Centripetal Marketing:
Excerpts from New
Marketing Book page 7

Why Ohio Oil Became
Marathon page 9

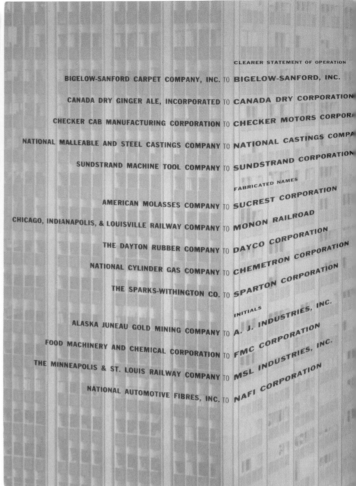

CLEARER STATEMENT OF OPERATION

BIGELOW-SANFORD CARPET COMPANY, INC. TO **BIGELOW-SANFORD, INC.**

CANADA DRY GINGER ALE, INCORPORATED TO **CANADA DRY CORPORATION**

CHECKER CAB MANUFACTURING CORPORATION TO **CHECKER MOTORS CORPORA**

NATIONAL MALLEABLE AND STEEL CASTINGS COMPANY TO **NATIONAL CASTINGS COMPA**

SUNDSTRAND MACHINE TOOL COMPANY TO **SUNDSTRAND CORPORATION**

FABRICATED NAMES

AMERICAN MOLASSES COMPANY TO **SUCREST CORPORATION**

CHICAGO, INDIANAPOLIS, & LOUISVILLE RAILWAY COMPANY TO **MONON RAILROAD**

THE DAYTON RUBBER COMPANY TO **DAYCO CORPORATION**

NATIONAL CYLINDER GAS COMPANY TO **CHEMETRON CORPORATION**

THE SPARKS-WITHINGTON CO. TO **SPARTON CORPORATION**

INITIALS

ALASKA JUNEAU GOLD MINING COMPANY TO **A. J. INDUSTRIES, INC.**

FOOD MACHINERY AND CHEMICAL CORPORATION TO **FMC CORPORATION**

THE MINNEAPOLIS & ST. LOUIS RAILWAY COMPANY TO **MSL INDUSTRIES, INC.**

NATIONAL AUTOMOTIVE FIBRES, INC. TO **NAFI CORPORATION**

WHY OHIO OIL CHANGED CORPORATE NAME

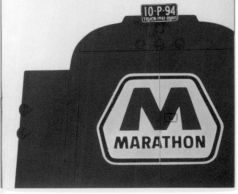

Ohio Oil Company's old gas
station signage included the
Speedway 79 symbol and the
old Greek Marathon runner

150

CORPORATE NAME CHANGING: HOW AND WHY

One out of every 10 companies listed on the Big Board has changed its corporate name within the last six years.

As more and more companies drop their name in favor of a new one, corporate management may be asking:

• What has prompted some of this country's industrial leaders to switch names with the apparent insouciance of a Hollywood starlet?

• Can an old name really be as confining to a corporation's career as the given name, Larushka Skikne, might have been to Laurence Harvey's?

• What are the advantages of one type of name change over another, and are these changes subject to corporate fashions?

To answer these questions and define the current name trends, Lippincott & Margulies, Inc. has conducted an analysis and classification study of all corporate name changes between 1956 and 1961 among companies listed on the New York Stock Exchange, based on data provided by the Exchange's Research Section. (For examples of three name categories enjoying current popularity, see list on page 2.)

During this six-year period, 133 companies have revised their corporate listing on the Big Board. This means an average of more than 20 name changes in each calendar year. Indeed corporate fickleness about names is further underscored by five of these major corporations which engaged in two name changes each during this period—an uneconomic move at best, when one takes into account the diffusion of a company's communications through frequent change.

Take these examples as extreme illustrations of the recent corporate name merry-go-'round:

In 1957, the Diamond Match Company changed its listing to Diamond Gardner Corporation. A brief two years later, the company asked to be known as the Diamond National Corporation.

Magic Chef, Inc. made a more gradual transition to its current name. In 1957, it used the composite, Magic Chef-Food Giant Markets, Inc., because of its merger. During the next year, it completed its transition to Food Giant Markets, Inc.

However, frequency of change is not the key culprit in the corporate name problem. And, as a matter of fact, there can rarely be any quarrel with the marketing needs which prompt the change.

A glimpse at the variety of name changes and the categories of names chosen gives an indication of the problem which various corporations sought to resolve through this change. Here then are the highlights of L&M's name change analysis:

• The most frequent type of change (46 corporations) was an attempt to find *a clearer statement of the corporate area of operation*. The companies that made this type of change generally tried to broaden the implied range of products and services offered, reflecting awareness that a narrow descriptive name could be a serious deterrent to sales.

More than 30 companies tried to achieve this aim by merely removing a restrictive element in their corporate name. For instance, Georgia-Pacific Plywood Company dropped "plywood" in 1956 and became the Georgia-Pacific Corporation. In 1957, United Cigar Whelan Stores Corporation became United Whelan Corporation. Lehigh Valley Coal became Lehigh Valley Industries, Inc. in 1958. In 1959, Northrop Aircraft became Northrop Corporation, in a move later paralleled

DESIGN SENSE 3

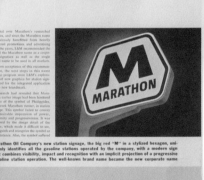

Marathon Oil Company's new station signage, the big red "M" in a stylized hexagon, uniformly identifies all the gasoline stations operated by the company, with a modern sign that combines visibility, impact and recognition with an implicit projection of a progressive gasoline station operation. The well-known brand name became the new corporate name.

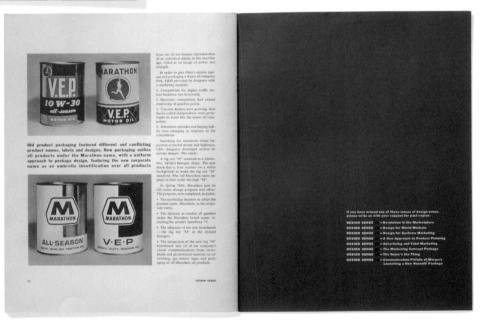

Old product packaging featured different and conflicting product names, labels and designs. New packaging unifies all products under the Marathon name, with a uniform approach to package design, featuring the new corporate name as an umbrella identification over all products

Does It Say What We Do?

One of the most common reasons companies change names is because the old one no longer reflects its core business. The then Union Carbide and Carbon Corporation knew no one in the general public knew what the chemical company actually did, and that its industrial customers always called it "Union Carbide." That simple truncation, along with a new corporate identity program, strengthened its image across all divisions.

(See Book 2, No. 26, "The Corporate Name Maze," 1962)

151

Design Sense
41
A MARKETING PUBLICATION OF LIPPINCOTT & MARGULIES

In This Issue–Two Assignments:

U.S. Rubber

Borg-Warner

Name Search Imperatives

Name search experts begin with questions, not with answers. The first and most important question is not what the name should be, but what it should convey. Other questions are: Where can it be found? What qualities should it have to meet the requirements of its application?

In such concepts lie the differences between one kind of name search program and another. The procedures are the same.

Since the U.S. Rubber program was different in many ways from anything we had done before, the conceptual base was prepared with great care. Our project team, working in close association with Gregg T. Ward, U.S. Rubber's Director of Advertising, "lived" with the company, soaked up its environment, interviewed company people at all levels—and also talked to outsiders to find out what the company was like to them.

Then the first step was taken: The target was defined through the establishment of the specific criteria the chosen name must fulfill. These criteria served both as the target in the name development phase and as the measuring stick when it came time to winnow the candidate list.

The nature of the criteria presaged the difficulties of the search. The name U.S. Rubber was looking for must be suitable for use in all potential markets, be without geographic or cultural restrictions, be capable of association with all products and the divisions and affiliates manufacturing them, and relate if possible to major brand franchises. In addition, it should project desirable image attributes, be without anti-social connotations in all the world's major languages, be tell-

ingly unique and relatively brief, possess audio-visual potentials and be legally available.

Where was such a name to be found?

A name search can be neither capricious, impulsive nor sentimental. Criteria give some indications of where to look, but only objective analysis can determine the scope of the search and lay out the avenues, the "name highways," along which suitable names may be found. This is of great importance because only a scientific approach can give assurance that the name sought will be there—that it cannot escape the procedural net.

Search directions in this case indicated some relatively narrow areas, such as initials, contractions and derivations of corporate and brand names, as well as two broad areas defined as "a completely new name with possible meaning," and "a fabricated or artificial name."

It is in the next step, the name generation phase, that creativity takes over. This is the one part of the game everyone can play. With the criteria as their target and reasonableness as their shield, the project team must patiently go down the roads that lead through the indicated areas until the possibilities of each are exhausted.

When the help of company employees or others without special skills in the communication field is enlisted in name generation, a number of names of doubtful parentage may be thrown into the net without any damage other than the extra work involved in the winnowing process. The extent to which unbridled creativity can clutter up the name-search landscape is illustrated, however, by the fact that a computer set to this task will compose 11 million 5-letter combinations if it is not restrained.

It is during this stage that recycling is

often called for—back-tracking to establish new criteria or a new search area, or to add limiting specifications to narrow, instead of expand, the search.

The next stage is the time of name harvest. The hundreds of names garnered from each of the search areas are evaluated by being run through the criteria sieve, the number being gradually reduced to the few of each group that hold some promise. With the selection of the list of primary name candidates—a list of 25 in the U.S. Rubber program—the project became visible and exciting to the cooperating company executives.

At this point a preliminary legal screening to determine the probable availability of the candidates is of utmost importance. The search can become not only a futile but a deeply disappointing exercise if this screening is delayed until the final candidates are selected. This screening and additional evaluation reduced the U.S. Rubber group to 10.

During this period the tempo of the search program increased. Meetings between the consultant team and client executives were held daily. The company's lawyers conducted a definitive legal search with the 50 states, Canada and selected European and South American countries as targets. The candidate names were submitted to linguistic experts who probed for any possible undesirable connotations or associations they might have in the major languages of the world. Design specialists began to conduct graphic explorations to determine the most attractive visual presentations.

The long program was nearing its climax. As a result of all these considerations, plus the use of professional judgment as to the believability of a name, the list was reduced to two final candidates: USCO and UniRoyal.

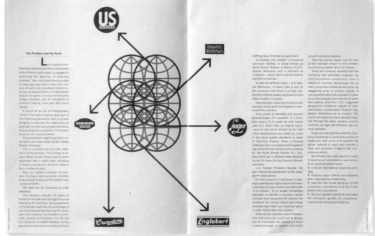

Parent Name vs. Division 153

Not all corporate divisions need well-defined ties with the parent company. It is possible, as Borg-Warner proved, to effectively communicate the varied scope of a corporation, while asserting the parent's strong reputation.

(See Book 2, No. 41, "U.S. Rubber and Borg-Warner," 1964)

Sense 77
A Communications, Marketing and Design
Publication of Lippincott & Margulies, Inc.

Corporate Name Selection
An in-depth look at the complexi-
ties of corporate nomenclature by
this country's leading consultant
on the subject.

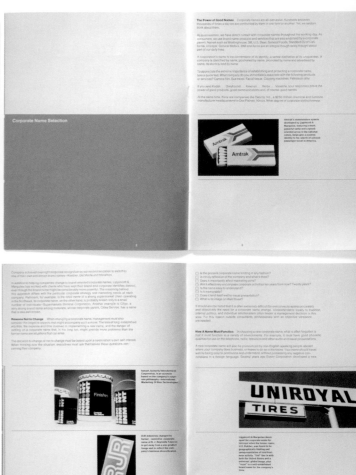

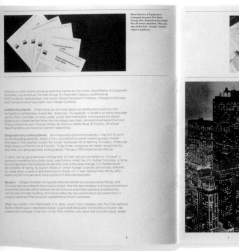

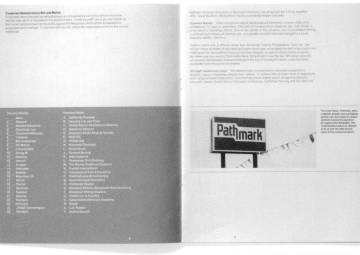
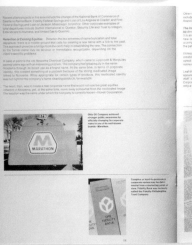
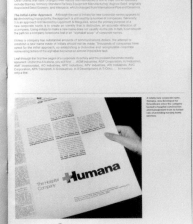
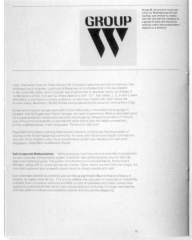
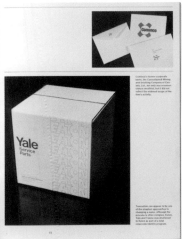

Choosing a Better Name

Changing a name presents many opportunities and pitfalls. Should you choose a truncated name? A total departure? Initials? An invented word? One that reflects your stock exchange symbol? A name the retains existing equities? A guide to the complexities of corporate nomenclature.

(See Book 2, No. 77, "Corporate Name Selection," 1976)

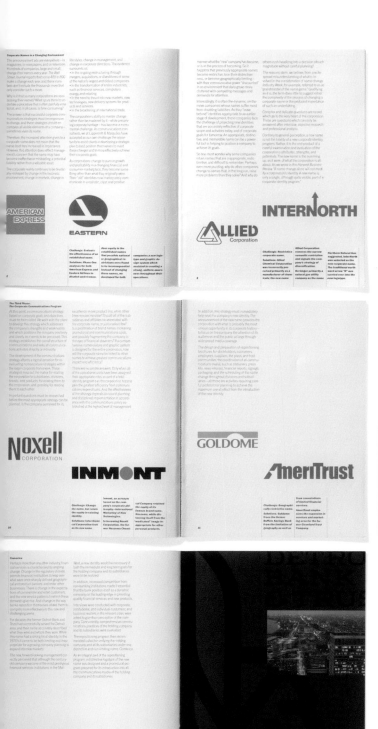

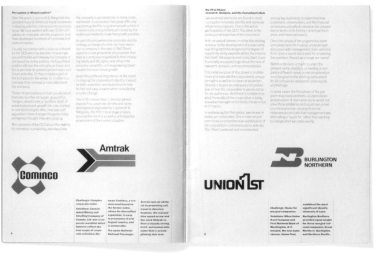

Perception and Misperception

"A name change alone won't modify a corporation's identity," Lippincott Mercer wrote in the Harvard Business Review, but when it's part of a well-constructed corporate identity program, it's an important start. Done right, it can free a company of indistinction ("First," "Federal," or "General") or geographical limits. Best of all, it can narrow the perception gap between what a company does and what its audience believes it does.

(See Book 2, No. 85, "The Corporate Name: To Change or Not to Change," 1984)

Corporate Brand and Wall Street

The corporate brand and Wall Street have been intertwined since Wall Street emerged. While many companies want to believe the balance sheet speaks for itself, a company's reputation plays an equally important role in its value. How sound is management? How well are core businesses defined? How different is it from its competitors? And, most important of all, how well has this company delivered on its promises? All the expensive and elaborate corporate identity programs—often just "an avalanche of puffery," Walter Margulies once wrote—can't fool investors who once believed in you.

While it's tempting to believe the current headlines, that today's accounting scandals, compromised research analysts, and corporate thievery have created an all-time low in investor confidence, these are all old problems. All center on credibility, the core challenge of every publicly-traded company. "The climate of disbelief," "The age of scrutiny," "Skepticism rampant—The Analysts," and "Divided Allegiance—The Accountants" might sound like current reading from *Business Week*, but all, in fact, appeared in early issues of *Sense*.

Over the years, *Sense* has chronicled cycles: there is a pattern that appears to be a push for performance, followed by investor exuberance and then fallout—bringing us back to the need for trust, real products, solid business strategies, and slow but steady performance. Waves of excessive merger and acquisition activity inevitably lead to overexpansion and divestitures; industry sizzle and reputation hype calls Wall Street's impartiality into question.

At Lippincott Mercer, we've been devoted students of what makes one company a "darling" of Wall Street, while its more solid competitors are largely ignored. The common thread here is that strong corporate brands have an advantage in all cycles. Strong brands attract the best talent, create preference for their products and services, and allow for recovery in the event of a crisis or downturn. A strong corporate brand is more likely to get good press, to attract investors, and yes, even command a premium from investors, and that premium is the P/E ratio.

Communication alone won't impress the sophisticated, wary Wall Street community. Companies must know what should be communicated, not send out vague clichés about "delivering on shareholder value." One only has to read the morning paper to find examples of companies that have struck out.

The moral? Know who you are. Know where you are going, and how you plan to get there. Communicate these facts to all your audiences—simply, directly, and frequently. And finally, live up to these goals and promises. That is the corporate brand's duty to Wall Street. If you handle all this correctly, Wall Street generally rewards you.

DESIGN SENSE

A MARKETING PUBLICATION OF LIPPINCOTT & MARGULIES INC. NUMBER 2

**Communication Pitfalls of Mergers:
How to Avoid Them. page 3**

Launching a New Package . . page 10

KEY MERGERS OF THE EARLY SIXTIES

AMERICAN STEEL FOUNDRIES (has changed name to Amsted Industries, Inc.) railroad and industrial castings, roller chains, cast iron pressure pipe, pipe coatings	**R. D. WOOD CO.** cast iron pressure pipe, valves, fittings **WHAT CHEER CLAY PRODUCTS CO.** clay sewer pipe and fittings
CAMPBELL SOUP CO. soups, juices, frozen foods	**PEPPERIDGE FARMS** baked goods
CHESEBROUGH-POND'S cosmetics, toilet goods, proprietary drugs	**Q-TIPS** cotton swabs
CLUETT, PEABODY & CO. apparel (Arrow Shirts)	**BOYD-RICHARDSON CO.** apparel stores
COCA COLA CO. soft drink beverages	**MINUTE MAID CORP.** frozen juices
DOW CHEMICAL CO. chemicals, plastics, packaging products (Saran Wrap)	**ALLIED LABORATORIES** research
FORD MOTOR CO. passenger cars and trucks and auto accessories	**PHILCO CORP.** tv-radio receivers, electronics
GENERAL FOODS CORP. packaged food and grocery products	**MAX DINISMAN INTERESTS** barbecue sauce
HUNT FOODS & INDUSTRIES canned and packaged foods, men's and women's shoes	**WESSON OIL & SNOWDRIFT CO.** cooking fats and oils
NATIONAL DISTILLERS & CHEMICAL CORP. liquor, industrial chemicals	**BRIDGEPORT BRASS CO.** brass, copper and bronze mill products, aluminum and special metals
STANDARD OIL CO. OF INDIANA petroleum refining and marketing	**IMPERIAL CASUALTY CO.** all forms of insurance except life

CORPORATE IDENTITY: A MERGER CASUALTY?

This month, when Thomas S. O'Neill, chairman of the board of General Tire & Rubber Company, looks over his annual report, he will see an industrial complex with little resemblance to the General Tire & Rubber Company of the mid-Fifties:

Today General Tire sales exceed $839 million annually from its aerospace rockets, ownership of television and radio stations, distribution of feature films, and manufacture of plastics and chemicals in addition to tires and rubber products.

Yet how many General Tire consumers and industrial customers know the full range of this company's products and services? How many investors are aware of General Tire's growth and diversification?

Certainly the corporate name links General Tire exclusively to the tire and rubber business. Nor does the firm go out of its way to proclaim its activities in other areas, diverse and profitable though these might be. In effect, each manufacturing and service division operates separately.

But General Tire is not the only company whose corporate identity has stood still despite its diversification mergers. Indeed the problem of reflecting a corporate identity changed through merger affects nearly every industry today.

Since 1957, more than 5,000 U.S. corporations have grown through mergers and acquisitions. In 1961 alone there were more corporate mergers (1,234, according to the Federal Trade Commission) than at any time since the war. This FTC figure represents a hefty 22% jump over recorded 1960 mergers. For a random listing of mergers in the early Sixties, look at the chart on this page.

DESIGN SENSE

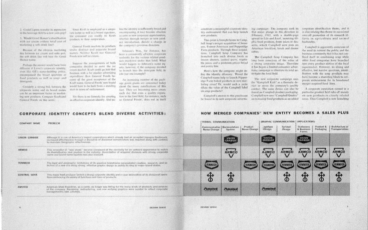

Identity: The First Casualty of a Merger 161

Many mergers combine unlike businesses in ways that baffle the public—beverage companies buy movie studios, magazine publishers merge with computer interests. Convincing investors of the advantages of such mergers requires a concerted identity program. In mergers, the more unrelated the businesses of the two companies, the greater the need for a sharper image.

(See Book 2, No. 25, "The Communication Pitfalls of Mergers," 1962)

Here are three of the blue-chip names in U.S. industry. Chrysler...Pet Milk...Eastern Air Lines. It would be difficult to find three great companies any more disparate in their activities. One, a world-wide producer of durable goods (cars and trucks, of course), ranks among the top ten manufacturers in the country. Another, no less world-renowned, is an older firm increasingly young at heart, a diversified processor of food. The third, relatively a newcomer to the front ranks of big business, has earned fame as a corporate pioneer in one of today's fastest-growing service industries, air transportation.

Yet the three have much in common. For one thing, all are engaged primarily in serving that most exacting of customers, the consumer. Here's another: until recently, the fortunes of all three were in decline—or, at best, growth had stalled. Now consider this. Each company recently brought to the summit dynamic new management. Messrs. Townsend, Gamble and Hall each determined to arrest the drift and turn his company around.

The goals were far-reaching. In every case, the aim was to scrap the fading corporate image and substitute—through better products and services, better methods and procedures, better planning and singular style—a corporate identity that said clearly: "We're going places!" To implement the new look and to communicate it effectively, each new president did something more. He called in our firm, Lippincott & Margulies, Inc. What were the results? As late reports indicate, the records still are being written. But the direction is apparent. Here, indeed, are three corporate turnarounds of spectacular proportions. More important, here can be found three designs for consistent and profitable growth in the years to come.

The Past as Prologue
The turnarounds vary as to dates and details because they took place over different periods and in different competitive surroundings.

Chrysler's operating and financial record had been a model of stability for decades. The corporation consistently maintained at least 20 per cent of the passenger-car market and second place among the industry's Big Three. Net profit margins (on sales) were above 5 per cent. But a 1951 profits slump, recalls Mr. Townsend, suddenly gave the "signal of trouble ahead." For the next ten years, Chrysler rode a financial roller coaster. Corporate earnings plunged into the red. Corporate volume plummeted to a poor third in the industry, seriously threatened by much smaller competitors. Corporate identity suffered worst of all. People were saying that Chrysler would never come back to its former strength; some said it couldn't come back at all. Chrysler had to do more than prove them wrong; it had to get the message across to its market, and fast.

During the 1950's, Pet Milk's fortunes also began to sour. Founded in 1885, it had built a hundred-million-dollar business on the strength of a single successful product: Pet Evaporated Milk. But times changed. After the depression and the war years, demand ebbed, as new competitive products nibbled away at Pet Milk's market. Though Pet remained a leading brand, 30 per cent of prewar canned milk volume simply vanished. The food company once famous for steady profits and growth suddenly became an up-and-downer, its earnings erratic. "We were poised on the brink," recalls a marketing man, "facing decline." Bluntly, Pet still was a one-product company—structurally, promotionally and philosophically old-fashioned. If profitable growth ever were to resume, drastic changes in its ways—a new outlook and a new look—were essential.

At Eastern, where governmental rate and route regulation tended to obscure operating revenues seemed to be flying high. Costs, however, were going up at a much faster rate. Hence, the operating ratio—the true altimeter of any transportation company—soared above the 95% danger point in 1957. With the introduction of widely heralded (but high-cost) shuttle service, it cracked through 100%—passing the point of no return. Net earnings turned to deficits. In 1961 and '62 alone, operating losses totaled a staggering $40 million. Strapped for working capital, its competition intensifying, Eastern's aging, propeller-driven fleet was deteriorating, its service going from bad to worse. By 1963, the airline had become, in the public's eye, a system grown old, unattractive and on the downgrade.

Frequently, a company suffering drift and decline may decide it needs new leadership and the benefits of a fresh perspective. The structure of management itself may be overhauled. As it happens, each of the three companies chose to make such a move. Each elevated a vigorous young executive to the presidency—the three men bear a striking resemblance to one another in background, experience and outlook (see page 5) and each man at once set out to revamp his team, its structure and the corporate financial and operating policies.

In Chrysler's case, Mr. Townsend and George H. Love, chairman of the board, retained several key executives while promoting a number of younger men to high responsibility. At the same time, the central management function was strengthened. Through introduction of advanced, highly refined reporting techniques, operating results throughout the vast corporation were flashed daily to headquarters. Responsibility was fixed precisely, up and down the line, and at staff level; cost and profit accountability was assigned directly on each operation. The result, as the new president noted: "A high degree of flexibility and precision in decision-making procedures, a healthy balance between centralized policy-making and decentralized execution." Most of the new men were in their forties. "We are," said Mr. Townsend, "lean and fast-moving."

Pet Milk's Gamble could be more deliberate in achieving the same result, noting that the management team had inherited "represents an unusual balance of youth and experience." Through subsequent retirements, a strengthening of the corporate staff and an expansion of operating responsibilities, this youthful-yet-veteran look became even more pronounced in Pet's deepening top echelons. The diversification program soon to be launched put a high premium on the versatility of the team as well. One executive could and did swap his

(INDEX: 1955=100)
1955
200
150
100
50
0
SALES
200
150
PROFITS 100
50
0
-50
-100

a line of nationally known brands that can swamp a supermarket: Downyflake pre-frozen waffles, Funsten pecans, Laura Scudder's potato chips, Sego liquid diet food, Musselman's apple sauce, Whitman's Sampler chocolates, Pet Formula Nursers (pre-filled, pre-sterilized disposable baby bottles), Big Shot chocolate syrup, HC fruit juices, Reese Finer Foods (imported cheeses) and even Stuckey's, a chain of roadside stores and snack bars in twenty-seven states. All told, to its three former operating divisions (plus a corporate division) Pet added seven more, each the producer and marketer of a clearly defined line of products.

As the product mix proliferated and the corporate structure grew, Pet's young management team worked overtime to keep profits from being diluted. The record has been remarkable. The recently reported year-end fiscal results showed both sales and earnings at all-time record highs. To salve the last of the growing pains, Mr. Gamble noted that the company now expects to concentrate on further consolidations of existing activities; the growth emphasis, for the time being, will be switched to more new products generated from within.

Meanwhile, what had all this done for Pet Milk's corporate identity? The answer is that until two years ago it was becoming fuzzier than ever. For three-quarters of a century, "Pet Milk" stood for one product. Now the trade, consumers, Wall Street and Pet's own employees were being asked to associate "Pet Milk" not only with growth, but with a mouthful of other assorted brand names, most of which long had enjoyed nationwide popularity of their own. This, essentially, was the problem Pet brought to Lippincott & Margulies in 1961.

L&M Leaves its Mark: II—
Pet learns how to sign its famous name.

Early that year, a management committee had probed deeply into the company's own psyche. They sought to define the kind of identity the company wanted, consistent with the goals outlined in the Gamble blueprint. Should the corporate name be retained? Should it be pruned to just "Pet," or changed to the more general "Pet Food" in either case perhaps risking confusion over what its business really was? Should the new divisions drop their own brand names and sell their products only under the "Pet" label? Alternatively, should Pet Milk follow, in Madison Avenue jargon, the Procter & Gamble model or that of Heinz—that is, give every established brand name total autonomy or shelter them all under the umbrella of a "Pet" association, while retaining some individuality.

The Pet committee decided that while "Evaporated Milk" had little magic left for modern consumers, too much money had been invested over the years in establishing "Pet Milk" as both a concept and a commodity to be discarded lightly. At that point, Lippincott & Margulies was assigned "to study all pertinent phases of (Pet's) visual identification and develop recommendations for appropriate unification." Design and marketing experts at once embarked on a two-year, in-depth study of consumer attitudes. The clear-cut response: Pet Milk Company stood for stability, bigness, compe-

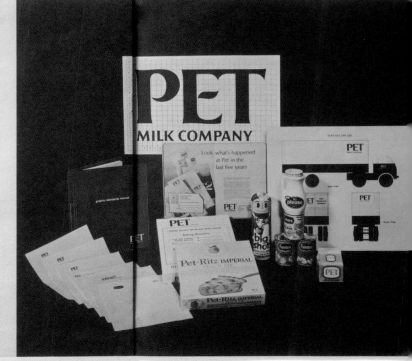

162

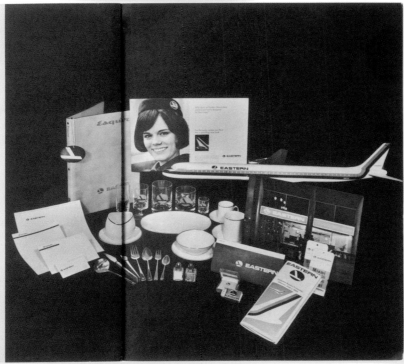

What Makes a Turnaround Work?

Even by the early 1960s, the new identity program symbolized by
a new logo was a tired story. But in Chrysler's astonishing turnaround,
it was the carmaker's exhaustive attention at the dealer level that
created 22 percent sales growth. That result, not the identity plan itself,
is what Wall Street responded to.

(See Book 2, No. 44, "Corporate Turnaround," 1965)

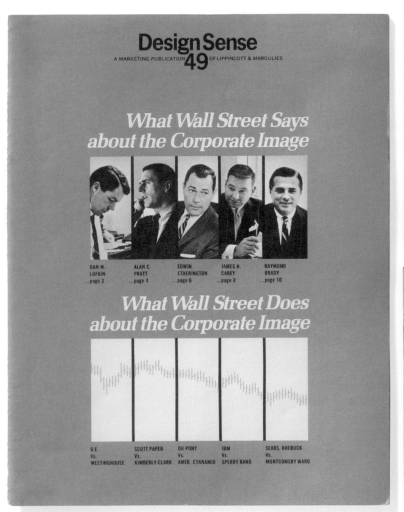

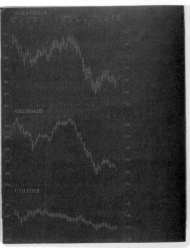

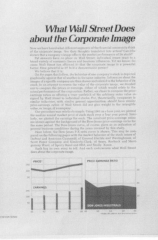

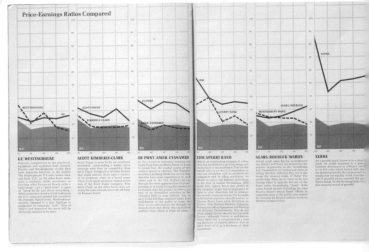

164 **Image Buffers a Stock**

A company's image is tangible. It begins with a concrete part of your reputation, adding predictable sales gains or aggressive product research. An identity program that underscores those strengths pays off in bad times, softening the blow when trouble comes unexpectedly.

(See Book 2, No. 49, "What Wall Street Says about the Corporate Image," 1966)

Lippincott & Margulies, Inc. has been privileged to serve as marketing and design consultants to a growing clientele. The scope of our assignments encompasses far more than the creation of the corporate symbols shown above. These represent but a small part of the activities undertaken for our clients.

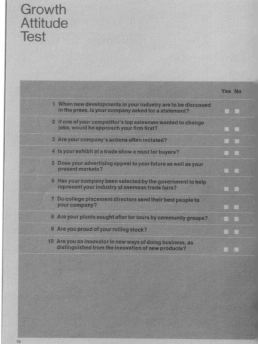

Check Your Growth Attitude

While it's true that your company's P/E ratio is one measure of your company's potential, this 20-question test is a more accurate barometer, with questions as challenging today as they were more than 30 years ago. Are you proud of your rolling stock price? Do securities analysts seek you out often as a speaker? Are you rated "most dangerous adversary" by your competitors?

(See Book 2, No. 55, "Growth and Your Price-Earnings Ratio," 1967)

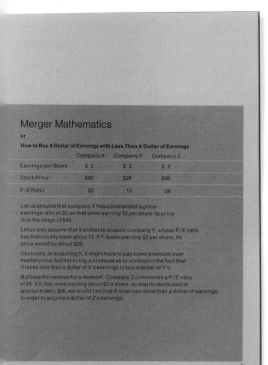

Merger Mathematics

or

How to Buy A Dollar of Earnings with Less Than A Dollar of Earnings

	Company X	Company Y	Company Z
Earnings per Share	$ 2	$ 2	$ 2
Stock Price	$40	$26	$56
P/E Ratio	20	13	28

Let us assume that company X has commanded a price-earnings ratio of 20, so that when earning $2 per share its price is in the range of $40.

Let us also assume that it wishes to acquire company Y, whose P/E ratio has historically been about 13. If Y is also earning $2 per share, its price would be about $26.

Obviously, in acquiring Y, X might have to pay some premium over market price, but not so big a premium as to contradict the fact that it takes less than a dollar of X's earnings to buy a dollar of Y's.

But take the reverse for a moment. Company Z commands a P/E ratio of 28. If it, too, were earning about $2 a share, so that its stock sold at approximately $56, we would find that X must use more than a dollar of earnings, in order to acquire a dollar of Z's earnings.

FOUR
WALL STREET
EXPERTS
COMMENT ON
THE P/E
RATIO

	Yes	No
11 Are security analyst organizations likely to seek you out as a speaker?	■	■
12 Do you welcome consultants rather than fear them?	■	■
13 Is your company rated the most dangerous adversary by your competitors?	■	■
14 Are your products the price leaders against which others discount?	■	■
15 Have you recently created a package, product or service that caused excitement in your industry?	■	■
16 Do your sales brochures look as though they had been designed twenty-five years ago?	■	■
17 Are your executives apologetic about their offices?	■	■
18 Do you often lose promising talent to other companies?	■	■
19 Does retirement seem attractive to your employees?	■	■
20 In your company, does one often hear the statement: "But we've always done it that way"?	■	■

Key to the test appears on the following page

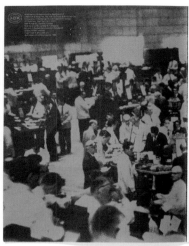

Selling the DNA of Your Merger

While everyone in the business world is used to mergers, so much can
go wrong if your story is not told properly. That's why the choreography
of corporate communications is essential. This 25-step plan guides
companies through every step of the transition, to make sure you're
conveying the great things that lie ahead for the new enterprise.

(See Book 2, No. 59, "The Vital Role of Communications in Mergers & Acquisitions," 1968)

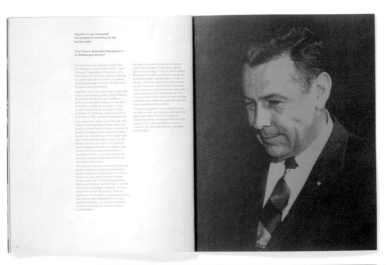
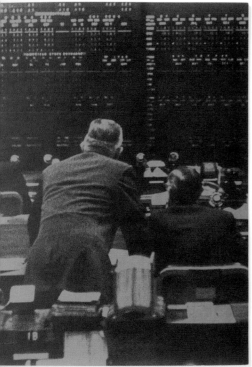

Where are banks going today? Wha
behind insurance diversification? T
new financial conglomerates. Inte
views with financial leaders: John H
L. Walter Lundell, Hulbert Aldrich, D
Lufkin, Gerald Tsai, Jr., J. Howard Lae

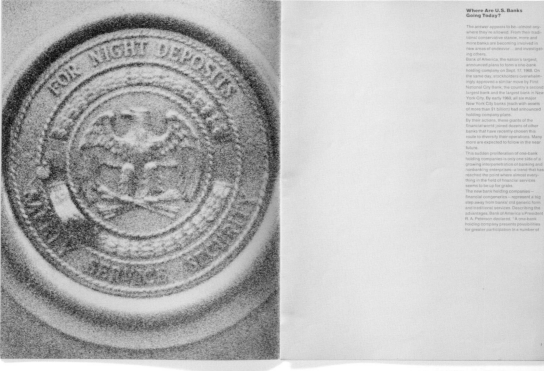

Where Are U.S. Banks Going Today?

The answer appears to be—almost anywhere they're allowed. From their traditional conservative stance, more and more banks are becoming involved in new areas of endeavor…and investigating others.

Bank of America, the nation's largest, announced plans to form a one-bank holding company on Sept. 17, 1968. On the same day, stockholders overwhelmingly approved a similar move by First National City Bank, the country's second largest bank and the largest bank in New York City. By early 1969, all six major New York City banks (each with assets of more than $1 billion) had announced holding company plans.

By their actions, these giants of the financial world joined dozens of other banks that have recently chosen this route to diversify their operations. Many more are expected to follow in the near future.

This sudden proliferation of one-bank holding companies is only one side of a growing interpenetration of banking and nonbanking enterprises—a trend that has reached the point where almost everything in the field of financial services seems to be up for grabs.

The new bank holding companies—financial congenerics—represent a big step away from banks' old generic form and traditional services. Describing the advantages, Bank of America's President R. A. Peterson declared, "A one-bank holding company presents possibilities for greater participation in a number of

Know What You Are, Then Say it!

The specific changes buffeting banks in this article have long since become ancient history, but what remains the same is that financial institutions, with their broad collection of retail divisions, commercial banks, and brokerage operations, are confusingly similar, even to insiders. Finding a believable identity—and then communicating it— is the only way your corporate brand can gain in value.

(See Book 2, No. 60, "Financial Services: A Field in Ferment," 1969)

Corporate Identity vs. Regulation

How can today's corporation sustain originality and innovation in the face of growing government control? The problems of highly regulated industries—airlines, railroads, public utilities, banks, insurance companies—are specialized, but often, solutions that work in other industries work here, too.

(See Book 2, No. 61, "The Challenge to Regulated Industries," 1969)

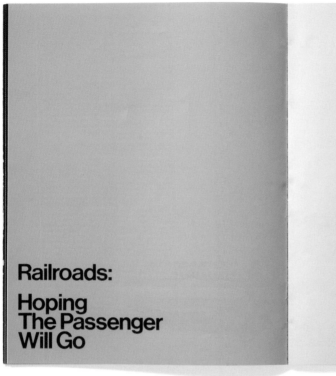

Away

Railroads:

Hoping The Passenger Will Go

If a contest were held for the most maladroit communications strategy of the last 20 years, the railroads might well be the entrants to beat.

"Few industries are as dependent on popular support as the railroads," the Wall Street Journal points out, "and yet the roads sometimes seem to be at war with the public." The Journal goes on to say, "The decline of passenger service is obviously not the fault of the railroads alone…The heavy hand of regulation…denied the railroads the flexibility they would have needed if they tried to meet the competitive threat."

In the eyes of much of the public, the railroads are most in trouble for their apparent disinterest in coping with the problem of declining passenger traffic. There has been a strong suggestion that the railroads simply hope that all passengers will quietly go away. Like it or not, most railroads are in the passenger business. The hope that someday they can totally disengage themselves from passenger responsibility to concentrate on more profitable freight hauling is highly unlikely, to say the least.

Many interested parties see an important future for passenger trains, especially in heavily populated corridors such as Richmond to Boston, Buffalo to Chicago, the Southeast and the West Coast. "There is hardly a better means for moving large numbers of people between substantial traffic-generating points," says Richard J. Barber, deputy assistant secretary of the Transportation Department. The beginning may lie in the new high-speed trains now being tried out under Transportation Department sponsorship between Washington-New York-Boston.

A seeming attitude of the "public be damned" has not done much for the railroad image, especially when one considers there are more than 26 million stockholders in the country today. And then there's the not so small matter of Wall Street. If the future looks bright, no one has bothered to inform the boys downtown yet. Their eyes right now are riveted on glamour

13

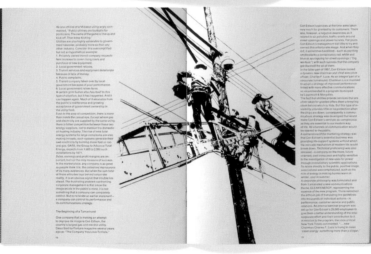

Staging a Small-Company Turnaround

American Motors Corporation was in trouble: the only brand consumers knew was the discontinued Rambler. But by an intense new-product focus (at dealerships, product personality was pushed far more than company name), and thinking small (its new Hornet and Gremlin were aimed at small imports, not "boats" from Detroit), the company gained a lean, aggressive, and spirited personality.

(See Book 2, No. 64, "American Motors," 1970)

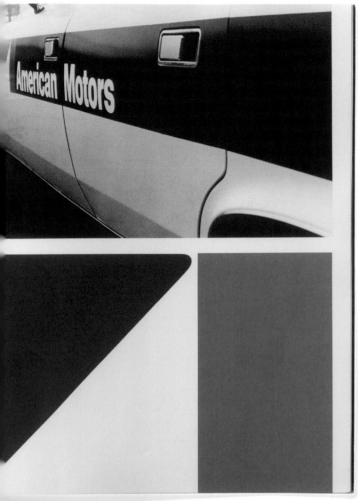

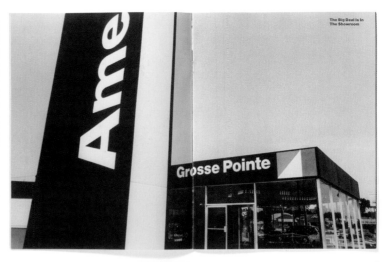

The Big Deal Is In
The Showroom

Grosse Pointe

A high priority was also given to the upgrading of American Motors 2,400 dealerships, many of which were housed in out-of-date, unimpressive facilities. The importance of this area could not be overstressed because it is in dealer showrooms that the final sale is made. It was imperative that the new environmental setting reflect the company's aggressive personality, set it well apart from its competitors, and generate a look that would relate to the 70's and New Generation. But equally important, the question arose/had to be considered; American Motors and its dealers were in no position to outspend their competitors. Too often, design programs of this type, even though imaginative, are created with little regard to the client's pocketbook. The result is that the company involved is often able to implement only a small portion of the total. As a consequence, the end product is more confusing and fragmented than the original.

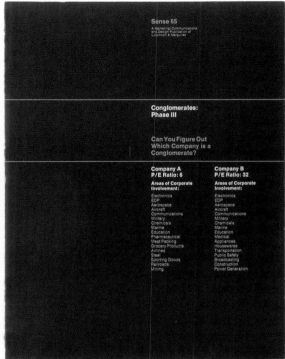

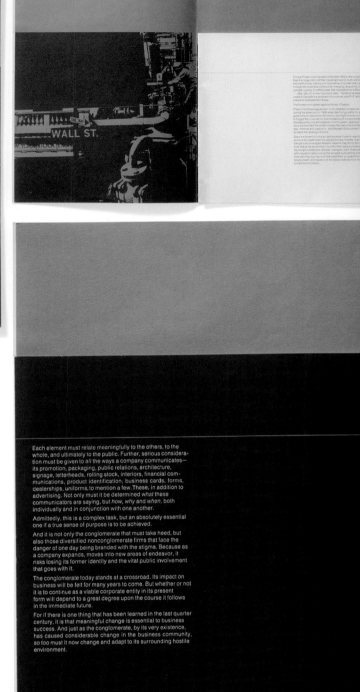

Conglomerates: Built-In Image Problems

Conglomerates create a unique problem for themselves. To investors, they are seen as without a purpose filling only the need to make profits, and as having little—if any—real product involvement with consumers. But why do some get saddled with the negative "conglomerate" label, while others are seen as "diversified?"

(See Book 2, No. 65, "Conglomerates: Phase Three," 1970)

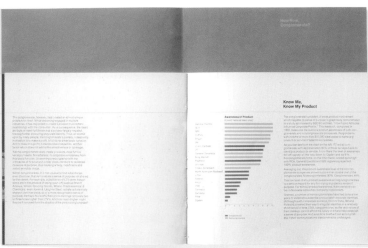

Forget the Sizzle, Forget the Steak

By the 1970s, the CEO's role was drastically different than his predecessors. Armed with ever more sophisticated data from both the market research department and his investor relations team, he learned fast that numbers lie. And the one truth? That the most important role of any CEO in any industry is understanding the relationship between product and customer.

(See Book 2, No. 66, "Marketing Quicksand: The '70s," 1972)

Sense 67

A Marketing/Communications
and Design Publication of
Lippincott & Margulies

Corporate Image and Those Magic Multiples.

Special Interviews with:
Gus Levy of Goldman Sachs
Gordon Williams of Business Week
Tom Johnson of Chemical Bank

When asked about corporate image, a well-known financial expert gave what is perhaps a classic definition: "Look at U.S. Financial, it grows 25% per annum and has a P/E multiple of 10. IBM, on the other hand, grows about 15% a year yet its multiple is 40. That difference in multiples *is what I call corporate image.*"

How Corporate Image Protects a Stock's Price

It's not surprising that this is still the most requested *Sense* article ever. In this timeless piece, Walter Margulies, while acknowledging that a company's corporate image has a measurable and significant effect on a stock price, points out how frequently "conglomerization outruns communications…Believable communications," he says, "must take into account corporate history, present activities, and plans for future growth."

(See Book 2, No. 67, "Corporate Image and Those Magic Multiples," 1972)

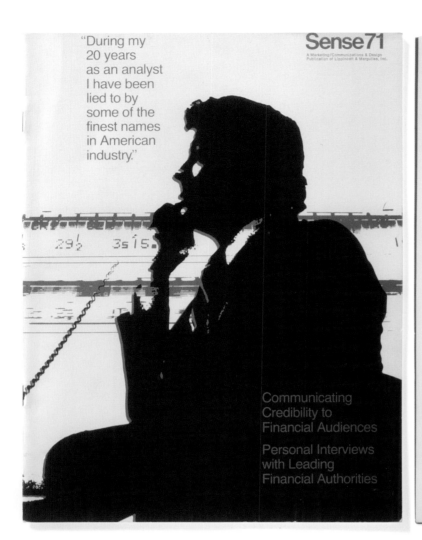

Creating a Credible Corporate Image

All corporate messages today, whether we choose to admit it or not,
are fragile craft floating on a sea of disbelief. The national mood creates
a credibility problem that demands more than cosmetics and good
intentions. Wall Street experts gauge credibility in only one way. "We
measure what we know against what we are told," one analyst explains.

(See Book 2, No. 71, "Communicating Credibility to Financial Audiences," 1974)

The Age of Scrutiny

"...no month passes in the work of a business journalist without his encountering some grotesque and engaging instance of corporate noncommunications with the outside world."

Skepticism Rampant – The Analysts

The Information Factor: More

Divided Allegiance – The Accountants

Forecasting – Has Its Time Come?

"The pressure on management to 'have something to say' is perhaps greatest of all in the direct confrontation with the analysts at luncheons, meetings and seminars."

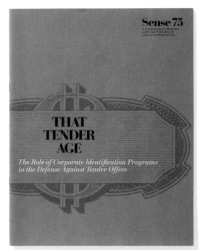

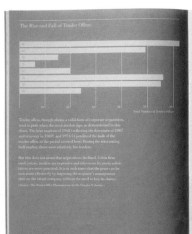

A Strong Identity Fends Off Unwanted Offers

When it comes to unfriendly tender offers, a successful and well-established corporate brand program is one of a company's best defenses (and one of the few things that is completely within its control). But a company's identity should be nurtured long before the fat hits the fire.

(See Book 2, No. 75, "That Tender Age: The Role of Corporate Identification Programs in the Defense Against Tender Offers," 1976)

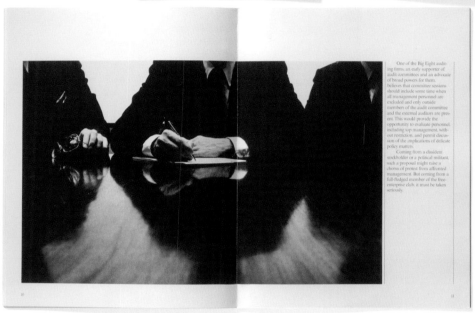

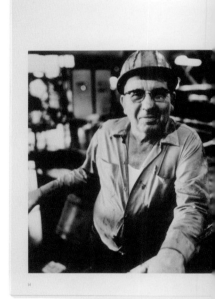

Outside Directors: An Audience You Can't Ignore

Outside directors vote on key issues—ousting CEOs, closing plants, acquisitions, R&D strategy. Well-crafted communications and up-to-date information have tremendous impact on ensuring that directors truly understand an organization and its people.

(See Book 2, No. 79, "Outside Directors: A Tough New Audience for Corporate Communications and Corporate Identity Planning," 1978)

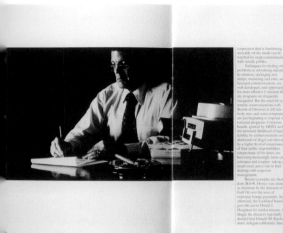

corporation that is functioning smoothly on the inside can be wrecked by inept communications with outside publics.

Techniques for dealing with problems in advertising and public relations, packaging and design, marketing and sales, and financial communications, are well developed, and opportunities for more effective Corporate Identity programs are frequently recognized. But the need for systematic communications with Boards of Directors is still relatively new, and some companies are just beginning to respond with remedial programs. Corporate boards, spurred by ERISA and by the increased likelihood of legal liability by embarrassments over disclosure of illegal activities and by a higher level of consciousness of their public responsibilities, symptomatic of the times, are becoming increasingly more outspoken and vigilant—taking a much more active role in their dealings with corporate management.

Recent examples are abundant. Bob R. Dorsey was ousted as chairman by the directors of Gulf Oil over the issue of improper foreign payments. Soon afterward, the Lockheed board gave the axe to Daniel J. Haughton for similar reasons. At Singer, the directors reportedly decided that Donald M. Kircher didn't delegate sufficiently. Since

the company was also having earnings problems, Kircher gave up the top job.

John W. Bergot resigned the presidency of Stanray Corporation under pressure. Richard H. Goldman was replaced as president of McGregor-Doniger. Orville F. Mertz left as president of Korthing Corp., a victim of bottom-line problems. Could more effective internal communications have lessened the number of CEO casualties?

Life in the executive suite has always been hazardous duty. But the risks today are greater than ever. Effective communication of corporate goals, image and performance to the members of the board—particularly to those who are not employees of the company—can no longer be taken for granted.

The challenge is perhaps a benefit, however well disguised. As more outside directors join the corporate board, the CEO has access to a new group of independent voices—investment bankers, consultants and executives of other corporations—who may spread the word of the company's vitality, capabilities and management competence.

Perhaps even more important is the chance to engage in quid pro quo with the directors. If they demand more of the CEO, then the CEO has every right to demand more of them, to shape

In 1927, the Michigan Tube Company had modest operations in Michigan to nine locations in Michigan, Nevada, California and Carolina. With annual sales of $ million, it is one of a dozen companies whose major factors in the field of specialty tubing for oil and petrochemical transportation and for and fabricated metal In addition to tubing, it working machinery, steel billets, and fabricated

it came to Lippincott & Michigan Seamless reputation of long for reliability, service, creation and quality engineered a major problem in Michigan to time presented to customers, and often confused represented to customers, investors and others financial community, thought Michigan Tube was a basic steel like U.S. Steel, which it is assumed that it was on cyclical sales to the industry, or that the takes is a commodity severe price competition using mills, which it isn't. It rently compared with that really aren't like it and upon the limited con-

notations of its corporate name. Michigan Seamless Tube was perceived as a small, regional, one-product company.

Operating subsidiaries functioned under names that were similarly restrictive. Its tube operation in Texas was Gulf States Tube and its welded tube unit was known as Standard Tube. Consequently, to the company's various publics it was known by different names, and thought of in terms of the specific products of its subsidiaries and divisions. And because the corporation was operating with so many different identities, its communications impact was diluted. Financial analysts did not see the company as the substantial, broadly-based specialty metals producer it had become, and customers frequently overlooked its in-depth capabilities.

Indeed, its name had become a liability. But a survey of customers, competition, security analysis and brokers showed that the problem ran deeper. Brochures and catalogues, packaging and labeling were inconsistent and contributed to the fragmented picture of the company. And although the company was recognized for its quality products, and had built a valuable reputation for service, many customers could not clearly distinguish Michigan Seamless Tube, or its subsidiaries or divisions, from its competitors.

Because of customer confu-

Each division and subsidiary employed different graphic treatments of the corporate name in product literature, signage, business forms and stationery.

A unified corporate look was recommended and adopted.

ture, signage, business forms and stationery. Even corporate headquarters turned out signs and printed material with different corporate logos.

A nomenclature system was devised for identifying the relationship of the divisions and subsidiaries to the parent company. Initially, where the divisional name had a high level of recognition, Quanex was placed in a prominent, but secondary position. After the Quanex name has established sufficient recognition, the emphasis will be reversed. Also, with a subsidiary nomenclature system, a corporate advertising campaign was now feasible.

From signs on plants and vehicles to stationery, business forms and uniforms, a unified corporate look was adopted. Similar treatments were extended down through the divisions. At the marketing level, salesmen were provided with materials that

reflected the broad scope of Quanex's product capabilities, not just those of one division.

The effort was not a cosmetic beauty treatment. By placing all its parts under the one nonrestrictive Quanex umbrella, the company was pulling itself together. The message was being carried into the marketplace by salesmen who were armed with professional, high quality, consistently attractive and informative promotional and technical product literature. It was also communicated to customers. By packaging and labeling that utilized the new graphic and nomenclature system.

Communicating these changes to the investment community required a commitment to develop and maintain regular contact with security analysts. Specific sectors of this group were identified as realistic targets for the company's efforts to attract new investor capital. An audio-visual

presentation was developed which could be shown to interested analysts by various members of the management team, broadening management's exposure to financial audiences. In order to maintain a high level of communications with analysts and brokers, a communications professional was added to the corporate staff.

The implementation of the new Quanex identity was addressed equally to short-term and long-term goals. The company did not expect overnight rewards. But some results were strongly felt almost immediately, particularly inside the company, among sales and marketing personnel.

The new identity has made other business ventures more attractive. A new Quanex Management Seamless Division has been established to market the company's computer services expertise to other corporations.

Breaking more ties with the past, Quanex is moving its corporate headquarters away from Michigan to Houston, Texas, in response to a shift in its customer base toward the Sun Belt. New investor interest appears to be reflected in the improvement in the company's P/E ratio since the program began.

Clean, modern and strong, Quanex is an appropriate identity for a forward-looking company in charge of its future.

Communicating the Future

New directions in a company's strategy, whether motivated by strategic decisions or changes in regulation, requires a review of communications strategies. It's up to the CEO—and the corporate brand strategy he defines—to "sell" these new plans with both realism and optimism.

(See Book 2, No. 86, "Deregulation and Diversification: Communicating in an Environment of Change," 1984)

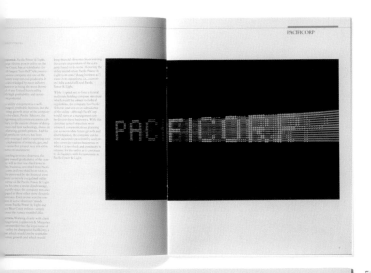

PIONEER

CHALLENGE: Pioneer Corporation began its career as Pioneer Natural Gas, a Texas-based regulated gas utility and gas distribution company. Diversification then took the company into other energy-related areas such as oil exploration, mining and production of mining equipment.

Pioneer was recognized as a strong performer in oil and gas exploration and production both on Wall Street and "in the oil patch," but this perception was undercut. Observers not thoroughly familiar with Pioneer Corporation related it solely to Pioneer Natural Gas because this was its heritage, even though this was no longer its actual strength. In fact, its corporate signature featured a gas flame symbol, further associating it with the regulated business. The company came to Lippincott & Margulies with questions of how best to disassociate itself from the gas utility image so that financial analysts would recognize it for the strong performing, growing company it really was.

SOLUTION: Since Pioneer is a name with high awareness levels and positive associations, Lippincott & Margulies recommended that the parent company retain Pioneer as the corporate name. In addition, a distinctive corporate logotype was developed with a wedge-shaped "underscore" which suggests oil drilling and other energy-related activities. Rather than include the regulated businesses under the Pioneer identity, it was recommended that the parent change the names of the regulated utilities so that analysts could focus on the oil production and on the gas exploration and production, rather than on the gas and transmission companies; and it would pave the way for divestiture of the regulated subsidiaries without loss of the Pioneer name and reputation.

The name Energas was developed and then adopted for the gas utility; the name Westar, for the gas transmission company; and Pioneer subsequently divested itself of both utilities.

11

TELECOMMUNICATIONS

The landmark settlement of the antitrust suit against the American Telephone and Telegraph Company (AT&T) on January 1, 1984, was a "long time coming," according to Robert La Blanc, a leading telecommunications analyst. Inflationary pressures led AT&T to file for a rate increase, unwittingly subjecting itself to an unprecedented round of public scrutiny.

The political climate was such that the motives of monopolies like AT&T were automatically under suspicion. Furthermore, business customers were aghast to find that their rates were subsidizing consumers. "This opened up competitive technologies to help business," says La Blanc, noting that companies began using their own switchboards and phones, as well as turning to rival carriers.

Then, too, technological breakthroughs paved the way for competitors by significantly lowering the entry field," says Peter Hall, the senior editor of *Financial World*, who has written extensively on the breakup. For example, micro-wave transmission became a widely available and inexpensive means of providing long distance service.

As a result, the laws began to change, adapting to demands for competitive products and services. By the time of the AT&T settlement, over 200 companies had already been authorized by the Federal Communications Commission to provide direct long distance dialing. Meanwhile, in the business phone market alone, the share controlled by AT&T and other public utilities dropped to 60 percent from 100 percent over the past 25 years.

Mr. La Blanc points out that telecommunications has been transformed from a "sheltered business to one where companies must compete on price, service and image." He continues, "The telephone company had a captive market. It didn't have to segment. But today they must look for niches."

Developing an identity for the seven regional holding companies severed from AT&T became a critical issue for each. The regionals were not tied to the Bell identity, even though the courts had granted them use of the Bell name. Nor were they limited strictly to the telephone business, or to a particular region for their nonregulated businesses. If anything, the new regionals had an overwhelming range of choices.

CHEMICAL BANK

CHALLENGE: Chemical Bank New York Trust Company promoted a rich heritage and total operations through a variety of mergers which left it with a long and prestigious operations name for a money center banking operation. Moreover, a brand name combining financial services to customers of disparate audiences to its branch offices. Retail services supported for consumer products such as savings and income were being offered to the same general customers as corporate lending. The bank needed a clearer institutional focus for its various customer audiences as well as a more commonsensible name.

SOLUTION: Comprehensive interviews with bank management, customers and the financial community resulted such an in-depth operational method revealed that while "Chemical Bank New York Trust Company" was an unwieldy element, it possessed invested identity upon a name which should be maintained. As part of a total corporate identification program, the name was legally changed to Chemical Bank, a simpler, more commercially viable, and a distinctive logotype was created for the name.

The informal abbreviation "Chem-Bank" is used in a retail context by create a new, informal, friendly atmosphere to project its business and personality of the bank as an improved financial point. This reflects part of the bank's philosophy that it is a service business, built not only on transactions but also on relationships. For communications efficiency, a "Chem" prefix nomenclature system was also developed to link various financial services: ChemChecking, ChemBase, ChemLoan, ChemAccess.

Chemical Bank has a strong, positive identity which works in concert with its strategic objective of strengthening its leadership position in the financial services marketplace worldwide.

13

Sense 87

A Communications, Marketing
and Design Publication of
Lippincott & Margulies Inc

Takeovers:

Are they restructuring Corporate America?

A view from the Top

John C. Whitehead
Former Senior Partner and Co-Chairman
Goldman, Sachs & Co.
Deputy United States Secretary of State (nominee)

Andrew C. Sigler
Chairman and Chief Executive Officer
Champion International Corporation
Chairman of the Business Roundtable's
Task Force on Corporate Responsibility

John F. McGillicuddy
Chairman and Chief Executive Officer
Manufacturers Hanover Trust

Carl C. Icahn
Chairman and Chief Executive Officer
Icahn & Company

John C. Whitehead

"The corporate executive who finds his stock undervalued is, of course, in a vulnerable position. What he must do is operate his company in such a way that investors will perceive the greater values that are in the company."

Andrew C. Sigler

"I think business has done a rotten job of describing what we are, how we are and how the system works... I think our system is uniquely good, but it's fragile."

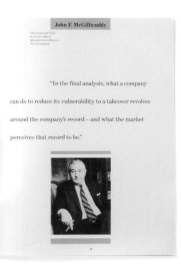

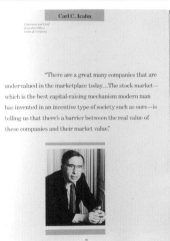

Fuzzy Images Invite Takeovers

Communicating a company's business intent to the marketplace is critical to avoid being a candidate for a hostile takeover. Without a reputation as a company that knows and excels at its core business, companies are vulnerable. A company's P/E ratio is based primarily on image, "the perception of investors as to the quality of management, the quality of the people in a company."

(See Book 2, No. 87, "Takeovers: Are They Restructuring Corporate America? A View from the Top," 1985)

sense

88th consecutive issue in a series of periodicals devoted to strategic communications issues affecting top management.

88

Diversify or Divest?
The Restructuring of
Corporate America

Martin S. Davis
Chairman and Chief Executive Officer
Gulf + Western Industries, Inc.

John H. Gutfreund
Chairman and Chief Executive Officer
Salomon Brothers, Inc.

Gerald Greenwald
Chairman
Chrysler Motors Corporation

Lippincott & Margulies Inc.

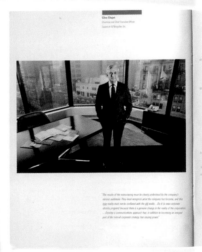

When It's Time to Rock the Boat

There are times when a company must restructure—hard decisions executives make when change can lead to more profits, and better return for shareholders. But don't assume you're always communicating change as well as you could be. "It's like the Bible," one Wall Street giant says. "You have to go back and reread it from time to time—there's something there you can learn."

(See Book 2, No. 88, "Diversify or Divest? The Restructuring of Corporate America," 1986)

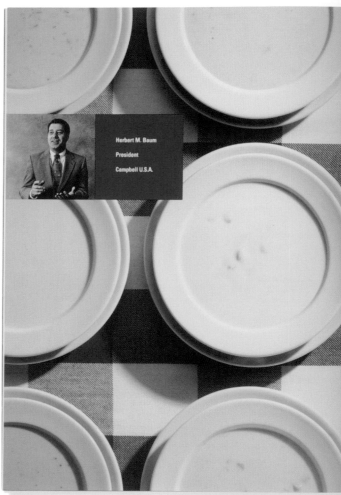

Protecting a Brand's Dollar Value

Brand value is the biggest item of goodwill any company has.
Protecting and increasing its dollar value, determined by what
its audiences think of the product, is the most important priority
a CEO has.

(See Book 2, No. 91, "What Makes a Brand's Image Valuable? The Importance of
Managing an Asset," 1989)

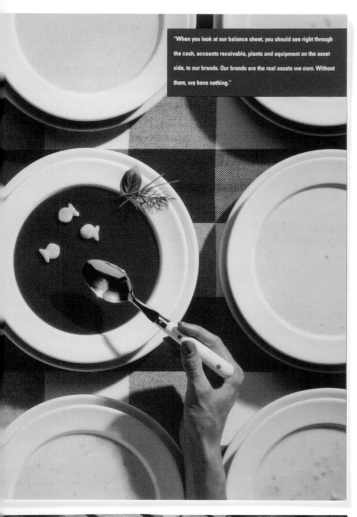

"When you look at our balance sheet, you should see right through the cash, accounts receivable, plants and equipment on the asset side, to our brands. Our brands are the real assets we own. Without them, we have nothing."

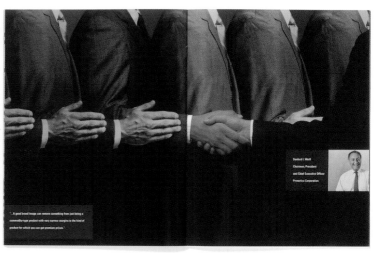

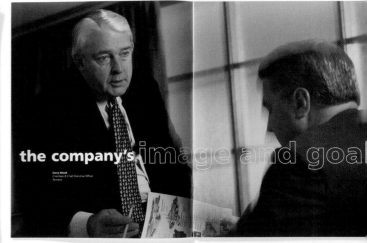

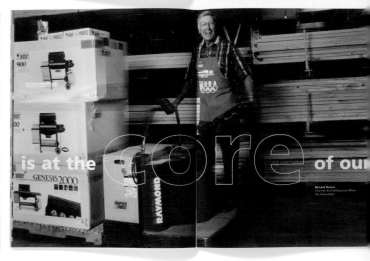

Linking Corporate and Brand Identity to Growth

Growth—whether in terms of earnings, profitability, market share, or geographic scope—is the driving force behind any flourishing company. A look at how The Home Depot built growth into its core identity: "Even in markets we haven't entered yet, consumers tell us they're waiting for us."

(See Book 2, No. 94, "Return on Image," 1996)

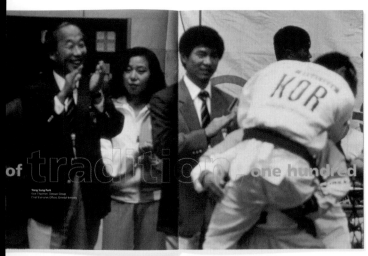

from the **employees."**

identity."

Customer Experience and Design

Not long ago, at the height of the dot.com frenzy, an expert or two predicted the death of all retail shopping. Who'd want to leave their home when everything from groceries to prescriptions could be purchased online? Even by dot.com standards, that prediction was patently stupid.

That's because people—all of us—crave experience. We shop, for example, for many reasons. It may be a a a chance to socialize, or how we gather information. Maybe we just like the way certain stores smell, or sound, or make us feel like we're part of the world.

Understanding the tiny details that make up these experiences was a goal of Lippincott Mercer right from the start. In the early 1940s, Gordon Lippincott had worked on such futurist projects as consumer helicopter interiors, and Walter Margulies' earliest successes had been in hotel design. Our company even designed a GE light bulb to specifically illuminate drugstores—bright enough to attract passersby, soft enough to entice browsing.

The success of early assignments showed how this attention to detail could pay off. While the U.S.S. Nautilus, the Navy's first atomic submarine, represented an engineering breakthrough with unlimited cruising power, it created a design challenge: How to make it possible for humans to endure the noise, the dark, and the small spaces for months at a time? A team of Lippincott Mercer designers, working nonstop for over nine months, created an interior that was as distinctive as it was livable. Early on, our designers created auto dealerships that were more conducive to sales, supermarkets that were more fun, and even big events—like the S. C. Johnson Pavilion at the 1964 World's Fair—that put a company's image in front of the public in entirely new ways. Starting with careful research, the questions are always the same: What colors, forms, materials, textures, lighting, and sounds (and even smells!) best communicate the brand?

Of course, much has changed, too. With consumers able to gather so much information on the Internet, some retailers have had to become more skillful at persuasion. A wealth of information about product segments has allowed for pinpointed focus on each segment, but created new questions. How can companies maintain relevance for each of the customer segments without disenfranchising others? How is it that an L.L. Bean can entice a novice fly-fisherman as well as a diehard bass hunter? Another shift has been an emphasis on creating emotional values—is this experience fun? entertaining? inspiring? distinctive?—rather than the more cut-and-dried traits of quality, value, and convenience. And how customer service and employee behavior can influence the consumer's experience is addressed much more directly.

Understanding how customers think and feel while experiencing any given brand is something Lippincott Mercer has taken as vitally important, right from the beginning. Our job: to make sure that experience is exactly what the brand's strategy intends it to be.

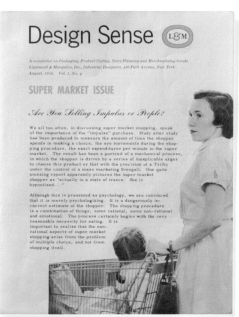

Design Sense L&M

A newsletter on Packaging, Product Styling, Store Planning and Merchandising trends. Lippincott & Margulies, Inc., Industrial Designers, 430 Park Avenue, New York. August, 1954. Vol. 1, No. 4

SUPER MARKET ISSUE

Are You Selling Impulses or People?

We all too often, in discussing super market shopping, speak of the importance of the "impulse" purchase. Study after study has been produced to measure the amount of time the shopper spends in making a choice, the eye movements during the shopping procedure, the exact expenditures per minute in the super market. The result has been a portrait of a mechanical process, in which the shopper is driven by a series of inexplicable urges to choose this product or that with the precision of a Trilby under the control of a mass marketing Svengali. One quite amazing report apparently pictures the super market shopper as "actually in a state of trance. She is hypnotized..."

Although this is presented as psychology, we are convinced that it is merely psychologizing. It is a dangerously incorrect estimate of the shopper. The shopping procedure is a combination of things, some rational, some non-rational and emotional. The process certainly begins with the very reasonable necessity for eating. It is important to realize that the non-rational aspects of super market shopping arise from the problem of multiple choice, and not from shopping itself.

Even here, we are inclined to doubt that the impulse is as simple as it seems.

What we call an impulse might be more correctly called a convergence of forces. In making a previously unconsidered choice, the shopper is in fact responding to a whole series of experiences—of conditioning—which culminate in this particular act at the point of sale. Although the choice may be non-rational, it is not necessarily unreasonable or mechanical. It is a response to a given complex of circumstances.

In designing super markets and packages for the super market shelf, we must concern ourselves not with tricks designed to hypnotize, but with triggers to action. To fall into the trap of looking upon Mrs. Consumer as a mechanism rather than a person can only result in the orientation that we can sell her what, and when, and where we want to, rather than the more correct evaluation that we can sell her only according to what she has come to need and what we can convince her she needs.

J. Gordon Lippincott and Walter P. Margulies

They're Selling Glamour in the Groceries

The heady revolution taking place among food retailers gets official public recognition this week in The Saturday Evening Post. (On the stands August 11th.) The Post carries the most searching, comprehensive look at the new super markets -- what's behind them, where they're going -- we've seen to date. Harold Mehling's story, "They're Putting Glamour in the Groceries," interviews top food chain developers, probes the meaning of changing shopping habits, gives facts on how giant operations are conducted. Biggest drive among food store operators, the article says, is to make shopping pleasurable with warm, colorful, dramatic interiors. How is this accomplished? Some of the answers the Post gives were found at L&M. Walter P. Margulies and J. Gordon Lippincott told reporter Mehling how they first challenged the old ideas in super market design; what they're aiming at in new stores for Elm Farms, Wm. Penn, Hinky Dinky, and others.

STEINBERG'S, CANADA
Where the Shopping Is Easy

Luxurious, beautiful, gay -- new words for describing a food store, have been pinned on L&M's design for the latest in the Steinberg chain: Steinberg's, Montreal.

A Design Emerges

Behind the package on the super market shelf lies intensive design exploration. Sometimes hundreds of comprehensives are prepared, ranging from blue-sky ideas to minute variations of what finally becomes the central theme. Here our goal was to express the natural wholesomeness of the product. Many "outdoor" symbols were drawn upon; these are a few ideas considered.

nucoa margarine — A PRODUCT OF THE BEST FOODS INC. NEW YORK, N.Y.
Psychological exploration—the egg as a symbol of nature.
Rejected as slow in communication value.

nucoa MARGARIN[E]
Leaf motif—to express outdoor goodness.
A possibility from the first.

NUCO MARGARINE
Childhood—nourishment and growth. Not unique enough.
Note experimentation with name change.

NUCOA MARGARIN[E]
Farm symbol, the rooster—down sweetness.
Too ambiguous in meaning.

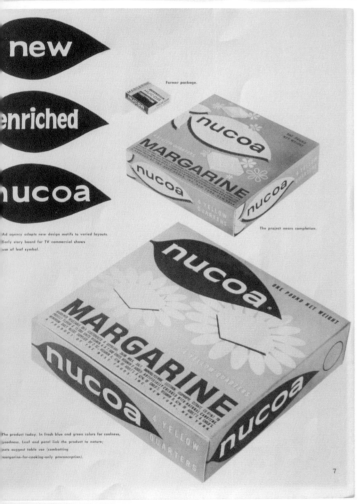

Why We Want to Shop

A Lippincott Mercer study of what 1950s women stored in their new deep-freezers startled us: They were empty! A well-stocked freezer meant less time shopping, less time being part of the busy world around them. Shoppers want "more stores where shopping is fun, and the shelves are stocked with delightfully packaged products."

(See Book 2, V.1, No. 4, "Supermarket Issue," 1956)

Design Sense L&M

A newsletter on Packaging, Product Styling, Store Planning and Merchandising trends
Lippincott & Margulies, Inc., Industrial Designers, 430 Park Avenue, New York
March, 1957 Vol. 2 No. 2

THE NEW SHOPPING TOWN

...a return to
the marketplace

Every retail establishment serves a dual function. From the point of view of the owner, the primary job of the store is to make a profit.

But no store can actually make profits unless it fulfills its more fundamental function of providing a marketplace for buyers and sellers.

This is the fact, whether consciously considered or not, that lies behind every decision made to improve the efficiency of retailing establishments. It is the basic core of the entire history of retail selling.

But let us consider for a moment what the concept of "marketplace" has meant.

In the Greek agora and the Roman market, under balmy skies, the populace heard philosophic debate, was entertained by parade and drama in the shadow of classic temples and monuments.

MARKETPLACE ISSUE

THE CUSTOMER LOOKS AT EFFICIENCY

HOW MANY CUSTOMERS ARE YOU LOSING?

STORE PERSONALITY... it's Vital to Have a Good One

Craving the Human Touch

Anyone who has ever wondered, in a crowded retailer, why so many shoppers are willing to endure the noise and chaos will have their questions answered here. All stores—from the highest-end jeweler to 7-Eleven—answer some need people have for human interaction.

(See Book 2, V.2, No. 2, "Marketplace Issue," 1957)

Robert Hall believes the young suburban family is more discriminating—wants to feel pride in the stores in which it shops...

and find shopping easy and pleasant. Costly fixtures, elaborate displays aren't always necessary to suggest fashion—here the colors, pinks, charcoal, blue green and burnt orange, carry the load.

Stress, in the family clothing store, is on the casual. A shopping expedition doesn't mean dressing up...

or leaving the children at home.

Everyone comes along. You drive over to buy a new suit

or dress in the same everyday way you would to go out to load up on groceries. It's a serious business making a decision but there is no swank to make the shopper feel inferior, uncomfortable. The atmosphere is friendly—

Robert Hall seems to have attained the kind of store they sought—one where everyone participates.

MOTIVATION BY DESIGN

New color slide film produced by L&M is a challenging presentation on contemporary product development and design—**available on request** for showings to management groups, advertising agencies and schools.

Lippincott & Margulies, Inc., Industrial Designers, 430 Park Avenue, New York

DESIGN SENSE

A MARKETING PUBLICATION OF LIPPINCOTT & MARGULIES INC. NUMBER 29

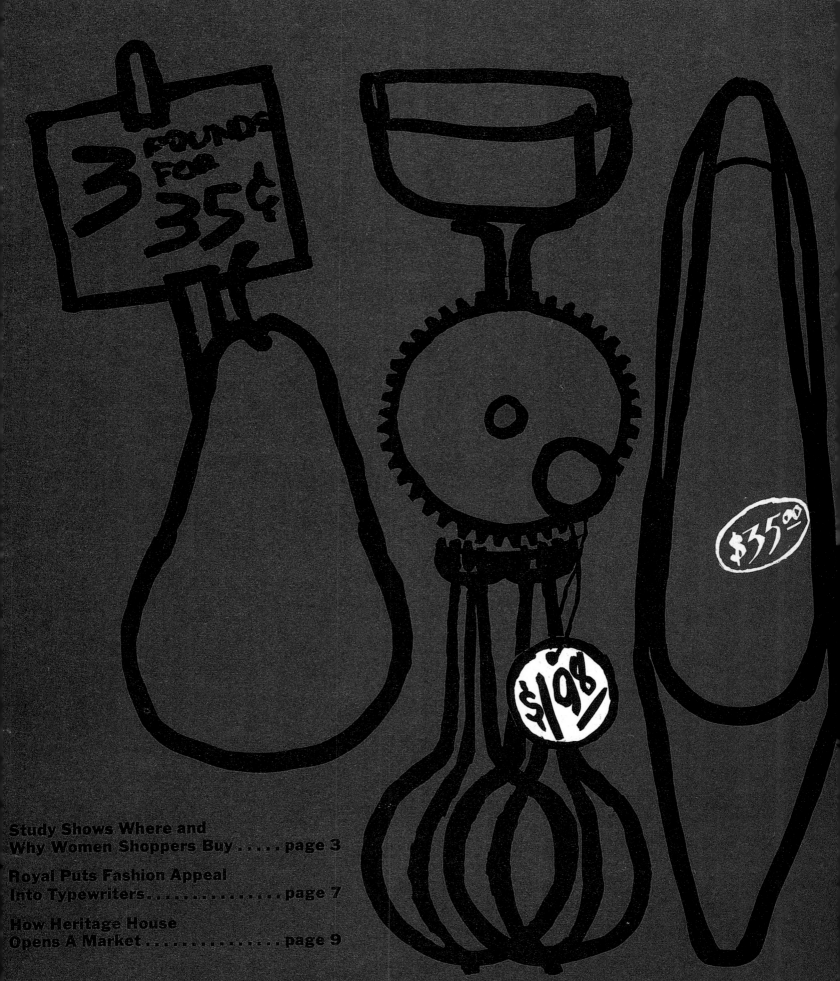

3 POUNDS FOR 35¢

$35.00

$1.98

Study Shows Where and
Why Women Shoppers Buy page 3

Royal Puts Fashion Appeal
Into Typewriters. page 7

How Heritage House
Opens A Market page 9

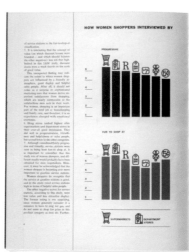
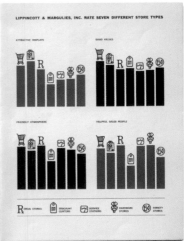

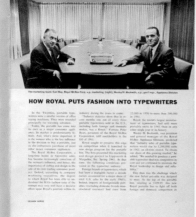
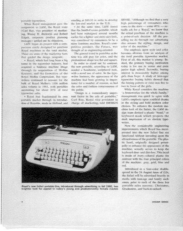
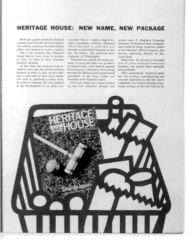

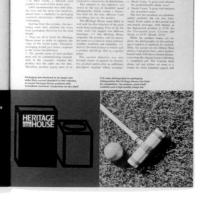
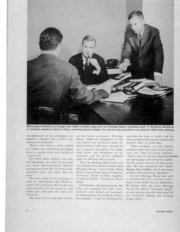

Retailers: Who Break the Mold?

205

Shoppers are influenced by both a store's image—a certain pro
shop's focused expertise, for example—as well as the store-type
image—Kmart shoppers recognize its similarity to Wal-Mart, as well
as its differences. From discounters to department stores, a look at
how some break the mold.

(See Book 2, No. 29, "Design Sense," 1962)

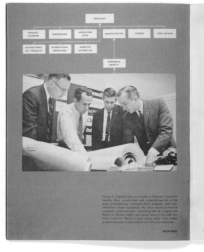

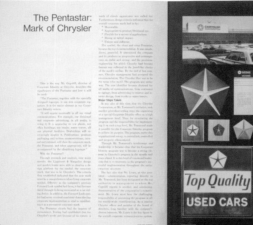

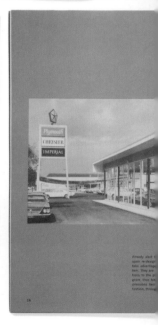

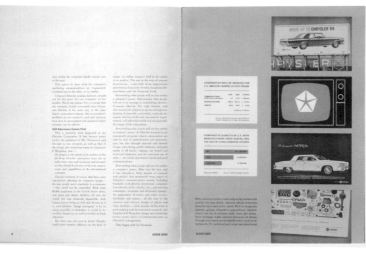

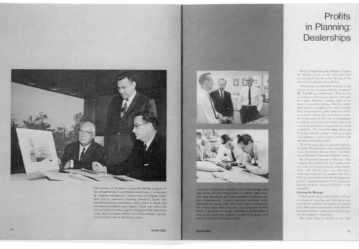

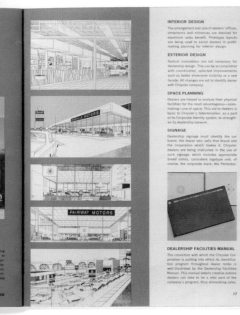

The Evolution of Car Dealers

For auto manufacturers, corporate identity's most vital proving ground happens at the dealer's showroom, where customers and car meet for the first time. Some things have changed: today, 85 percent of customers will have done Web research first. But this tale of how Chrysler revolutionized its dealers in the 1960s raises issues that are still critical.

(See Book 2, No. 36, "Special Issue: Chrysler Corporation," 1964)

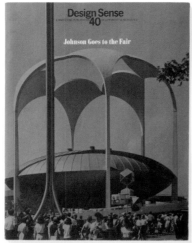

Design Sense 40

Johnson Goes to the Fair

The working bonds between S.C. Johnson & Son, Inc.—world-renowned "wax maker" of Racine, Wisconsin—and Lippincott & Margulies, Inc., extend back to 1956 and have always involved many products besides wax. This eight-year period has covered a host of great advances in the fields of industrial design and marketing. Among the most significant of these developments, especially as it has affected S.C. Johnson & Son, Inc., is the burgeoning interdependence of research and package design and marketing. In these fields, whiskers have come to even sharper stops and hounds. Since the turn of the century our country has emerged from the Dark Ages of industrial design, when fritz often overwhelmed function. And we have just come too, from the all-too-recent Stone Age of scientific marketing, when the typical sales effort was a risky experiment conducted in a vacuum called "the public."

There is no better example of our close working relationship with S.C. Johnson & Son than the joint effort that culminated in Johnson's Pavilion at the 1964-65 New York World's Fair. In the planning and execution of this difficult project our company contributed all its skills in exchange for Johnson's total cooperation with us—all the way from Johnson's initial decision to enter the Fair, the design of the Johnson Pavilion, through the pointers of the Pavilion's widely acclaimed main attraction, a short motion picture titled "To Be Alive!" As a matter of fact, the entire Johnson exhibit has won so much general acclaim that our company is pleasantly embarrassed by its success. The Tint has been loudly applauded by critics and public alike.

With its extensive experience in Johnson's global corporate identity and international marketing programs, Lippincott & Margulies endeavored to express Johnson's most marketing concept in the company's World's Fair project. General marketing concepts are often abstract in the extreme. We sought visually to crystallize the Johnson concept in the Pavilion and its attractions. This was attempted chiefly by means of striking design and wordless imagery. For example, even without its narrator, Johnson's film could be readily appreciated by most Boston or Swedes. Universal appeal was the keynote of our approach to this World's Fair enterprise. We aimed for the stars and, with the particular cooperation and understanding of Brand Chairman H. F. Johnson and President Howard Packard, we came. In our upmost, one's reach is reaching our awesomely noble description.

Through the years, S.C. Johnson & Son, Inc. and our company have proved good traveling companions. Johnson now markets some 60 household and industrial products in more than 70 countries. In many overseas, excellence of Johnson's package design has been the key that opened the doors to new markets, both domestic and foreign. Moreover, beyond these aims lay its no vacuum called "unknown consumers." Through broad and penetrative marketing research the company has inscrutably processed invaluable advanced knowledge of the territories and their peculiarities, which far from being working mysteries, become known factors that could be turned to Johnson's advantage.

This issue of *Design Sense* is devoted to several major facets of our past and continuing bonds with S.C. Johnson & Son, Inc.

Foreword

Lippincott & Margulies

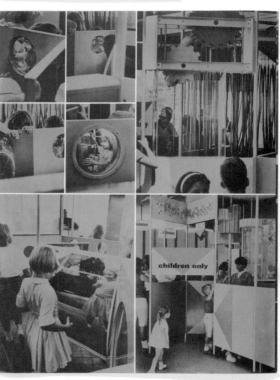

Just outside the Golden Rondelle one concourse that unites the public with propriety and in good taste. Children delight in threading their way through a "fun machine" that also cures adults on occasion. Other fringe attractions are a home-care machine that "telegraphs" answers to often-asked household questions, a bank of quick shoe-shine machines, and an "international court" displaying flooring materials to be found in various parts of the world.

mated 8 million Fair goers will visit the Johnson Pavilion—only one-fifth of the number of viewers, for example, who might watch a normal TV spectacular staged by Johnson at less cost. But a spectacular would be soon forgotten, whereas the impressions of a Golden Rondelle will linger as pleasant memories for years to come.

It is notable that the Golden Rondelle expresses Johnson's international identity through its very lack of design nationality and ancestry. It cannot be accused of looking like an upside-down Manhattan skyscraper or a non-leaning Tower of Pisa or an attenuated Buddhist shrine. The Rondelle's commercial lures are little more than fringe attractions—a home-care center that "telegraphs" answers to common questions, a "nonsense machine" to amuse children (and more than a few adults), a battery of speedy shoe-shine machines, an "international court" of various flooring materials from all over the globe. Throughout the entire construction phase, President Packard kept the project on schedule and oversaw the budget, while Mr. Samuel C. Johnson, Jr.—then in charge of Johnson's operations in Europe, where Mr. Walter P. Margulies had personally briefed him on plans—was kept current on the exhibit's progress.

Most of the World's Fair structures are built to be destroyed when the Fair ended, or shortly thereafter. Ease of demolition was a key factor in their structural design. In contrast, the Golden Rondelle is one World's Fair pavilion that will have a carefully planned future on the morning after the Fair closes. Land has already been purchased in Racine by S.C. Johnson & Son, Inc., next to the company's Frank Lloyd Wright tower. When the Fair ends, the Golden Rondelle, built for ease of dismantling, will be taken apart, shipped to Racine and reassembled as a permanent exhibition center. This reutilization of the structure thus satisfies one of Lippincott & Margulies' five criteria for Johnson's participation in the Fair. It promotes the Golden Rondelle to the status of a long-term investment, unlike the ephemeral buildings that surround it in New York.

In their conception of the Johnson exhibit as a whole, the consultants compared it to a pebble dropped into the big pond that is the Fair. Measurable ripples would be generated and their effect would be measurably felt. Johnson would thus gain greater recognition as a corporate entity, especially in New York City and on the Northeastern seaboard, and an important new public relations tool would have been created.

Evolving the Main Attraction

"What is inside the big clamshell?" is becoming a common question addressed by Fair visitors to attendants at Johnson's Golden Rondelle. All esthetics aside, this "clamshell" is indeed a handy, everyman description of the Rondelle itself. The answer is: the clamshell's innards consist of a movie theater seating 500 people. Aside from its split, triple screen and unique setting, the theater itself is not startlingly unusual. But the movie is.

In fact, the film has created such a stir that the details of its evolution are well worth telling. It is a first-rate vehicle for augmenting Johnson's corporate identity—yet it never alludes to Johnson by name nor even displays Johnson's corporate symbol. It is an extremely potent tool for heightening consumer goodwill and acceptance of Johnson's products—yet it never once mentions or depicts a Johnson's product or brand name.

The evolution of the movie proceeded simultaneously with the conception of the Golden Rondelle itself. In early discussions with Johnson executives, Lippincott & Margulies tentatively recommended a lively theme: man's use of his increased leisure time. But further analysis showed that there was something wrong with this picture. Americans, with perhaps the most leisure time of any people in the world, might find such a theme highly entertaining and memorable. In many foreign lands, however, hardworking peasants, factory hands, craftsmen, shopkeepers, farmers—an overworked 40-hour-work weeks and automotive tion—might easily resent the theme, envy "the leisure class" and feel hostile toward the mo-

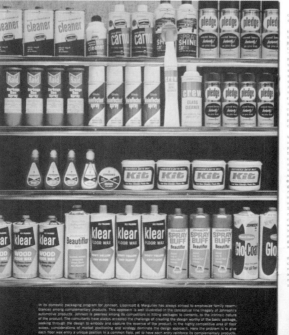

chises are more powerful equities in the minds of European consumers.

This was an open invitation for wide variations in package design. But such variations tend to fraction communications and increase packaging costs, as well as stepping up the chance of confusion with other corporate "Johnson" items (of which the U.S. has more than a hundred). Johnson desired to undertake the long-range program of gradually standardizing its packages with its present single corporate mark. The double-diamond symbol is now coming to symbolize Johnson itself in the minds of consumers. The "wax" has remained (although in some languages it comes in first position), but the apostrophe in Johnson's has yielded to a plant mark. The current solution, with the symbol nested inside the "J" of "Johnson," seems the happiest compromise, serving the best interest of unified corporate identity.

A European packaging program was launched for Johnson in late 1962. Mr. Samuel C. Johnson, Jr., then head of the company's European operations and now back in the U.S. as executive vice president, was concerned with the widening deviation among marketing plans for Johnson products in various countries. Packages for essentially the same product were beginning to resemble each other less and less. Lippincott & Margulies surveyed Johnson's various European managers, asked them to state their marketing plans and submit pictures of their products. The quality of labels was assessed. Studies were even made of the degree of each manager's adaptability to possible packaging changes. The question that continually arose was the merit of keeping an original package in a given country vs. switching to completely new packaging. But the underlying aim was gradually to standardize the imagery of packaging for a given product throughout Europe.

A combination of Lippincott & Margulies' on-the-spot observation and analysis, plus a careful weighing of the European managers' recommendations and preferences, produced an overall finding: the most important element in European market packaging is graphic similarity. It has not always been easy to persuade Johnson's European managers of this. Each naturally tends to favor his own packaging over that of the manager in the country next door. But the graphic similarity objective is being achieved, thus far without any managerial bloodshed.

Simultaneously, Lippincott & Margulies made a marketing feasibility study to determine how Johnson's true position in Europe. The challenge was manifest: a need to maximize Johnson's impact in European markets at both the corporate and brand levels. The major factors analyzed were:

1) The growth of self-service (calling for self-merchandising packaging).

2) The increasing mobility of consumers (leading to greater homogeneity among countries).

3) The "oversplit" of European advertising (heightening possibilities of package standardization and effective communications). This in-depth survey indirectly helped Johnson in seeing itself as Europeans see it. Such an experience is vital to the corporate self-knowledge that leads to meaningful systems of communications and marketing.

More than most other large corporations, S.C. Johnson & Son has a very lucid picture of itself in its corporate mind. It sees its own image without distortion, knows its own identity without rationalization, envisions its own future without unrealistic euphoria.

In its domestic packaging program for Johnson, Lippincott & Margulies has always strived to emphasize family resemblances among complementary products. This approach is well illustrated in the conceptual-line imagery of Johnson's automotive products. Johnson is peerless among its competitors in fitting packages to contents, to the intrinsic nature of the product. The consultants have always accepted the challenge of creating the design worthy of the basic package, seeking through the design to embody and capture the essence of the product. In the highly competitive area of floor waxes, considerations of market positioning and strategy dominate the design approach. Here the problem is to give each floor wax entry a unique position in a common field, yet to have each entry reinforce its complementary products.

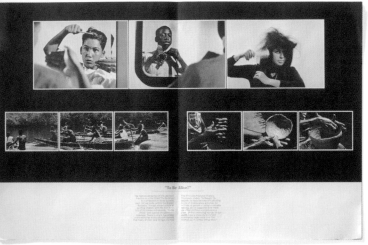

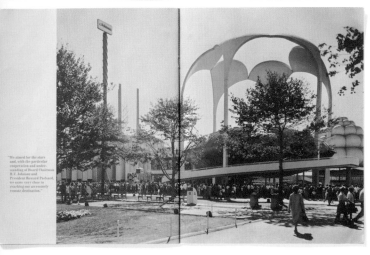

Once-in-a-Lifetime Opportunities

209

Hot dogs were introduced at a world's fair. So were elevators. So when S.C. Johnson decided to create an exhibit at the 1964 World's Fair, it aimed high. The Golden Rondelle, a seashell-shaped movie theater, attracted more visitors than any other exhibit. There, fairgoers viewed "To Be Alive!," a short film that celebrated humanity's everyday triumphs. Mentioning neither the company nor its products, the exhibit solidified Johnson's image as a caring, innovative company.

(See Book 2, No. 40, "Johnson Goes to the Fair," 1964)

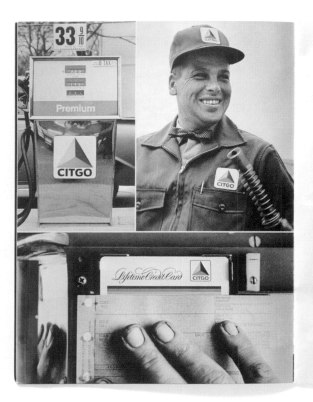

Outside the company, however, this stood for little. Hardly anyone saw the significance of the delta; as for the expanding circle outlined in green, many people thought it was some sort of shamrock.

The dominant green color of the symbol was also a further handicap in projecting a strong corporate image. Greens in the blue-and-green family are basically recessive, tend to fade out in a highway context and fail to match the liveliness and impact of reds and oranges.

Meanwhile, an exhaustive survey of some 315 service stations, documented by over 2,500 photographs, pointed up the lack of standardization in the company symbol (one station managed six variations of it), station architecture, pump design, dealer uniforms, station housekeeping, etc.

This simply added to the fragmentation and inconsistency of the Cities Service Oil Company message to the motorist. And while the company has been steadily involved in change and is a technical leader in the industry, public perception of this was slowed by a marketing name, symbol and colors developed in an earlier era.

The next step was to come up with a positive program. But before such obvious moves as a new name, symbol and color, a new communications strategy had to be developed.

Cities Service Oil Company had to be shown as the best of the majors, a company that provided matchless products and services for motorists. All of its competitors, however, boasted similar products and services. The challenge was how the company could project a unique personality. How, for instance, could it communicate the key factor in selling gas today — power — without simply aping the competition. It was patently impossible, after all, to claim to have two tigers in the tank!

Nonetheless there was a solution. Most major oil companies were found to share two notable negatives: the image of a vast impersonal organization and one that seems static and self-satisfied. Cities Service Oil Company could break the pattern by showing that (1) it was a major that was big and powerful, but not impersonal and (2) that it was active and progressive.

To achieve this, the company's former advertising approach (which was keyed heavily to such abstractions as far as the consumer was concerned as geology and production) would be dropped. In its stead would come a communications format designed to foster the new corporate personality as well as counteracting misconceptions previously held by the public.

First, all advertising and promotion would show action. Static concepts and situations would be avoided at all costs.

Second, people must be involved. In place of the old monolithic and coldly mechanical image, the emphasis had to be on authentic people doing exciting things in a believable manner.

Third, the company's projection must underscore specifics in order to combat the vagueness that had plagued it in the past. Thus, obvious advertising stereotypes would bow wherever possible to particular persons, places and situations.

Fourth, the company would always be shown as progressive and modern — constantly planning, searching, experimenting and changing for the benefit of the motorist.

Once this new communications strategy for Cities Service Oil Company had been finalized, a dramatic moment was at hand. To drive home its new personality, the company's marketing name would now be changed, its traditional symbol redesigned and its service stations given a completely new look. Properly integrated, this would communicate a clear and consistent corporate picture to the consumer.

Just dreaming up any name wouldn't do. To begin with, it had to be short enough for fast recognition on the highway. It had to be easy to pronounce and remember. It had to suggest dynamic qualities. It could not be geographically or socially limited. It had to be applicable to the oil industry, flexible for possible expansion and compatible with its image objectives of progress, interest in people, stature and dynamic action. What's more, it could not be a totally new name — that is, one without some reference to its predecessor.

There were innumerable directions to take: among them initials, contractions, existing product names of the company, proper names and fabricated names. It was decided that a contraction of the company's old name, between four and seven letters long, would provide the best bridge. To make sure no possibility was overlooked, various combinations were even programmed into a computer. As a result, there were more than 70,000 candidates.

Weeks went into sifting and considering them. There were two finalists: CITCO and CITGO. Both had the same believable bridge, but in the end it was felt that CITGO contained a unique quality and sense of action that could not be topped.

In similarly painstaking fashion, hundreds of new symbols were considered.

Equally important was the color scheme. A special effort was made to retain green, so long a part of the company's history, but it was too recessive. And despite the fact that red, white and blue are competitively commonplace, test after test showed that no other combination worked as well. The trick was how it was put together.

After the CITGO logotype had been picked, it was included in five final symbol designs, each with its own variation of red, white and blue. Next each symbol underwent exhaustive field analysis. In one test, a photograph was taken of a company service station in an extremely busy highway environment with a background of heavy foliage to boot.

Each of the five symbols, scaled to size, was then placed on successive color photographs of the station as a motorist might see it. Two of the five were immediately superior in visibility and impact. The solution was to combine the best qualities of each. The results of this included a rectangle outlined in blue with a controlled white field. On the field is a three-dimensional triangle, reminiscent of the old delta, in three shades of red. Underneath, in blue, is the new logotype spelling out CITGO.

Further applications followed immediately to project new company image: the three shades of red on the raised triangle were turned into a tri-color band for use on company trucks, service stations and station equipment. Pump islands received special design considerations. They are the most important item in a station, although often overlooked. But this is what the motorist looks for and where he spends most of his time. Beyond this, the basic design concept is currently being carried out in packaging, dealer uniforms, credit cards and sales promotion.

The results will be unveiled on May 17, 1965.

To bring it about, Cities Service Oil Company launched an eye-popping logistics operation. To provide new uniforms, enough material was used to cover 230 football fields or clothe three U.S. Army Divisions. For the new symbol, almost a million square feet of cast acrylic was ordered — enough to put a plastic roof over eleven city blocks. To dress up trucks, signs and service stations in the new company colors, 300,000 gallons of paint were required. At the same time 30,000 high output fluorescent lamps were being installed in company stations along with a hundred thousand pounds of copper lighting ballast — enough to mint a million and a half pennies and solve the country's coin shortage.

In conjunction with its external marketing changes, the Cities Service Oil Company has thoroughly streamlined its marketing organization during the past year. Lines of communication have been tightened and the marketing structure consolidated. Within marketing divisions of the company, the sales force has been reorganized and work responsibilities clearly defined.

For Lippincott & Margulies, long used to major client projects, it was the biggest program ever taken on relative to the amount of time involved — less than eighteen months from start to finish — and one of the most satisfying.

For CITGO, it is the start of a new era.

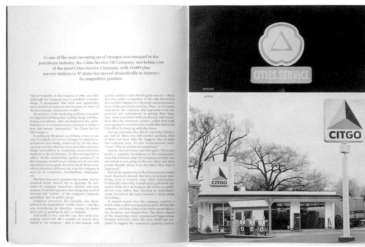

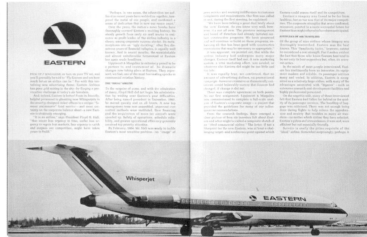

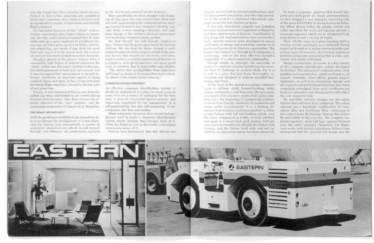

How Long Should a New Image Take?

No one could remember what Cities Service Oil did, not even the people who gassed up there weekly. A new image, including new stations, signage, pump islands, uniforms, and lighting—not to mention the new name of CITGO—was researched, planned and implemented in just under 18 months.

(See Book 2, No. 43, "Closing the Image Gap: Two Case Histories," 1965)

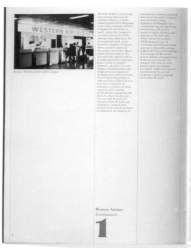

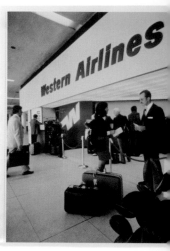

Western Airlines
Environment

1

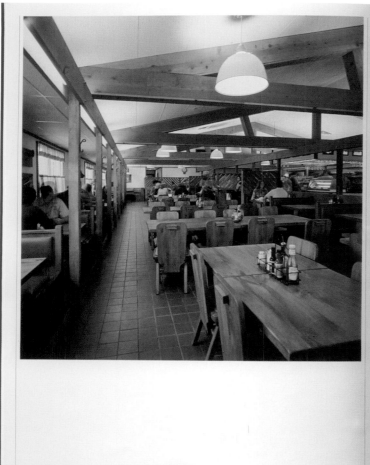

Environmental marketing design was used by Ponderosa to upgrade the quality of its dining atmosphere and to improve its overall competitive position. The restaurant chain, specializing in steak dinners at modest cost, had been forced over the years to gradually increase its prices. At the same time, the design of the restaurants did not change, resulting in a dining atmosphere created for inexpensive meals in restaurants that were, in fact, serving steak dinners at much higher cost. A Lippincott & Margulies environmental marketing design study strongly recommended that the "mess hall" style of eating be replaced by booths with padded seats and dividers for privacy. A dramatic note was added by moving the broiler to a more visible location, allowing customers to watch the steaks cook over charcoal fires. From a marketing standpoint, the move was highly successful, since meals are now served hotter and waiting time is reduced. Interiors were substantially upgraded to preserve the natural look; the Western decor was selected for more mature diners. The wall-mounted menu board was redesigned to show clearly the ample steak size being served. A dessert and coffee bar was added which proved profitable for Ponderosa and added another dramatic note for customers. Uniforms were created in denim and red-checked design to appeal to the family market being sought. Outside, L&M refined the logo on Ponderosa's pylon sign. Every detail in the environmental marketing design was directed toward one goal— increased sales for Ponderosa.

Old Ponderosa interior to be upgraded by new design.

Ponderosa
Environment

3

Major Visual Changes, Minimal Renovations

People hated the look of Kentucky Fried Chicken's stores, and towns were banning the chain's signature bucket atop its signs. Seizing the zoning problems as an opportunity to strengthen its down-home, finger lickin' good reputation, Lippincott Mercer designed a drop-on roof, mullioned windows, new shutters, and a sign that allowed for easy removal of the bucket if zoning laws changed.

(See Book 2, No. 73, "Selling the Sizzle and the Steak: Environmental Marketing Design," 1975)

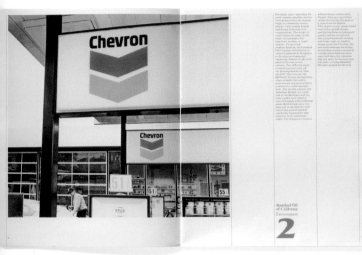

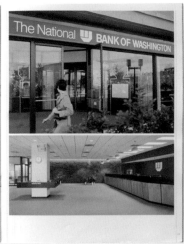

Standard Oil
of California
Environment

2

National Bank
of Washington
Environment

4

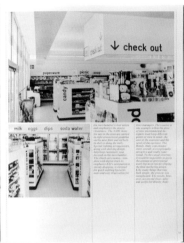

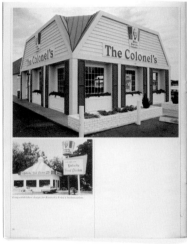

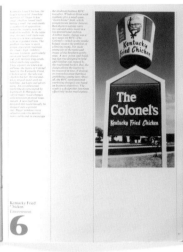

Handy Andy
Environment

5

Kentucky Fried
Chicken
Environment

6

Long-established design for Kentucky Fried Chicken system.

Sense 78
A Communications,
Marketing and Design Publication
of Lippincott & Margulies, Inc.

Retail Power

A new marketing communications thrust by select retailers, big and small, is paving the way to improved image and profits.

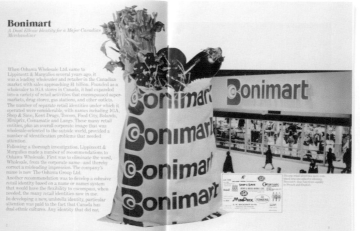

Bonimart
A Dual-Ethnic Identity for a Major Canadian Merchandiser

When Oshawa Wholesale Ltd. came to Lippincott & Margulies several years ago, it was a leading wholesaler and retailer in the Canadian market with sales approaching $1 billion. Founded as a wholesaler to IGA stores in Canada, it had expanded into a variety of retail activities that encompassed supermarkets, drug stores, gas stations, and other outlets.

The number of separate retail identities under which it operated were considerable, with names including IGA, Shop & Save, Kent Drugs, Towers, Food City, Bolands, Mini-prix, Consumate and Langs. These many retail entities, plus an overall corporate image that was wholesale-oriented to the outside world, provided a number of identification problems that needed attention.

Following a thorough investigation, Lippincott & Margulies made a number of recommendations to Oshawa Wholesale. First was to eliminate the word, Wholesale, from the corporate name—and thereby correct a misleading impression. The company's name is now The Oshawa Group Ltd.

Another recommendation was to develop a cohesive retail identity based on a name or names system that would have the flexibility to encompass, when needed, the many retail identities now in use.

In developing a new, umbrella identity, particular attention was paid to the fact that Canada has dual ethnic cultures. Any identity that did not

address the needs of both its English- and French-speaking peoples would have a problem.

Following image criteria thus established, a new retail identity was finally developed: *Bonimart*. The name is unique in that it has meaning in both French and English and relates equally to both cultures. Many portions of Oshawa's retail food and merchandise activities were moved under this umbrella.

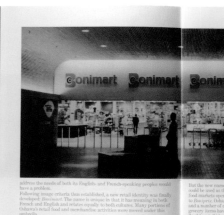

But the new name offered additional advantages. The *Bonimart* name could be used as the base for other food markets operating under the *Bonimart* umbrella. To date, a number of *Bonimart* food markets operating under the *Bonimart* umbrella. Oshawa's convenience food markets and a number of controlled-line or grocery items have opened under this flexible retail identification system.

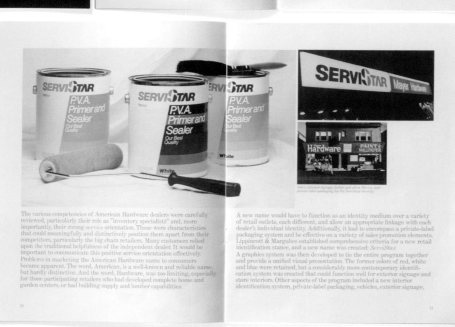

The various competencies of American Hardware dealers were carefully reviewed, particularly their role as "inventory specialists" and, more importantly, their strong *service* orientation. These were characteristics that could meaningfully and distinctively position them apart from their competitors, particularly the big chain retailers. Many customers relied upon the traditional helpfulness of the independent dealer. It would be important to communicate this positive service orientation effectively.

Problems in marketing the American Hardware name to consumers became apparent. The word, American, is a well-known and reliable name, but hardly distinctive. And the word, Hardware, was too limiting, especially for those participating retailers who had developed complete home and garden centers, or had building supply and lumber capabilities.

A new name would have to function as an identity medium over a variety of retail outlets, each different, and allow an appropriate linkage with each dealer's individual identity. Additionally, it had to encompass a private-label packaging system and be effective on a variety of sales promotion elements. Lippincott & Margulies established comprehensive criteria for a new retail identification stance, and a new name was created: *ServiStar*.

A graphics system was then developed to tie the entire program together and provide a unified visual presentation. The former colors of red, white and blue were retained, but a considerably more contemporary identification system was created that could function well for exterior signage and store interiors. Other aspects of the program included a new interior identification system, private-label packaging, vehicles, exterior signage,

Fast Fare
A Convenience Store Chain Builds a Competitive Edge

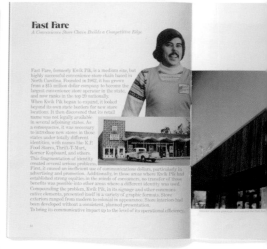

Fast Fare, formerly Kwik Pik, is a medium size, but highly successful convenience store chain based in North Carolina. Founded in 1962, it has grown from a $15 million dollar company to become the largest convenience store operator in the state, and now ranks in the top 20 nationally.

When Kwik Pik began to expand, it looked beyond its own state borders for new store locations. It then discovered that its retail name was not legally available in several adjoining states. As a consequence, it was necessary to introduce new stores in those states under totally different identities, with names like K.P. Food Stores, Thrift-T-Mart, Korner Kupboard, and others.

This fragmentation of identity created several serious problems. First, it caused an inefficient use of communications dollars, particularly in advertising and promotion. Additionally, in those areas where Kwik Pik had established strong equities in the minds of consumers, no transfer of those benefits was possible into other areas where a different identity was used.

Compounding the problem, Kwik Pik, in its signage and other communicative elements, presented itself in a variety of graphic formats. Store exteriors ranged from modern to colonial in appearance. Store interiors had been developed without a consistent, planned presentation.

To bring its communicative impact up to the level of its operational efficiency,

Cassano's
Heightened Image Appeal for a Small Fast-Food Marketer

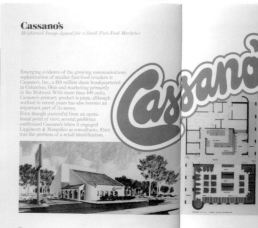

Emerging evidence of the growing communications sophistication of smaller fast-food retailers is Cassano's, Inc., a $19 million chain headquartered in Columbus, Ohio and marketing primarily in the Midwest. With more than 100 units, Cassano's primary product is pizza, although seafood in recent years has also become an important part of the menu.

Even though successful from an operational point of view, several problems confronted Cassano's when it engaged Lippincott & Margulies as consultants. First was the problem of a retail identification.

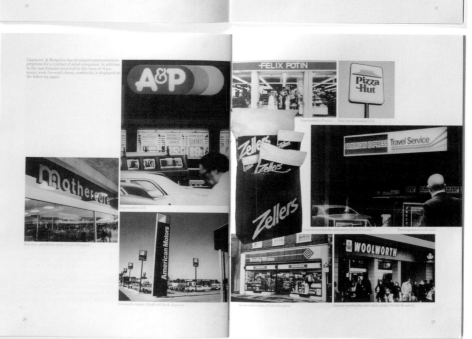

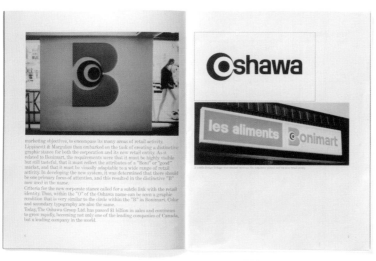

marketing objectives, to encompass its many areas of retail activity. Lippincott & Margulies then embarked on the task of creating a distinctive graphic stance for both the corporation and its new retail entity. As it related to Bonimart, the requirements were that it must be highly visible but still tasteful, that it must reflect the attributes of a "Boni" or "good" market, and that it must be visually adaptable to a wide range of retail activity. In developing the new system, it was determined that there should be one primary focus of attention, and this resulted in the distinctive "B" now used in the name.

Criteria for the new corporate stance called for a subtle link with the retail identity. Thus, within the "O" of the Oshawa name can be seen a graphic rendition that is very similar to the circle within the "B" in Bonimart. Color and secondary typography are also the same.

Today, The Oshawa Group Ltd. has passed $1 billion in sales and continues to grow rapidly, becoming not only one of the leading companies of Canada, but a leading company in the world.

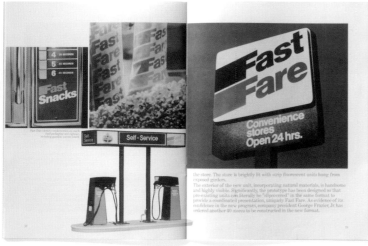

the store. The store is brightly lit with strip fluorescent units hung from exposed girders.

The exterior of the new unit, incorporating natural materials, is handsome and highly visible. Significantly, the prototype has been designed so that pre-existing units can literally be "slipcovered" in the name format to provide a coordinated presentation, uniquely Fast Fare. As evidence of its confidence in the new program, company president George Frazier, Jr. has ordered another 40 stores to be constructed in the new format.

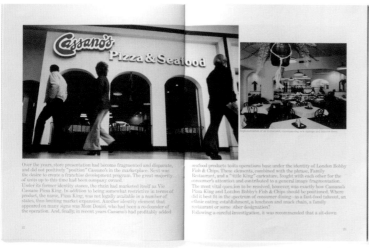

Over the years, store presentation had become fragmented and disparate, and did not positively "position" Cassano's in the marketplace. Next was the desire to create a franchise development program. The great majority of units up to this time had been company owned.

Under its former identity stance, the chain had marketed itself as Vie Cassano-Pizza King. In addition to being somewhat restrictive in terms of product, the name, Pizza King, was not legally available in a number of states, thus limiting market expansion. Another identity element that appeared on many signs was Mom Donisi, who had been a co-founder of the operation. And, finally, in recent years Cassano's had profitably added

seafood products to its operations base under the identity of London Bobby Fish & Chips. These elements, combined with the phrase, Family Restaurant, and a "little King" caricature, fought with each other for the consumer's attention and contributed to a general image fragmentation.

The most vital question to be resolved, however, was exactly how Cassano's Pizza King and London Bobby's Fish & Chips should be positioned. Where did it best fit in the spectrum of consumer dining—as a fast-food takeout, an ethnic eating establishment, a luncheon and snack chain, a family restaurant or some other designation?

Following a careful investigation, it was recommended that a sit-down

Corporate Identity for Small Retailers

Cohesive, well-executed identity programs don't work only for national and international retailers. Smaller chains may even have an advantage in finding and developing a unique positioning in the market, and many customers like their ability to have "more personality" than the average national store. Two case studies in finding solutions on smaller budgets.

(See Book 2, No. 78, "Retail Power," 1977)

Index

10 The Birth of Corporate Identity

12 Nameplates Mean More Than You Think in Today's Marketing

14 Uni-Marketing

16 Corporate Identity—Part One

18 Corporate Identity—Part Two: The System at Work

20 Image Communication for Companies and Products

22 Design for Systems Marketing

24 Special Issue on Advertising and Total Marketing

26 Brand and Communications Strategy

28 Design Sense 28

30 Design Sense 30

32 Corporate Identity Revisited: New On-Rushing Complexities Demand a More Subtle, Sensitive Response

34 Position Your Product and Sign Your Ad

36 Global Communications: It's Later Than You Think

38 Overkill

40 Uncommon Rewards for the Uncommon Marketer

42 Con Edison: A Troubled Giant and Its Dramatic Turnaround

44 Renewed Vitality for Very Large Corporations

46 Enter Superbrand: A Unique Marketing Concept That Builds for the Future

48 The New Shape of Financial Services

50 Closing the Image Gap

52 Banking's Other Asset

54 The Pursuit of Excellence in the Emerging Marketplace

56 "Why Don't People See Your Company the Way It Really Is?"

58 Communications Productivity

60 Being One of One: Standing Out from the Crowd

62 The Globalization of American Industry

64 Corporate Identity As a Marketing Tool

66 Today's Decisions, Tomorrow's Image

68 Employees and Image: The New Corporate Ambassadors in the Marketplace

70 Creating the Preeminent Global Brand

72 Design and Business
74 Design Can't Stand Still
76 Trademark Issue
78 Design for Sales
80 Revolution in the Marketplace
82 Design for World Markets
84 The Design-Marketing Consultant
86 The Creative Man
88 Fulfillment: Executing a Corporate Identity Plan
90 Multi-Disciplined Marketing

92 The Marriage of Science and Design
94 Is Good Design Practical?
96 These Are Your Customers…
98 Planning for New Products—Part One
100 Planning for New Products—Part Two
102 How Much Is Good Design Worth?
104 Progress Report on Design Research
106 A New Approach to New Product Planning
108 Marketing-Concept Package
110 Design Sense 33
112 Design Sense 34
114 The Taste of Color
116 Marketing & the Supreme Court
118 To Change or Not to Change Your Package: A Multi-Billion Dollar Marketing Decision
120 Can Brand Be Measured?

122 Marketing Strategy
124 Design Sense 27
126 Special Marketing Issue
128 Design Sense 32
130 Design Sense 35
132 International Markets
134 Ethnic Marketing Spoken Here
136 The Youth Market: Adorable? Deplorable? Ignorable?
138 Canada's Future: Market or Marketer?
140 The New Adults—Marketing's Bewildering Bonanza
142 Advertising: In the Eye of a Hurricane
144 Lifting the Fog from Multinational Marketing

146 The Role of Naming
148 The Name's the Thing: Today's Hottest "Image" Problem and How to Solve It
150 The Corporate Name Maze
152 U.S. Rubber and Borg-Warner
154 Corporate Name Selection
156 The Corporate Name: To Change or Not to Change

158 Corporate Brand and Wall Street
160 The Communication Pitfalls of Mergers
162 Corporate Turnaround
164 What Wall Street Says about the Corporate Image
166 Growth and Your Price-Earnings Ratio
168 The Vital Role of Communications in Mergers & Acquisitions
170 Financial Services: A Field in Ferment
172 The Challenge to Regulated Industries
174 American Motors
176 Conglomerates: Phase Three
178 Marketing Quicksand: The '70s
180 Corporate Image and Those Magic Multiples
182 Communicating Credibility to Financial Audiences
184 That Tender Age: The Role of Corporate Identification Programs in the Defense Against Tender Offers
186 Outside Directors: A Tough New Audience for Corporate Communications and Corporate Identity Planning
188 Deregulation and Diversification: Communicating in an Environment of Change
190 Takeovers: Are They Restructuring Corporate America? A View from the Top
192 Diversify or Divest? The Restructuring of Corporate America
194 What Makes a Brand's Image Valuable? The Importance of Managing an Asset
196 Return on Image

198 Customer Experience and Design
200 Supermarket Issue
202 Marketplace Issue
204 Design Sense 29
206 Special Issue: Chrysler Corporation
208 Johnson Goes to the Fair
210 Closing the Image Gap: Two Case Histories
212 Selling the Sizzle and the Steak: Environmental Marketing Design
214 Retail Power